PATRICK McNEIL, creator of designmeltdown.com

THE WEB DESIGNER'S volume 3

IDEA BOOK

inspiration from today's best web design trends, themes and styles

HOW
BOOKS
Cincinnati, Ohio
www.howdesign.com

For more excellent books and resources for designers, visit www.howdesign.com.

17 16 15 14_13 5 4 3 2 1

ISBN-13: 978-1-4403-2396-6

Distributed in Canada by Fraser Direct
100 Armstrong Avenue
Georgetown, Ontario, Canada L7G 5S4
Tel: (905) 877-4411

Distributed in the U.K. and Europe by F&W Media International, LTD
Brunel House, Forde Close, Newton Abbot, TQ12 4PU, UK
Tel: (+44) 1626 323200, Fax: (+44) 1626 323319
Email: enquiries@fwmedia.com

Distributed in Australia by Capricorn Link
P.O. Box 704, Windsor, NSW 2756 Australia
Tel: (02) 4560-1600

Editor: Scott Francis
Art director: Ronson Slagle
Production coordinator: Greg Nock

Dedication

For Angela, Jack and Maizy.

About the Author

To say that Patrick is obsessed with web design is a bit of an understatement. What began as a simple exploration of design on his blog Design-Meltdown eventually turned into a best-selling series of books. With a passion for technology and design, Patrick McNeil has found himself at home on the web where these two fields merge so perfectly. His love of design drives him to obsess over the trends and patterns collected in his books. Beyond observing trends, Patrick is focused on front-end development techniques and teaching designers to effectively leverage the web as a design medium. For more information about Patrick, visit his personal site, pmcneil.com or follow him on Twitter @designmeltdown.

Acknowledgments

Writing a book is a huge task and inevitably there are countless people along the way to thank. More than anyone, I owe a huge debt of gratitude to the growing community of designers who take an interest in the books I write. Without all of the outstanding work produced by designers around the world this book would not be possible. I consider it a privilege to dig through these beautiful websites and to compile the work of designers I sincerely admire. Your awesome work is what makes my job possible. Thank you!

Note

If you would like to submit your designs for possible use in future books, please visit TheWebDesigners IdeaBook.com to sign up for my mailing list. You will be informed of book releases, calls for entries and other information directly related to the books.

Contents

Word From the Author

Pretty much anytime you wrap up a huge project that you're passionate about, you feel a bit like celebrating. Like when you finish remodeling a house, or when you build a wooden rocking chair for your new baby boy, or when you finally launch a new pet project. Finishing a book is very much like this, and with each new book I manage to wrap up I can hardly believe where I am in life. Writing these Idea Books is about as much fun as I can imagine having at work. I get to sift through thousands of amazing designs, meet many new people and ultimately obsess over the web design industry. To say I am fortunate to be in this role is a vast understatement.

Gushing emotions aside, it truly is fun to see a book like this come together. With each new volume—and a greater history to look back on—it becomes more and more evident how far the industry has come. Each year the industry grows and refines itself further. The quality of design improves, the quantity of great design increases and the sense of community grows stronger. This is what makes the web so special; at the end of the day we are all working together in a complex interchange of ideas, tools and clients. And it is my hope that this book captures a snapshot of the web as it existed in 2012.

One of the biggest hurdles I faced in writing this book is that with each new book, the base of people interested in submitting their work grows. This is obviously a good thing, but it also means I have to pass on more and more work because of limited space. This means hundreds—perhaps thousands—of gorgeous sites I would love to include simply won't fit.

What really inspires me when writing this book series is the amazing designers. For every artist who is in the limelight and whose name many of us recognize, there are a hundred others lurking in the shadows and cranking out incredible work. Many haven't found their way into the spotlight; others don't want to. I take joy in finding some of these designers who run below the radar. I am frequently delighted to discover that the designer behind a site I love is also behind five others I love as well. It is the work of these unsung heroes that I most love to showcase. Sure, some works you find here come from some very well-known people, but for the most part, you probably have not seen most of the material. I think this is what makes my Idea Books extra special; they offer a fresh set of inspiration rather than the same huge names we all know about.

— *Patrick McNeil*

01 / Technology

One of the reasons many people (myself included) love the web is because it so perfectly combines technology and design. And while technology has always had an impact on design, I believe we are currently experiencing a situation in which many technologies come together and force massive shifts in the industry. The result is a major change in web design styles, trends and techniques.

Consider the following technologies:
- the explosion of new devices (tablets, smartphones, and so forth)
- the progress of responsive designs and development techniques
- refinements in using custom type online
- the introduction of CSS3 and HTML5
- refinements in many content management systems

With all of these areas moving together at once, we can clearly see how the face of the web is changing; in fact, we see it firsthand each day as we use the web. The industry is in a time of increased flux and along with this comes many new design patterns. What I find fascinating is how they interconnect. Each of these technologies has pushed the industry along, but it is the combination of all these things that have become the collective catalyst for change; a perfect storm if you will.

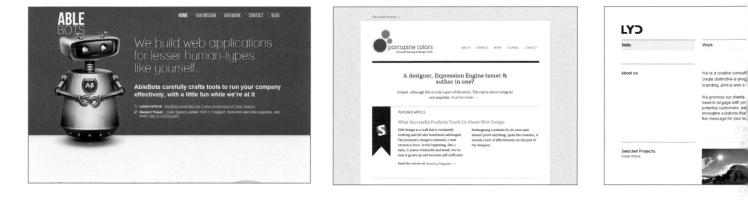

A prime example of this is responsive design. With responsive design, the goal is to have a website adapt to the user's device and function in an ideal way in each situation. If I view the site on a PC, smartphone or tablet, I basically get a tailored experience for that device. This is primarily accomplished by developing style sheets for each potential layout. As it turns out, with CSS3 we can apply many more visual styles in code, something that was previously accomplished with images. This is rather convenient when we are applying style variations, such as drop shadows, rounded corners or gradients to the same set of elements. Combine this with improvements like the support for multiple backgrounds on one element, which means the HTML is simpler and easier to manage, which reduces the complexity dramatically and really helps when we're creating multiple versions of a page via CSS. Then add to the top of this far greater support for custom type in a page via CSS. Now it's far easier to embed text in a page, reducing the need for things like image-based text or plug-ins that render custom type in a flash (sIFR[1]). I know this is a lot to process, but I want you to see that it is all woven together into a perfect storm. Each piece contributes to the overall evolution of the process, with the result being rather dramatic change in a much shorter time span then we normally experience. To be sure, the web is in perpetual motion, but for the last few years it has been moving at warp speed.

Let's dig in and look at a variety of technologies that have shaped the web as we find it today. And, of course, along the way we will look at a ton of beautiful designs that demonstrate some of the potential uses of these technologies. While it is not the goal of this book to be a technical manual, I will also provide a brief introduction to each of these topics in case you're not acclimated to them. Ultimately, though, we are here to observe the beautiful designs in an effort to spark ideas and inspire you.

Content Management Systems

A critical part of the web is the use of content management systems (CMS for short). This technology has had a profound impact on the cost and process of getting content online. And while these systems have been around for a long time, in recent years they have reached a truly amazing point.

A CMS allows many people to manage and publish content to a website. At the heart of every CMS is a system for creating page templates. Users of the system populate it with content through an interface streamlined for data and content entry. Then, when the site is displayed for users on the web, the templates and content are merged and result in the output of the actual site. This means the content management is isolated from the structural bits allowing almost anyone to publish content once a site is set up (think Word-Press for example).

A CMS is a tremendous tool for saving both time and money. They most often come packed with far more features than you would ever build on your own. And in general they offer so much value that the vast majority of websites are built on one. A few years ago a CMS was an upgrade that clients paid extra for. These days it is a standard feature.

Content management systems fall into two categories: hosted and self-installed. A self-installed CMS is one that you download as a software package and install to your own web-hosting account. A hosted CMS is one that you simply sign up for and instantly begin using. With the hosted option there is nothing to install, it's just a matter of activating an account.

With the self-hosted option, you have ultimate control and flexibility to make changes. You can often install any number of extensions or modifications to the system and can even change the code that powers the system. In contrast, a hosted platform is typically locked down and has very clear boundaries. The host has total control but is also in charge of maintenance, updates and upgrades. Each approach has its place. A sampling from both categories is represented here.

A small sampling of the CMSes available to the public follow. I tried to hit the big names, but I wanted to include some less-known options as well. I also included a few examples of niche-hosted content management systems, which demonstrate how targeted some of these platforms are becoming.

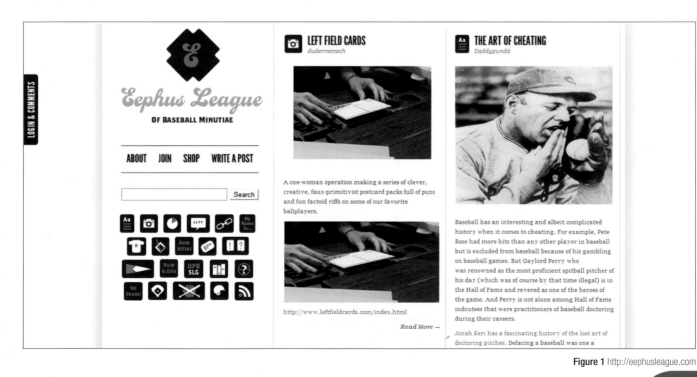

WORDPRESS

Perhaps the most obvious system to include is WordPress. This CMS comes in both a hosted version (WordPress.com) and a self-hosted one (wordpress.org). At the time of this writing, the WordPress site claims to power in excess of 71 million websites, half of these being on the hosted platform. WordPress is clearly a huge player and impossible to ignore.

While WordPress started as a blogging platform, it has grown into a full-fledged CMS that is capable of handling almost any type of site. In fact, users have morphed WordPress into just about everything imaginable. It has been turned into things like an e-commerce platform, a trouble ticket system, a directory engine and a social network, to name a few. If you need to make your WordPress site do something, there is almost always a good tutorial or plug-in out there to guide you through it.

I am excited to say that the range of sites shown here clearly demonstrate the ability WordPress has to be pushed into nearly any form imaginable (which is true of every CMS presented here). If you currently think of this CMS as merely a blogging engine, the samples here will convince you otherwise.

A great example of the flexibility to be found here can be seen in the Eephus League site **(figure 1).** This gorgeous site in no way feels locked In or controlled by the restraints of a CMS. Instead it is clearly laid out in a fresh way that is tailored to the content. Compare this to the Growcase site **(figure 2).** The two are nothing alike. The point is that WordPress is a flexible system that results in sites that look and feel unique.

Find more about WordPress at http://wordpress.org/ and http://wordpress.com/.

Figure 1 http://eephusleague.com

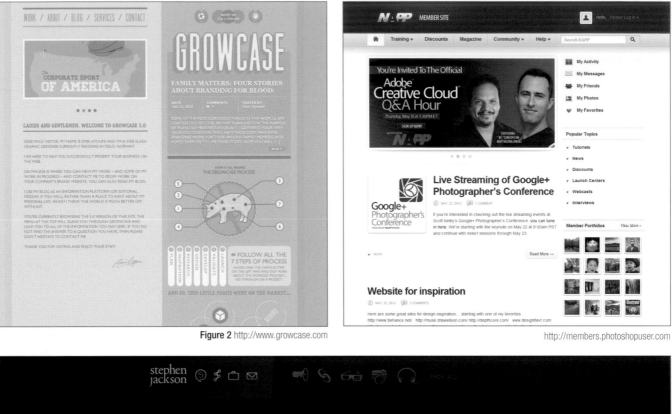

Figure 2 http://www.growcase.com

http://members.photoshopuser.com

http://www.stephenjackson.us/socialstream

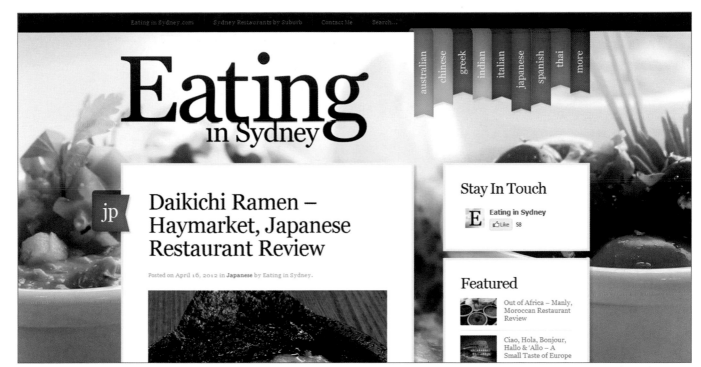

http://www.eatinginsydney.com

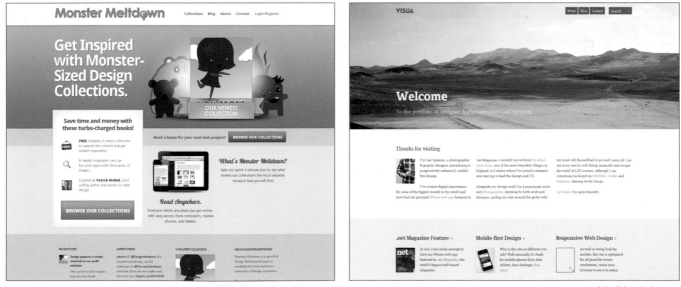

http://monster.designmeltdown.com

http://visuadesign.com

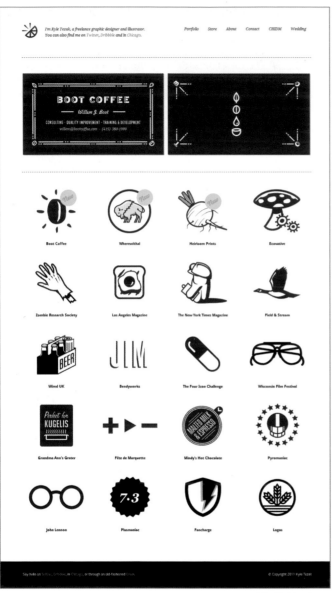

http://kyletezak.com

http://albumartcollection.com

http://www.madebywheat.com

http://trainibles.com

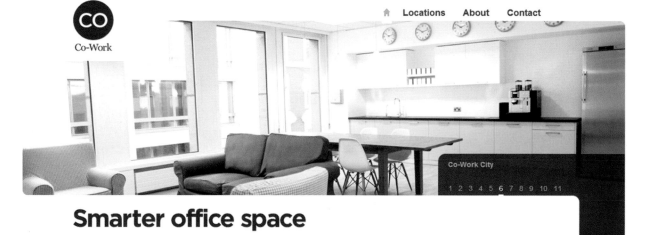

http://co-work.co

EXPRESSION ENGINE

While many self-hosted CMSes are entirely free (think WordPress), Expression Engine is a licensed software application that charges a fee for its use. Expression Engine was the number-two most referenced CMS in all of the entries I received for this book (number one being WordPress). Frankly, I was surprised by this fact, but it does prove that this platform has a loyal following of well-respected professionals.

I suspect many of you can't imagine why you would pay for a CMS when so many excellent choices are free. But just like anything, paid versions come with some key perks. Things like guaranteed support, ongoing updates and an ecosystem keyed off of generating revenue. But, of course, the intention of this book is not to sell you on a particular CMS or its merits. My mission here is to inform, inspire and challenge your designs.

This particular CMS can be leveraged in quite a wide range of ways, as demonstrated by the variety of samples collected here. I really love that if you study the samples in this chapter you still will not come up with an obvious visual way in which they are connected. A CMS shouldn't get in the way of the designer, and this one certainly doesn't. If you're approaching Expression Engine for a design project, I hope you find the small gathering of sites here inspiring.

Learn more about Expression Engine at http://expressionengine.com/.

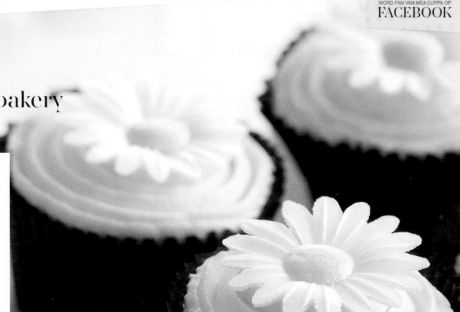

http://www.meacuppa.be

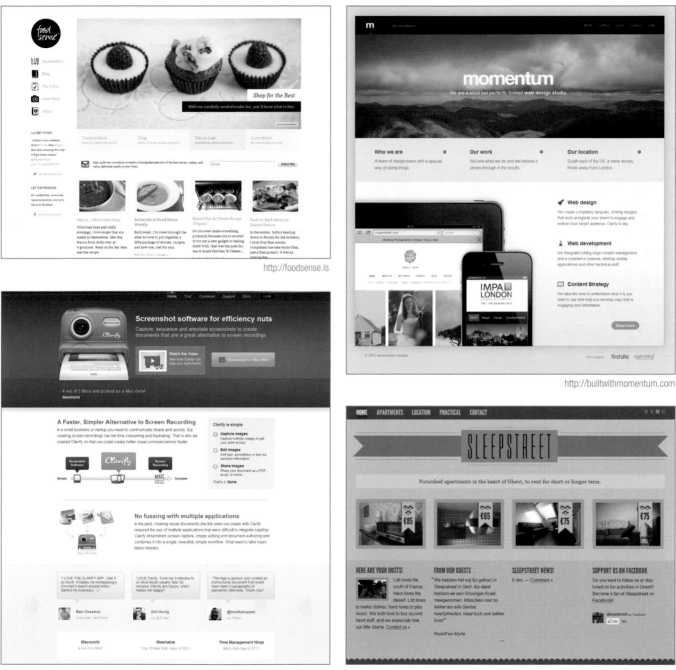

http://foodsense.is

http://builtwithmomentum.com

http://www.clarify-it.com

http://www.sleepstreet.be

http://prote.in

http://www.ballchairshop.com

http://davebrookes.com

http://viminteractive.com

http://www.foundationsix.com

DRUPAL

While Drupal is an incredible platform for building sites, I wouldn't say it is as universally approachable as WordPress. But that doesn't in any way detract from the power of Drupal. In order to appreciate Drupal, you must understand the niche it fills. Drupal is a developer-friendly platform that is easily extended, very secure, extremely stable and powerful enough to scale to extremely large volume sites. So while WordPress will let you point and click all around the admin area while you build the bulk of your site, you build a Drupal site mostly outside of the actual interface. But, of course, like any good CMS, the end users can manage the content through an easy-to-use admin area much as you would expect.

Needless to say, Drupal is a slightly different beast, but as you can tell from the design samples provided here, its developer-centric approach doesn't exclude the possibility of great design. In fact, the samples demonstrate that a combination of first-class design and Drupal is a clear possibility.

The Meri Hanko **(figure 1)** site is one such sample. Here the layout does not adhere to any predefined norms or standards. It is clear that the interface was designed from scratch. While we can't know whether the CMS forced Meri Hanko to remove any part of the site, there is no reason to believe that the underlying system prohibited the designer from tailoring the site to the client's needs.

To learn more about Drupal visit http://drupal.org.

http://www.nationalparks.org

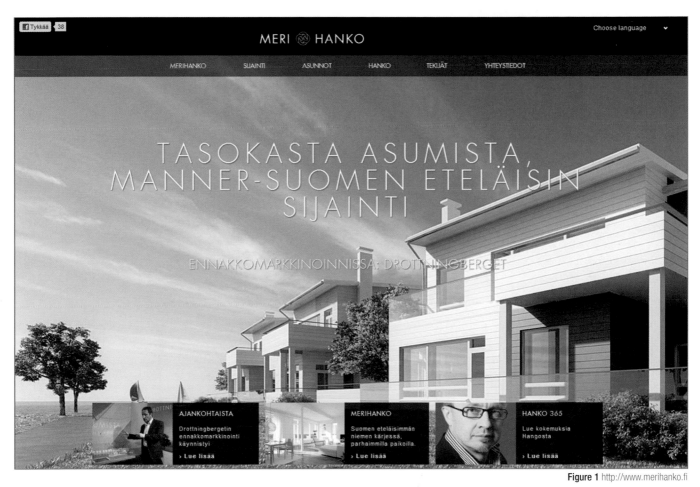

Figure 1 http://www.merihanko.fi

http://inspiration4web.com

http://www.studiowith.nl

http://apartfromwar.news21.com

http://www.rezonova.com

http://paolareina.ru

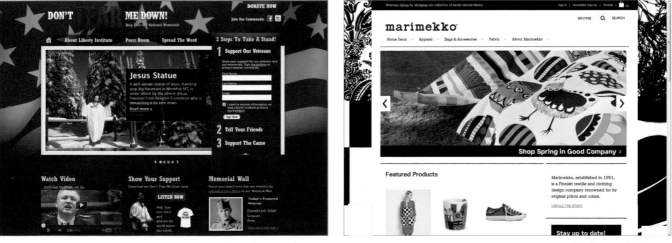

MAGENTO

Magento is a slightly different type of CMS in that it is an e-commerce platform. You might not think of an e-commerce system as being a CMS, but in fact, it is. The content used to run an online shop is perhaps one of the most difficult aspects of setting up a shop. And populating this content onto a site is a huge task. Thus a streamlined CMS is key to creating such a site.

Magento is an interesting e-commerce system in that it is one of the only open source[2] platforms. This means that you can download it and run it on your own hosting plan, and also view all of the code

used to run it. It is a platform ripe for extension; there is certainly a rich community of developers extending the platform in numerous ways.

While you can download and run this software on your own servers, you can also pay to have Magento host a site. This is the exact same model as WordPress, and in fact, Magento is really the WordPress equivalent in the e-commerce world. If this sounds interesting to you, check out Magento Go (http://go.magento.com/).

So, if you have been reading along so far (and not just looking at the pretty pictures),

you have no doubt figured out that a key trademark of a good CMS is its flexibility. As such, we should expect to find a wide range of design options when it comes to using Magento. And, of course, this is exactly what we find. In fact, I worked really hard to compile an eclectic list of e-commerce sites built on this platform for this chapter. I think you will find in the samples here a wide range of solutions that hardly feel tethered by a limited CMS.

Learn more about Magento here: http://www.magentocommerce.com/

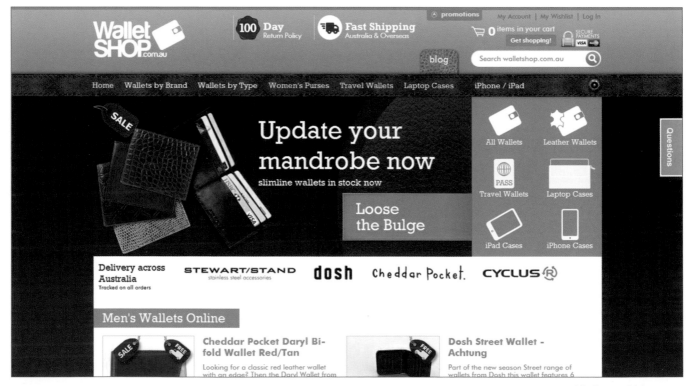

http://www.schoolhouseelectric.com

http://www.huzza.net

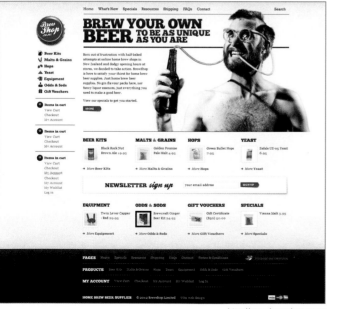

http://www.brewshop.co.nz

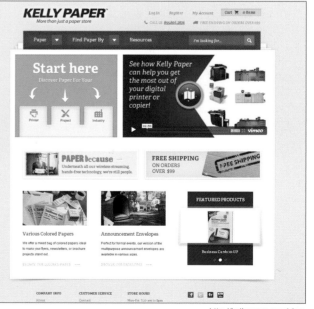

http://kellypaper.com/shop

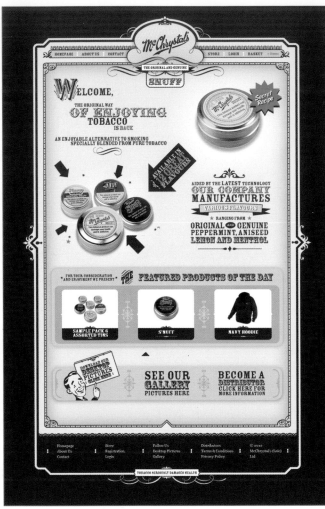

http://www.mcchrystals.co.uk

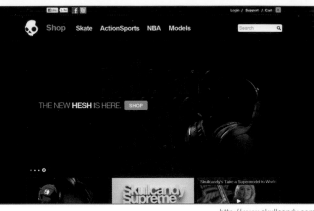

http://www.skullcandy.com

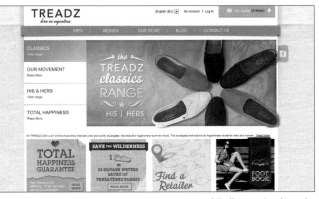

http://www.mytreadz.com/eu

http://twistedtime.com

SQUARESPACE

With all the incredible systems I have presented so far, you might wonder why the world would need more CMSes. The reality is that not any one CMS, or even any small group of CMSes, will satisfy all the needs out there. This is why systems like Squarespace, which may very well be new to you, are not only viable products but incredibly successful.

Squarespace can be used for many different types of sites and is extremely flexible, but a few of the core modules make it particularly attractive to those in the creative industry. These include the standard blog modules, but also some incredible image gallery tools and an amazing drag-and-drop interface for laying out pages. This intuitive interface allows you to structure your site the way you want to, without having to dig around in the code. In the end, this makes producing custom content layouts not only easier, but a normal part of building content. Frankly, this system excels in an area most systems pretty much ignore.

Another way in which Squarespace stands out as a leader is in its handling of external tools. For example, when you publish content to your blog via Squarespace, you can at the same time push teasers out to Facebook and Twitter. This might not sound all that revolutionary, but it is a powerful way to publish content and streamline the social promotion aspects of doing so.

Get more details about Squarespace at: http://www.squarespace.com.

RHYS LOGAN

STORY-TELLER, PHOTOJOURNALIST, PHOTOGRAPHER.

Alive Portfolios Bio & Contact Blog Multimedia Links

Copyright © Rhys Logan 2011. All Rights Reserved.

http://rrhys.squarespace.com

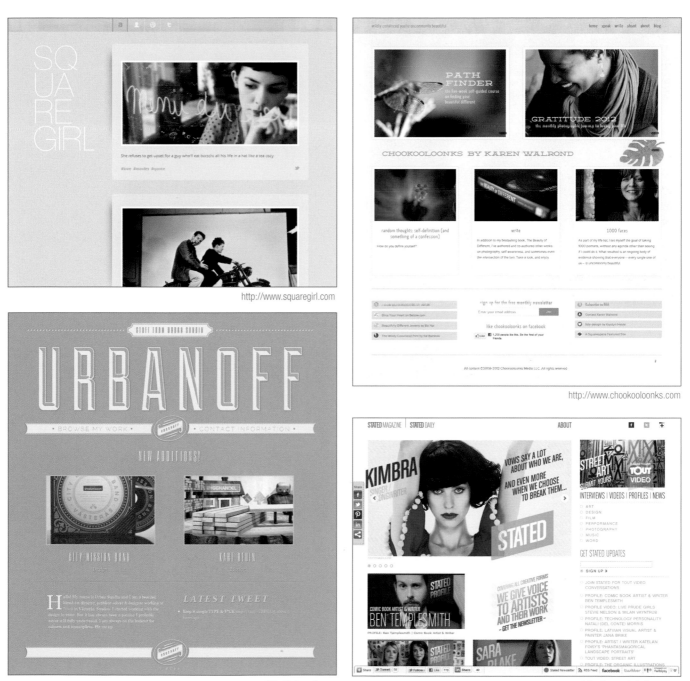

http://www.squaregirl.com

http://www.chookooloonks.com

http://urbanoff.com

http://www.statedmag.com

http://hope-revo.squarespace.com

http://montessorium.com

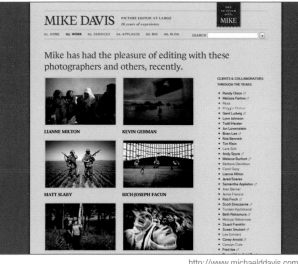

http://www.michaelddavis.com/work

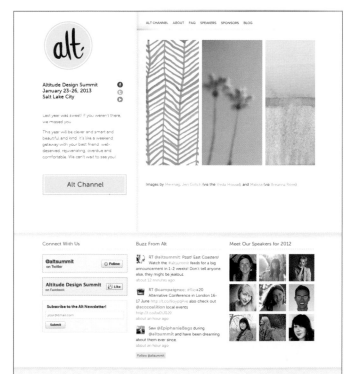

http://www.altitudesummit.com

http://bgoodwin.squarespace.com

http://www.inspiredgoodness.com

SHOPIFY

Shopify is a CMS with a singular focus: e-commerce. With Shopify you can quickly set up and run an awesome online shop. For many, the single reason for getting online is to run a store. And hosted quick-to-launch tools like Shopify make getting a business online and selling product about as easy as can be. Many contenders occupy this space, but Shopify is definitely one of the leading options.

If you're tempted to compare Shopify to Magento, don't bother. They are entirely different animals, though each has its place. Shopify offers many built-in features and is fully hosted. This means you don't have to worry about the technical complications of running an online store. And the biggest key is that you can be up and selling product exceedingly fast.

Designing and implementing an e-commerce site is no small task. Many pages, elements, forms and widgets must be considered. As such, building on top of solid templates is a fantastic approach. Fortunately, Shopify features a huge array of beautiful e-commerce templates. The templates alone are worth a tremendous amount of saved time and money.

Learn all about Shopify on their site, http://www.shopify.com.

http://www.dodocase.com

http://www.luhsetea.com

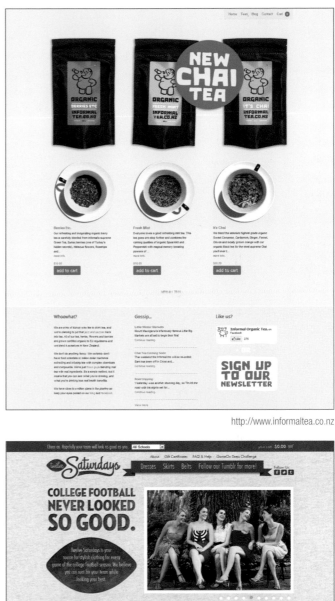

http://www.informaltea.co.nz

http://fetchapp.com

http://www.twelvesaturdays.com

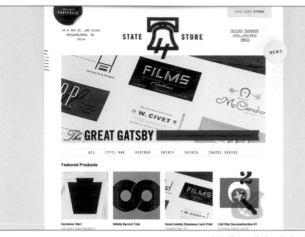

http://store.theheadsofstate.com

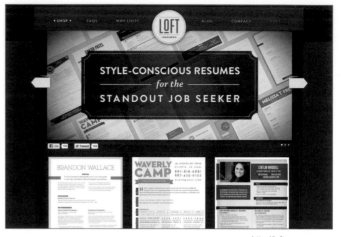

http://loftresumes.com

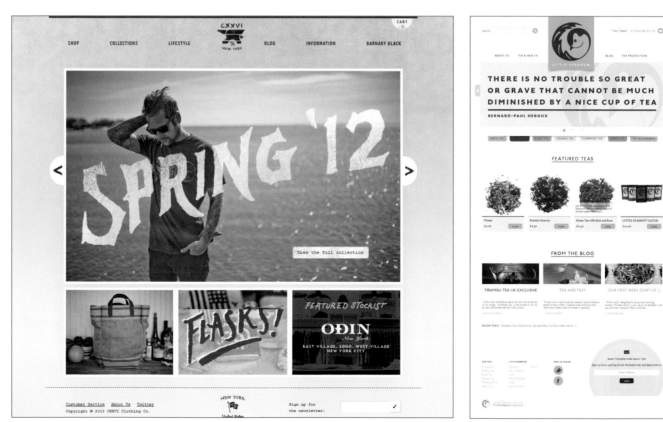

http://cxxvi.net

http://littlesparrowtea.com

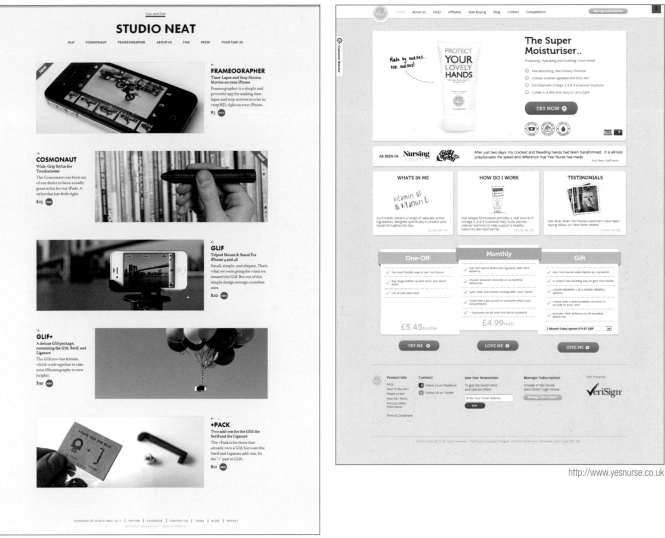

http://www.studioneat.com

http://www.yesnurse.co.uk

LIGHTCMS

One type of hosted CMS that is becoming more common is what I describe as the all-inclusive approach. Many systems fall into this niche; even Adobe offers one (Business Catalyst). These all-inclusive systems not only allow you to publish content, but also incorporate many diverse features that ultimately cover all the bases; things like e-commerce, blogging, photo galleries, forms, calendars and more. Given the purpose of this book I have settled on showcasing LightCMS for a few simple reasons. Foremost among these reasons is one that strikes at why you are most likely looking at this book to begin with—inspiration. When you survey various systems, it is interesting to observe how some of them seem to have varying degrees of design quality attached to them. Perhaps this is simply due to the audience they attract, or maybe it is more about the quality of the system itself. The answer is, of course, beyond the scope of this book, so let's focus on the aesthetics.

A quick survey of the samples here quickly demonstrates that a strong template offering is not the reason the designs on this system are better than others. You will no doubt notice in the samples a total lack of consistency—it is clear that not everyone on the platform is using the same template. Ah, but this is perhaps a trick, because one of the single best features of LightCMS is that it provides (free of charge) a huge array of absolutely awesome templates. At the end of the day, we can't easily connect these samples to a template without signing up for LightCMS and surveying the templates they provide.

Use the sites here as a source of inspiration and a sampling of what this powerful CMS can do.

Learn more about LightCMS at http://www.lightcms.com/

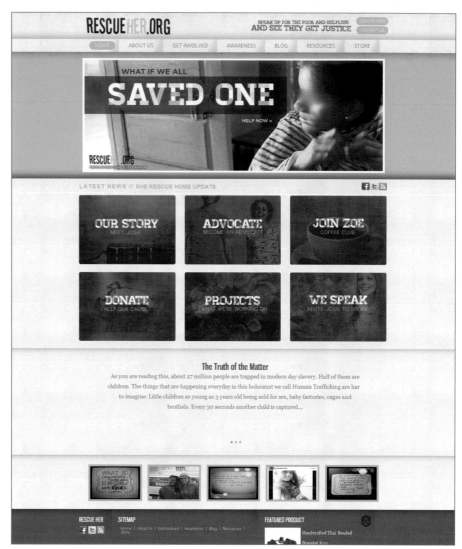

http://www.rescueher.org

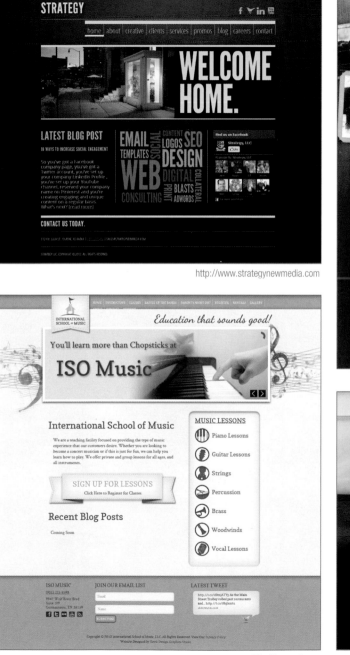

http://www.strategynewmedia.com

http://isomusic.org

http://www.hansenangusranch.com

http://www.steadfastcreative.com

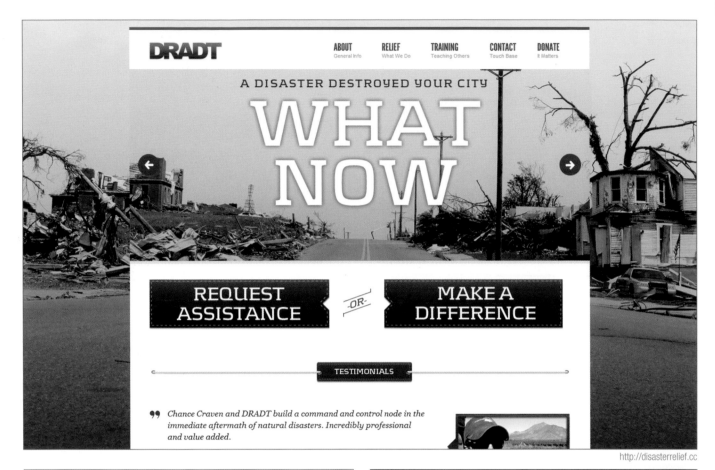

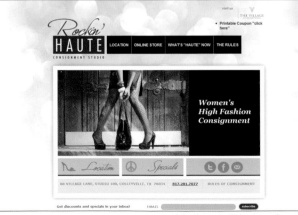

BELLSTRIKE

The final CMS I want to showcase is an unlikely candidate. When we consider giants like WordPress, Drupal and Magento, it is perhaps perplexing why a tiny niche system like Bellstrike makes the list. Well, Bellstrike is here to demonstrate the full range of options available to designers and developers, and one such option is an extremely specific niche system. Bellstrike makes it silly simple to get a nonprofit site up and running—and most important, accepting donations. This last part is the type of thing you should expect from a niche CMS, which typically provides a common foundation (publishing content in some form), along with features that are very specific to the niche market. With this in mind, you might even consider tools such as Shopify a niche product as well. If you want more examples of tools like this, check out Weduary.com, Ebandlive.com and Ekklesia360.com.

Systems in this line range in flexibility. Some allow users to apply a 100 percent custom design; others allow for only limited customization of fixed templates. Bellstrike falls into the latter category. At the time of this writing, it offers four templates that can be customized in minor ways. As a result, sites built on this (and similar systems) look very similar. One quick look at the samples here and you will easily identify which sites share a common template.

I imagine the designer in you is offended, annoyed or otherwise put off by this limitation and drawback. However, consider the upside: the limited number of available templates makes it more difficult for site owners to break the site, vastly reduces the time to launch a site and gives the CMS provider an easier way to push extra features out to their client base.

Read about Bellstrike here: http://bellstrike.com.

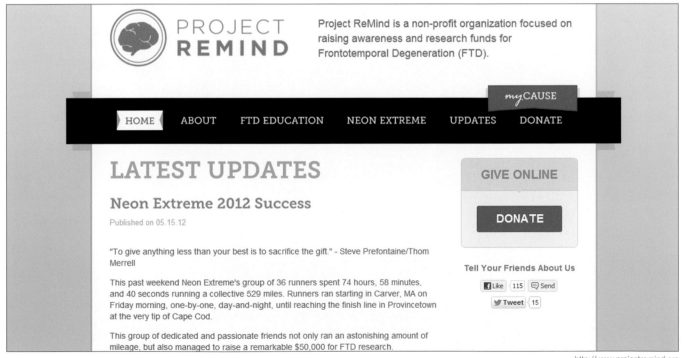

http://www.projectremind.org

THE KUMARI PROJECT

The Kumari Project empowers Nepalese orphans, especially girls, by providing basic healthcare, education, and job training and opportunities.

*my*CAUSE

HOME ABOUT PROGRAMS PHOTO GALLERY BLOG DONATE

GETTING HEALTHY

Youth Plus Foundation of Nepal with a team of doctors and nurses from Nepal's premiere hospitals volunteered on their Saturday off to host a medical camp on June 9 for children living in Panchkhal Children's Home and Siphal Child Protection Home.

They provided routine check ups for 90 children and necessary medicines, which were generously donated by several local pharmaceutical suppliers.

Thank you to the doctors, nurses, and assistants who cared for The Kumari Project's children:

Dr. Nishan Bhueljal
Nepal Dangol
Dr. Prakash Dangol
Dr. Suman Rawal
Babita Shakya
Neelam Shrestha
Ranju Shrestha
Khusbu Thapa
Dr. Anish Yadav

GIVE ONLINE

DONATE

Tell Your Friends About Us

Like 43 Send

Tweet 0

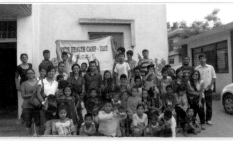

Medical Team with children at Siphal Child Protection Home

River International

RI is a registered 501(c)3 non-profit that provides safe, clean drinking water to the people of the Amazon. We also partner with local churches to bring transformation by equipping & training them to learn how to mold places of influence in society. Together we can shape history! Lets Give Life!

HOME ABOUT MINISTRIES SAWYER WATER ... BLOG DONATE

http://www.riverintl.org

ELDER SOURCE SENIOR MINISTRIES

We provide Christian materials to senior care centers, encourage volunteers of all ages and assist churches in senior in-reach and out-reach.

HOME ABOUT PROGRAMS VOLUNTEER BLOG DONATE

INSPIRING SENIORS TO LIVE WITH PURPOSE BY HONORING GOD IN THEIR LATTER YEARS

Elder Source exists to facilitate senior ministry by distributing senior-friendly Christian resources to seniors in care centers, creating opportunities that encourage and edify seniors to be productive and spiritually fertile, and building partnerships with like-minded organizations, churches, and individuals that will value and honor seniors.

In the United States, approximately 10,000 Baby Boomers are turning 50 every day. This means the population of Americans aged 65 and over will jump from 35 million to 71.5 million between the years 2010 and 2030. The number of men and women 85 and older will increase by over 70%!

This trend has enormous implications for every segment of our society, including the church. That's why we must begin now to prepare for what many

GIVE ONLINE
DONATE

Tell Your Friends About Us

Like 3 Send
Tweet 0

http://www.eldersourceinfo.org

Water for Panama is a non-profit organization primarily funding water projects in the Indian villages of Panama. Through supporting the mission of Davids Well, our work is an expression of the love of our Savior. Clean water is the foundation, and this is just the beginning.

HOME ABOUT PROGRAMS STORE! BLOG DONATE

LATEST UPDATES

Concert for Clean Water
Published on 06.23.12

Location: Wildwood Christian Church (ballfield)
Time: 6:30
Date: August 3rd

Join us for a Water for Panama event presenting The Capture! Free admission. All proceeds go to clean water projects built by Davids Well.

Bring your own seating/snacks/whatever!

GIVE ONLINE
DONATE

Tell Your Friends About Us

Like 5 Send
Tweet 4

http://www.waterforpanama.org

Typography

One of the biggest frustrations of web designers over the years has been the limits put on them in the area of typography. In particular, there are limited options in the area of font selection. Even today, web-safe fonts are a standard go-to list of options. However, many modern developments have made it vastly easier to circumvent the limitations in this area. Yes, there have long been ways around this problem, but recent progress in browser development has given this area of web design a kick in the pants. Let's take a look at a few key technologies and a pile of design samples that go along with them.

@FONT-FACE

In CSS we can use the @font-face option to embed a font file in a page. This then enables us to specify it as the font for a block of text. CSS2 first introduced this feature, which until recently was unsupported by most browsers. In a great bit of irony, Internet Explorer has supported it since version 4. Using @font-face is remarkably simple, and is the most popular way to attach custom fonts to almost any web page.

The one quirk is that different browsers rely on different formats. A key tool for getting around this with ease is Font Squirrel (http://www.fontsquirrel.com). It quickly converts a font file into the necessary formats. A number of font services also allow you to embed the font files in your page by copying and pasting a tiny bit of code.

One of the great things about this approach is that you can attach a font to a page and apply it to text written in HTML. This means that the text can be easily managed and updated and the font is automatically applied. In the past, many bits of fancy text would have been rendered with images. The difference between managing standard text and image-based text is night and day. Image-based text has to be re-created, exported and uploaded to the server. In contrast, editable text can simply be updated in the page and the style is "auto-magically" applied. In this way, @font-face is a clear step forward.

Another huge perk to this approach is that it allows you to more easily stylize and adjust the text with standard CSS commands. Combine this with responsive web design and you have a powerful combo (see page 071 for more on this topic). Think of it this way: Responsive web design requires the same content to be styled in a variety of ways, and @font-face based techniques mean that the same text can easily be styled in a variety of ways. With responsive design, you will have the same text to which different sets of CSS are applied, depending on the user's interface. So the same text can be styled in multiple ways. Image-based text is not nearly as simple.

http://ablebots.com

http://www.sajkomusic.com/en

http://www.htmlandcssbook.com

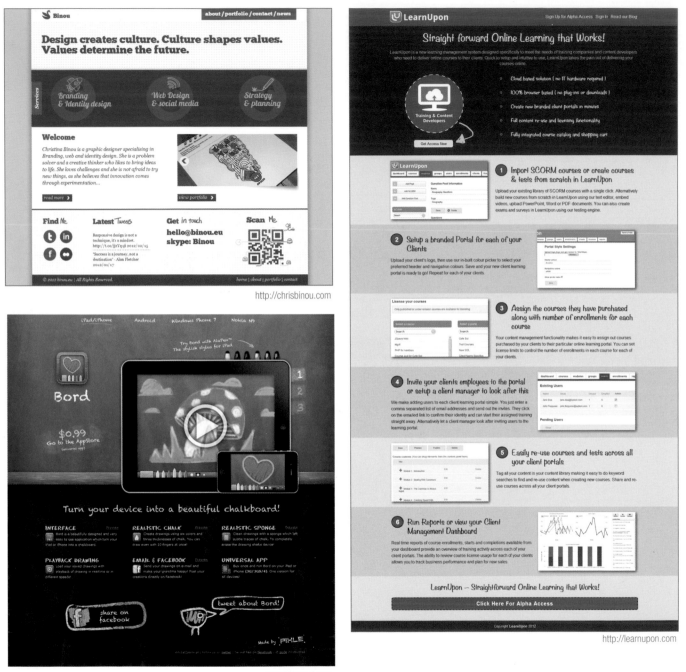

http://chrisbinou.com

http://bord.pixle.pl

http://learnupon.com

Hi, my name is Siska Flaurensia

I'm a Digital Designer.*

THESE ARE SOME OF MY COOL CLIENT PROJECTS

ONEPAGE**THEME**

Zeke & Milo
pet photography

accenture

INSEAD

Microsite
This microsite is an intuitive, elegant, and easy-to-use interface design to capture visitor's stay preferences before they visit Alila Villa Soori Bali.

VIEW DESIGN

AGENCY | DIVISION

designolosophy

Gracious Style

Locs

nobuooo

LUXE *Bidet*

squeezeoflimestudio

ABOUT/I'm a Digital Designer and Front End Developer specializes in web, app, e-commerce, and branding, who has the privilege to work on a myriad of creative projects with diverse entrepreneurial and corporate clients all across the globe—from San Diego to Singapore. A "citizen of the world" who loves to travel, sing in the car, and eat red velvet cupcakes.

NOT ONLY DESIGN/I have an experienced background in Marketing & Sales, Management, and Social Media. Love reading the brilliance of 37signals' Rework.

RULE THE WORLD WITH/HTML5, CSS3, jQuery, Magento, WordPress, Adobe Creative Suite, MacBook Pro + iPad, and my intoxicatingly sweet charm.

CONTACT/Say Hello/LinkedIn/Twitter

***SERIOUSLY**/Don't try to understand what I do. Just love me.

© 2012 SiskaFlaurensia. Developed using Responsive Layout utilizing 1140 Grid that adjusts beautifully to any screen size.

— Go back up —

http://siskaflaurensia.com

inVISION

WE'RE HIRING! COME TO SAY! ❤

HOME TOUR CUSTOMERS SIGN-UP LOGIN

Create Fully Interactive Wireframes & Prototypes
The Easy & Beautiful Way!

GET STARTED ▶ or Learn More

Design fully-interactive prototypes
Let your clients experience your vision of their site.

Gather feedback from key stakeholders
Comments can be left directly on-screen.

Work with the tools you already know
Use your favorite graphics program to design screens.

Collaborate with other designers
Quickly pull other designers into your project for free.

Share your designs with a single click
Easily email or IM a direct link to your prototype.

Also Design For iPhone and iPad
Interact with your designs directly on the device.

WHAT THE WORLD'S FAVORITE DESIGNERS ARE SAYING...

"We use InVision to really get at the closest representation of our finished app before we finish designing or building it. It's an outstanding easy to use piece of web ware that helps us be awesome."

Matthew Smith Zaarly

AA American Airlines WHOLE FOODS Google twilio Zappos eBay IDEO KICKSTARTER Bb Blackboard

InVision is helping designers everywhere master the art of user experience design. Are you in? TRY IT FREE ▶

19,888 DESIGNERS 122,223 SCREENS INVISION'D AND COUNTING

Plans & Pricing · About Us · Media & Brand Kit · Security · Terms of Service CONTACT KEEP IN TOUCH

ANY QUESTIONS? ASK LIVE HELP! ▶

http://www.invisionapp.com

Touchtech

home
about us
what we do
our work

MOBILE AND CLOUD DEVELOPMENT

Building the future

At Touchtech we're passionate about building great mobile applications that leverage the full capabilities of smartphones and cloud services. We believe that the recent explosion of interest in mobile and tablet computing is going to continue and we want to help your business embrace this new era of technology.

The way we work

There's a lot of work that goes into building a great mobile product and most of it isn't coding. You need a good design that presents functionality in a simple but relevant way. Add to that great artwork and presentation, use of modern smartphone features as well as a effective model to distribute the application to your intended users.

At Touchtech we help guide you through the process of App development so that we can build an App that will truly delight your users.

📞 +64 021 153 0902 ✉ office@touchtech.co.nz 📍 PO Box 11463, Manners Street Central, Wellington 6142 New Zealand

http://www.touchtech.co.nz

TYPEKIT

Typekit (https://typekit.com) is a font delivery service that Adobe owns. This service is entirely based on the @font-face technique for embedding fonts. Users of this system simply attach a CSS file to a page. The file is hosted on the Typekit servers. This CSS file then loads up the requested font, making it available in the normal CSS files you create on the site. Embedding a font in this way couldn't be easier—there's nothing to download. Just copy a line of code and use the font like you would any other typeface inside your CSS.

One important detail about Typekit is that it is a commercial service. You pay for the amount of usage you require. So if you run a large site that is very popular, it will cost you more than a small site with very little traffic. Point is, it isn't free. For many, this commercial aspect is a shortcoming that rules the option out. Others embrace this service for its access to a vast array of top-notch fonts.

Using a custom typeface doesn't mean you have to go over the top. Refer to the Concentrate site as an example **(figure 1)**. Here the font Adelle[3] was used on the titles and body copy. This nice slab serif font gives the page a unique feel but doesn't get in the way. Sure, the designer could have used a default font with great success, but the unique typeface gives the page a distinct style that helps set it apart.

We find a very similar strategy on the Rocket website **(figure 2)**. Here, the designer has relied exclusively on the font

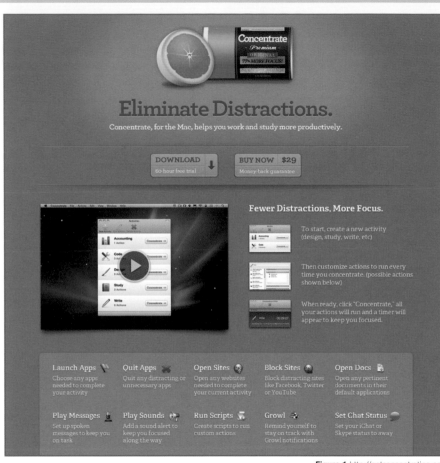

Figure 1 http://getconcentrating.com

Future PT[4]. One of the biggest benefits of a commercial service like Typekit is not only the quality of the fonts, but the diversity inside a single typeface. Future PT, for example, includes ten different weights. By simply using a variety of weights inside the same typeface, the Rocket site remains unified with a gorgeous typographic feel.

If you're at all interested in Typekit, I encourage you to check out the typographic experiments of Daniel Eden **(figure 3)**. This beautiful set of type pairings is entirely based on Typekit. I can't imagine visiting this page and not getting some immediate typographic inspiration. It's definitely one of the best showcases of just how awesome web type can look.

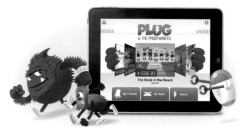

Figure 2 http://rocketmobile.co

Figure 3 http://daneden.me/type

http://circlemeetups.com

http://southernfemme.com

http://andyrutledge.com

042

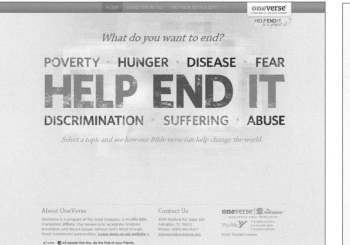

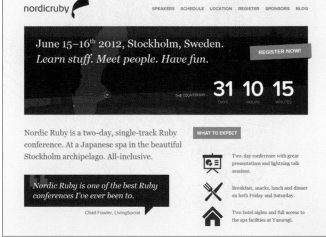

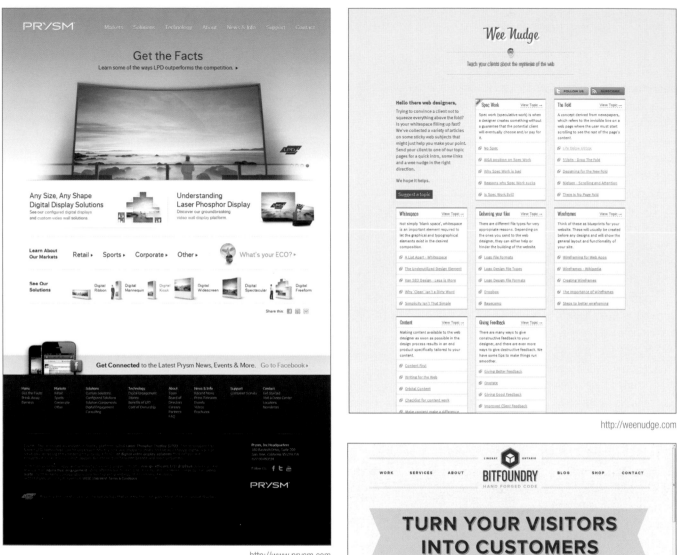

http://www.prysm.com

http://weenudge.com

http://bitfoundry.ca

GOOGLE FONTS

Google Fonts is another font-serving service based on the basic @font-face techniques. In terms of use, it works exactly like Typekit—a remote CSS file is attached to a page and then referenced in the styling of text. Learn more about Google Fonts here: www.google.com/webfonts.

In contrast to Typekit, Google Fonts is 100 percent free. This has made it a popular choice for those not interested in paying to use fonts (and let's face it, that is a lot of people). Fortunately, Google has rounded up some really solid typefaces for interested parties to select from. So while it is free, it isn't a second-rate set of options.

Perhaps the only negative I can think of in relation to this service is that since it is free, many of the typefaces get overused. Lobster, for example, is one frequently used typeface. But, as with any element, regardless of the frequency of usage, it is all about how you actually use it. With this in mind, the samples collected here not only leverage this great service, but do so in reasonable ways that serve to enhance the site's design.

One of many beautiful samples I want to highlight is the ColumnFiveMedia.com site **(figure 1)**. Most prominent in this site is the use of the font Josefin Slab in the large text at the top of the page. Interest-

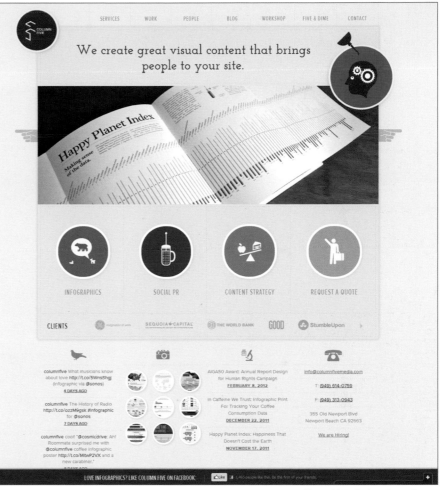

Figure 1 http://columnfivemedia.com

ingly, this site also uses a Typekit font for the main navigation and other supporting text in the page. A mix of solutions is entirely possible and reasonable. In this case the typefaces make for a far more distinct design.

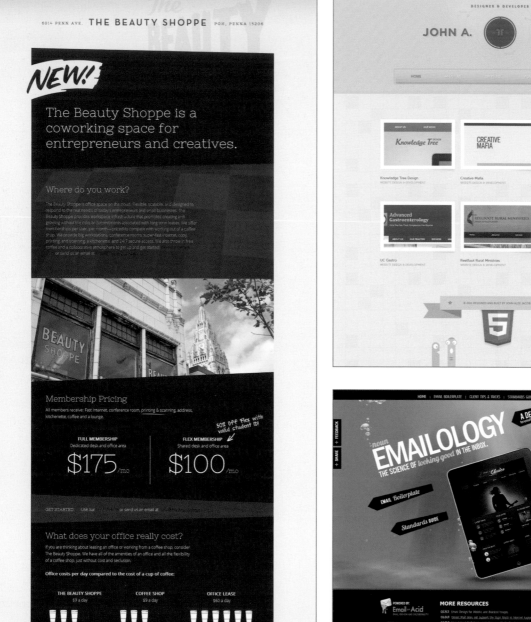

http://thebeautyshoppe.org

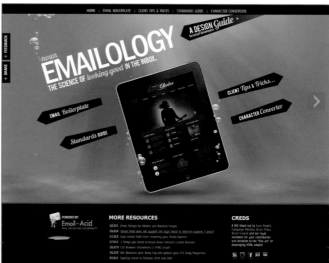

http://johnjacob.eu

http://www.emailology.org

http://weare2ndfloor.com

http://www.x-silium.com

http://sobuzzme.com

http://www.ermankutlu.co.uk

http://www.madebycreature.com

http://osvaldas.info

http://www.joeellis.la

http://www.choiceresponse.com

CUFÓN

Cufón is a JavaScript-based utility that applies custom typefaces to blocks of text as a page loads. At one point in time Cufón was a premier solution used by countless developers. With the forward movement in the support of @font-face, Cufón has fallen by the wayside. Frankly speaking, I was not planning to include this type solution, but I did so for a number of reasons that I will get to later. (Learn more about Cufón at http://cufon.shoqolate.com/generate.)

It turns out that many developers continue to rely on this tool for one common reason: browser support. Since not every browser supports @font-face, Cufón is a nice alternative that works pretty much everywhere. So it seems there is still a place in the world for this tool. As such, I wanted to provide some impressive examples of Cufón at work.

Take a look at the Thedroidsonroids. com site **(figure 1)**. Here all of the large bold text is rendered with Cufón, including the navigation, the large full-width sales pitch and the bucket headers at the bottom. The typeface used accents the page without looking overly decorative. In this way a unique feel is brought to the page without distracting from the overall design. In more thematic situations such as this one it can be tempting to use a more decorative niche font. Fortunately the designer allowed the illustrations to shine and let the text play a supporting role.

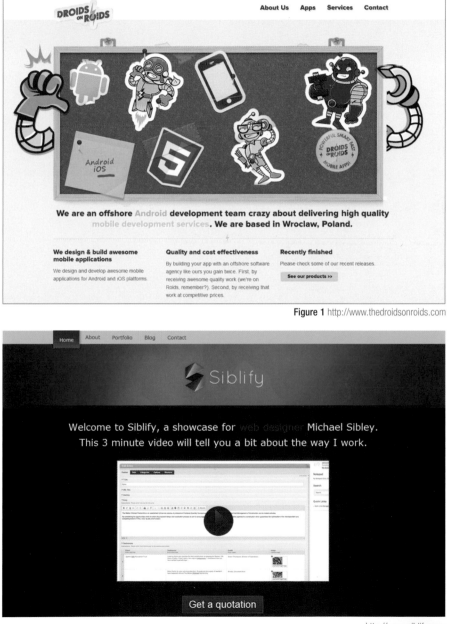

Figure 1 http://www.thedroidsonroids.com

http://www.siblify.com

http://mrbava.com

http://www.sylvain-ollier.com

http://penandpixel.ie

http://hopefornorthtexas.org

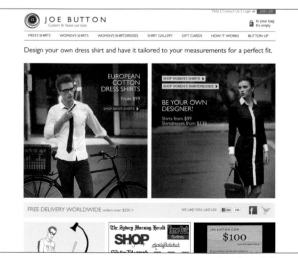

http://www.joebutton.com

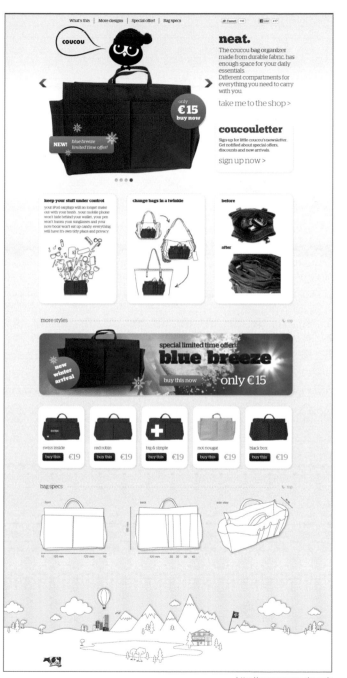

http://www.coucoushop.ch

Code

While this book is by no means about code, it is not hard to make an argument that code has a radical impact on design. In fact, I have long been an advocate of the idea that a firm knowledge in how things are actually coded will inform and empower designers. With this in mind, I want to briefly focus on a few developments in the area of code that continue to impact the industry and the design of the web.

CSS3

Again, this is not a book on coding, so my introduction to CSS3 is extremely brief and focused on the nuances that impact designers most. Don't let CSS3 scare you off as some crazy new language. CSS3 is nothing more than the third revision to CSS. In fact, what is currently known as CSS is actually CSS2. So someday we will likely simply refer to CSS3 as CSS.

CSS3 builds on top of CSS2. So anything you might have learned about CSS carries forward. There are, of course, a large number of new things in CSS3 and a lot of things that got improved. Many of these dramatically impact the way designers and developers plan sites. Most notable among these are the visual effects that are not possible through code. Prior to CSS3, these elements were implemented with images. Here are some key visuals that are now possible with pure code and no images:

- Rounded corners on containers, images form controls, etc.
- Drop shadows on elements like images and containers
- Text shadows (used to produce the ever-popular chisel effect, as found in the letterpress section on page 131)
- RGBA, which is RGB (colors) with an alpha channel, making partially transparent colors possible
- @font-face for embedding fonts
- Transitions to create animations when CSS changes
- Gradients to apply to text and backgrounds

Of the many samples included here, one that demonstrates well the use of some new CSS3-based techniques is the Bookmarkly.com site **(figure 1)**. A few of the elements on this seemingly simple page are based on CSS3 properties: the rounded corners, drop shadows, text shadows, and the CSS-based animations when the browser resizes. Most of these styles would have greatly increased the complexity of the site prior to CSS3. The rounded corners would have required a lot of images and a fair amount of extra code. The shadowed text would have required some serious trickery to avoid having it embedded in images. And of course the form controls would have been coded far differently.

The end result is a smooth site that relies heavily on code for styles. This makes it easy to update, restyle and tweak depending on the user's interface (more on this in the responsive design section on page 071).

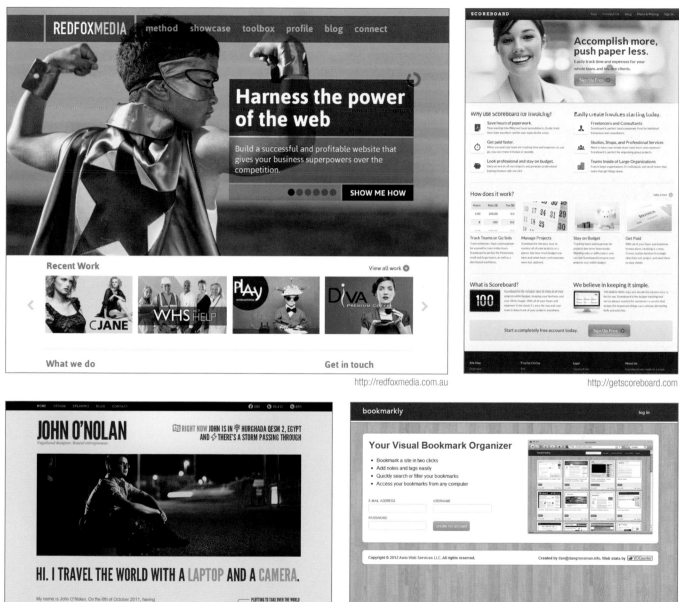

http://redfoxmedia.com.au

http://getscoreboard.com

http://john.onolan.org

Figure 1 http://bookmarkly.com

http://www.iqonicdesign.com

http://www.fontfont.com

http://www.rule.fm

http://www.libertyinstitute.org

http://joelglovier.com

http://www.paulogoode.com

http://www.solidshops.com

http://litmus.com

http://www.webcoursesagency.com

HTML5

Much like CSS3, HTML5 is nothing more than the newest specification for HTML. What we refer to as simply HTML is actually HTML4. And someday we will likely refer to HTML5 as HTML. Unlike CSS3, HTML5 actually has very little impact on the visual side of things. And as such, this chapter is perhaps one of the most difficult to write. In fact, I struggle to draw any real connections between design practices and HTML5.

I did a great deal of research in this arena and I discovered that, for the most part, HTML5 represents subtle shifts in the way things are coded. The only real potential impact on the designer lies in the area of the canvas options inside HTML5. Granted, this opens up a lot of options for the designer but is frankly beyond the scope of this inspiration-oriented book.

I can, however, find plenty of beautiful sites built on HTML5. On the surface they look like normal websites, which is exactly what they are. It just happens that HTML5 has slightly changed how they are coded and has most likely made them a bit easier to maintain.

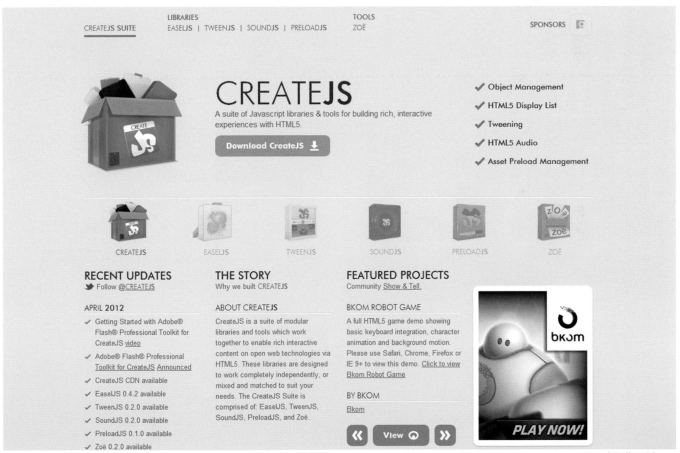

http://learnlakenona.com

http://www.gilttaste.com

http://greenways.co.uk

http://wijmo.com

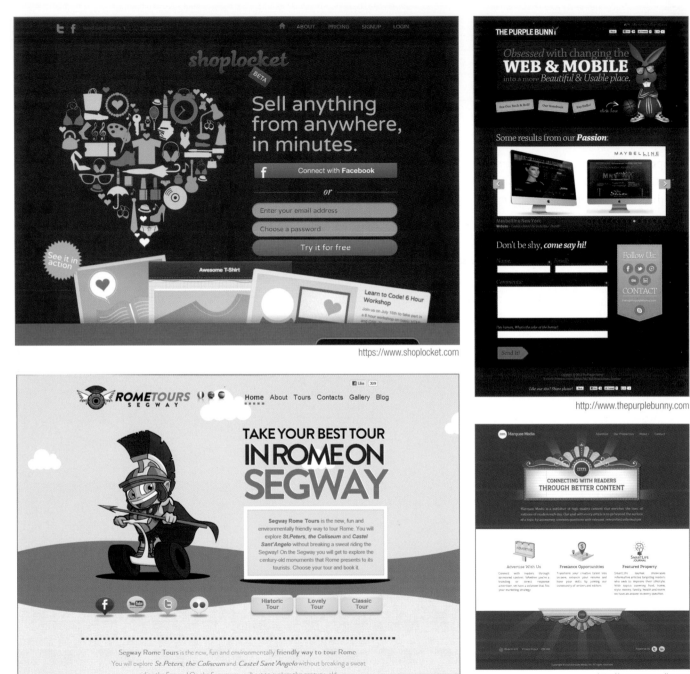

https://www.shoplocket.com

http://www.thepurplebunny.com

http://www.segwayrometours.com

http://marqueemedia.com

FLASH

While many have declared Flash dead, it is anything but. In fact, there are many implementations of the product that still wow clients and customers. The reality is that the web has advanced, and Flash is not nearly as prominent as it once was. In my opinion, Flash has simply settled into its place in the world.

Perhaps the most glaring problem with Flash is that it can't run on the iPad or iPhone. This simple shortcoming has singlehandedly forced Flash out of the limelight. With this in mind, one of the most critical things a Flash-based site can do is to provide a functional fallback for users on iOS products.

This is exactly what we find on Jordan-Hollender.com **(figure 1)**. Take a look at **figure 2** to see how this same site looks on the iPad. Here the designer has prepared an HTML-based alternative to the site. Ultimately this means that the site had to be built twice: once in Flash and again as HTML. Clearly, this extra burden means you better really want to use the functionality of Flash for the benefit of your site. Otherwise you're just wasting time.

Darren Farrell, children's book author

DOWNLOAD IMAGE / ADD TO LIGHTBOX / VIEW THUMBNAILS < 01 / 24 >

Figure 1 http://www.jordanhollender.com, normal view on desktop with Flash

Figure 2 http://www.jordanhollender.com, view on iPad without Flash

http://www.diesel.com/ourglory

http://kfgame.ru

http://battleofthecheetos.com, normal view on desktop with Flash

http://battleofthecheetos.com, view on iPad without Flash

http://bankers.ownedition.com

http://wall-of-fame.com **Top:** Normal view on desktop with Flash, **Bottom:** View on iPad without Flash

http://www.lucasarts.com/games/legostarwarsiii/index.jsp
Top: Normal view on desktop with Flash, **Bottom:** View on iPad without Flash

http://www.pikibox.com **Top:** Desktop view—note the Flash video player,
Bottom: iPad view—note the non-Flash based video module

JAVASCRIPT AND JQUERY

Beyond HTML, JavaScript is one of the oldest and most foundational tools of the web. For many years following its debut in 1995, JavaScript lived in relative obscurity. Around 2005 (give or take a few years), JavaScript slowly started to gain momentum. The industry's perspective changed and JavaScript became a highly valued tool. Fast-forward to today and you will find that JavaScript is quite possibly one of the most powerful tools in the web designer's tool belt. I specifically say web *designers* here as JavaScript enables front-end coders to create interactive designs.

Perhaps the easiest and most concise way to describe JavaScript is this: Java Script allows designers to modify the HTML and CSS of a page based on various interactions with the user. This allows you to bring pages to life in gorgeous ways. Survey the samples provided here and you will only get a small part of the view. Load these sites into your browser and you will plainly see how JavaScript transforms static HTML and CSS into a far more engaging and beautiful experience.

The portfolio of Andrei Gorokhov **(figure 1)** stands as a good demonstration of how JavaScript brings a design to life. His hexagon display of portfolio items might otherwise lack interest for those who view them. Thanks to his use of JavaScript, the elements interact as users hover over them. Even better, the three filter buttons in the middle allow you to highlight the items you're interested in. The site then

Figure 1 http://gorohov.name

shows a cross section of items that fit the criteria from the filters. It's a very interesting way to interact with the content from the perspective that matters most to the viewer. If it weren't for the JavaScript at work, the page might be rather dull in comparison.

For those designing a more thematic site, JavaScript is particularly handy. Check out Fishy.com.br **(figure 2)**. Here,

the ocean-themed site is animated and brought to life with jQuery. It would be a cool site to look at even if it wasn't animated, but the animation brings the elements to life and makes for an unforgettable experience. Here jQuery is the icing on the cake, and the greater understanding the designer has of this tool, the more likely it can be put to work in meaningful and practical ways.

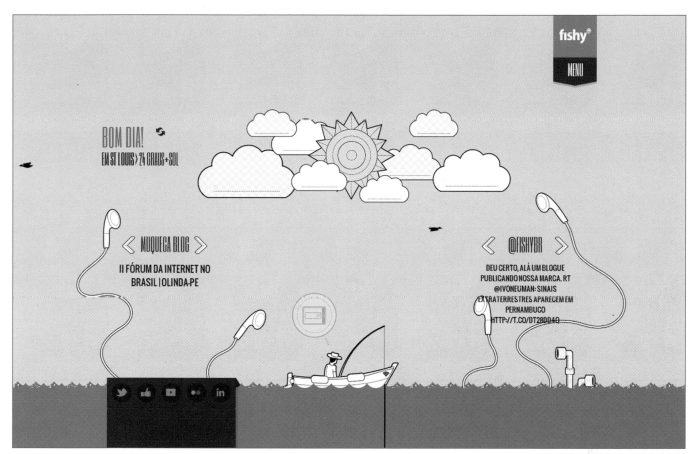

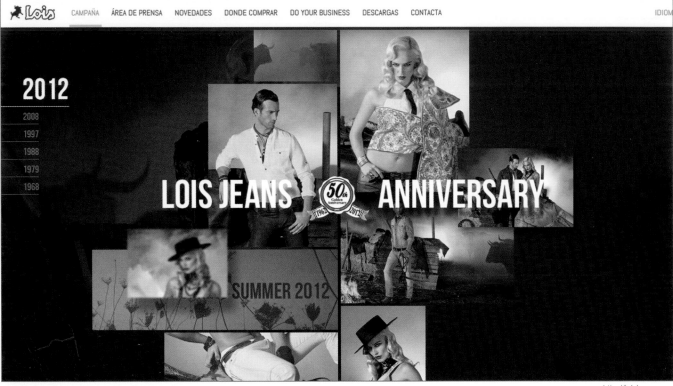

http://loisjeans.com

http://bobadilium.com

http://experimint.nl

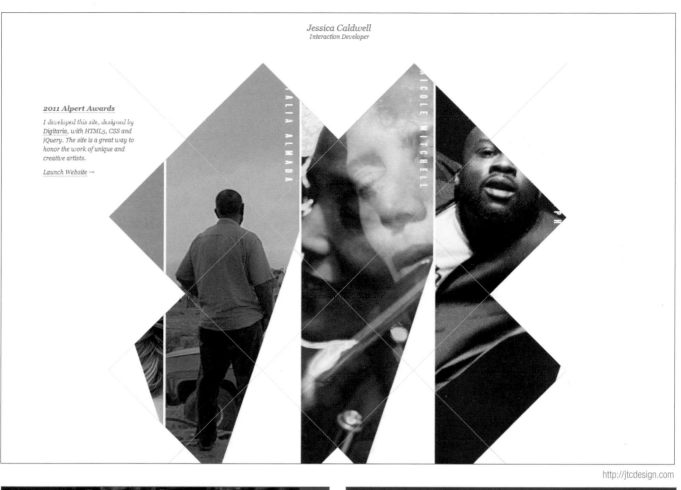

Jessica Caldwell
Interaction Developer

2011 Alpert Awards

I developed this site, designed by
Digitaria, with HTML5, CSS and
jQuery. The site is a great way to
honor the work of unique and
creative artists.

Launch Website →

http://jtcdesign.com

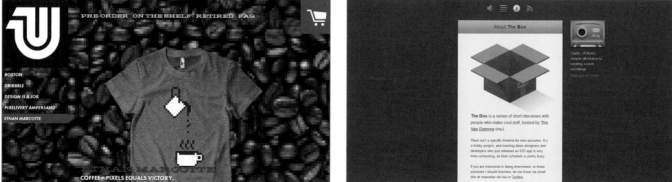

http://www.unitedpixelworkers.com

http://thebox.maxvoltar.com

WHITEBOARD

View Our Work

We empower visionaries to lead meaningful brands.

http://whiteboard.is

070

Devices

Few things in the history of the Internet have forced change as drastically as the influx of devices has. Currently, this includes a diverse range of tablets and smartphones, but might soon include many other devices like televisions, automobiles, and so forth.

These new devices have an influence over some fundamental web elements. For starters, they come in a wide range of screen sizes, from the very small phone to the medium-size tablets to the standard desktop with monitors up to 30 inches wide. Second, users interact with sites using touch on mobile devices and tablets versus a mouse on standard computers. Finally, users on phones and tablets are on the go, with different needs and much shorter attention spans.

As a result, the industry has undergone some radical changes that significantly change the way sites are designed and built. Here I want to cover several key topics along this line of thinking and provide plenty of inspiration to go along with it.

RESPONSIVE DESIGN

Responsive web design is the practice of designing and building sites in such a way that the site adapts to whatever interface the user views it on. For instance, on a desktop the user might get a standard layout with multiple columns. The same site, when rendered on a smartphone, might reformat into a single column of content. The goal is to present the content in such a way that it can be most easily consumed and interacted with. The end result should be a site that responds to a user's environment instead of a site forced into a single format designed for desktop computers with larger monitors.

I am not going to get into the mechanics of how all this works, but assuming you have some interest or if you want to explore it, I want to point you in the right general direction. Each variation of the site is styled using a separate set of CSS. And the correct CSS is most commonly applied to the page through something called media queries.

I do want to clear up one detail before I dive into the inspiration part of this topic. I am purposely not going in depth into the topic of adaptive design. Responsive design was originally conceived as being based on sites that are entirely fluid and can scale to any size. In contrast, adaptive sites adapt by stepping to key sizes. That is to say an adaptive site might snap to three or four key sizes but is not fluid over the entire range. This may seem like splitting hairs, and is why many people lump the idea of adaptive design in with responsive design. It seems that many already consider the two interchangeable terms[5].

Okay, so on with the inspiration. Take a look at the Easy Designs blog **(figure 1)**. If you view it in a browser you will see that the layout changes and responds with a layout tailored to fit your browser (or device) size. In this case, not only the format changes, but some of the extra decorative elements get trimmed away as the screen gets smaller and smaller.

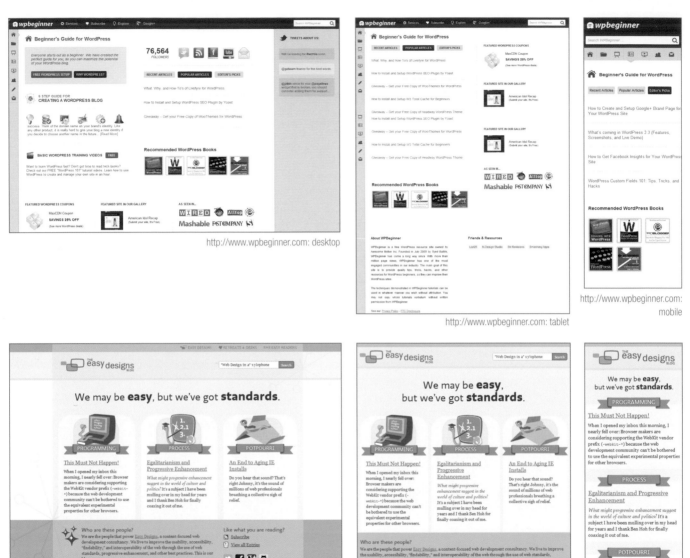

http://www.wpbeginner.com: desktop

http://www.wpbeginner.com: tablet

http://www.wpbeginner.com: mobile

Figure 1 http://blog.easy-designs.net: desktop

Figure 1 http://blog.easy-designs.net: tablet

Figure 1 http://blog.easy-designs.net: mobile

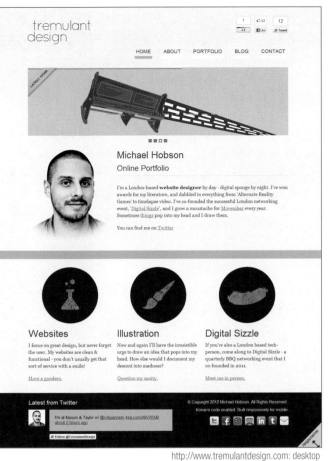

http://www.tremulantdesign.com: desktop

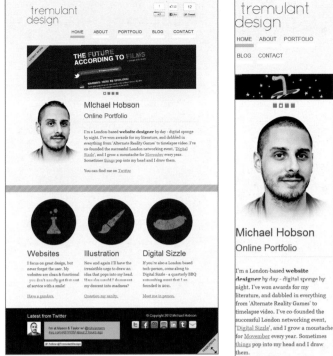

http://www.tremulantdesign.com: tablet

http://www.tremulant-design.com: mobile

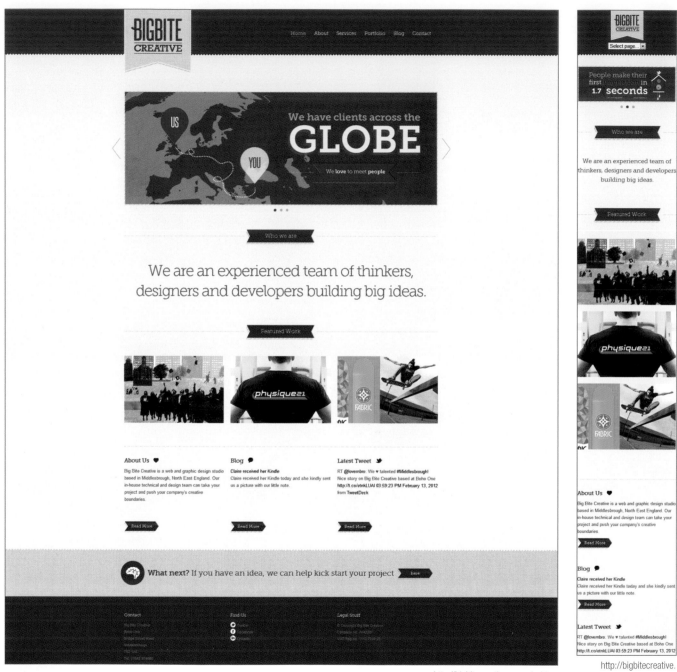

http://bigbitecreative.com: desktop

http://bigbitecreative.com: mobile

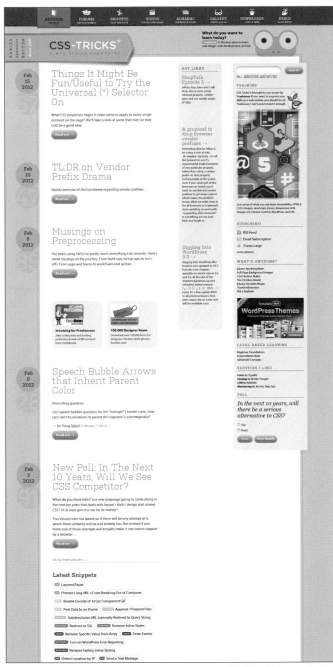

http://css-tricks.com: desktop

http://css-tricks.com: tablet

http://css-tricks.com: mobile

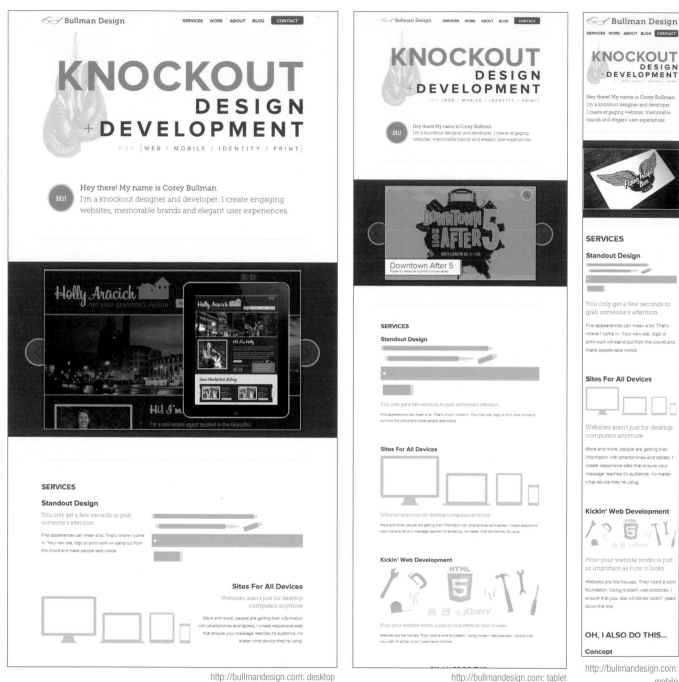

http://bullmandesign.com: desktop

http://bullmandesign.com: tablet

http://bullmandesign.com: mobile

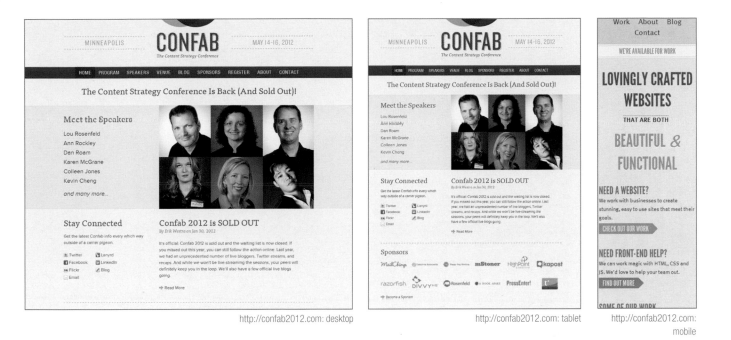

http://confab2012.com: desktop

http://confab2012.com: tablet

http://confab2012.com: mobile

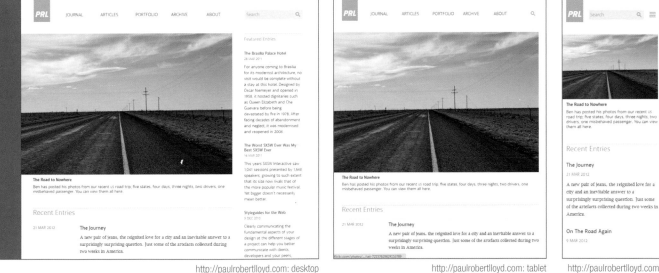

http://paulrobertlloyd.com: desktop

http://paulrobertlloyd.com: tablet

http://paulrobertlloyd.com: mobile

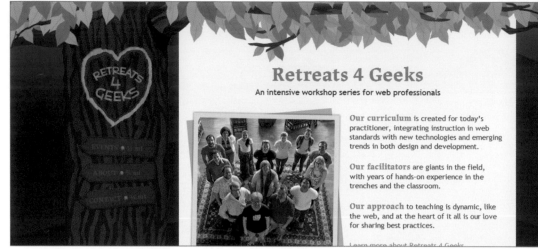

Retreats 4 Geeks

An intensive workshop series for web professionals

Our curriculum is created for today's practitioner, integrating instruction in web standards with new technologies and emerging trends in both design and development.

Our facilitators are giants in the field, with years of hands-on experience in the trenches and the classroom.

Our approach to teaching is dynamic, like the web, and at the heart of it all is our love for sharing best practices.

Learn more about Retreats 4 Geeks

http://retreats4geeks.com: desktop

Retreats 4 Geeks

An intensive workshop series for web professionals

Our curriculum is created for today's practitioner, integrating instruction in web standards with new technologies and emerging trends in both

http://retreats4geeks.com: mobile

Retreats 4 Geeks

An intensive workshop series for web professionals

Our curriculum is created for today's practitioner, integrating instruction in web standards with new technologies and emerging trends in both design and development.

Our facilitators are giants in the field, with years of hands-on experience in the trenches and the classroom.

Our approach to teaching is dynamic, like the web, and at the heart of it all is our love for sharing best practices.

Learn more about Retreats 4 Geeks.

"Retreats 4 Geeks was an incredible experience. Not only did I make a bunch of new friends, but my understanding of my craft became much more nuanced. I also left with a greater appreciation for Web Standards and the inspiration to use my awesome coding powers for good."

— Allison Urban, MailChimp

http://retreats4geeks.com: tablet

MOBILE SPECIFIC

While much of the industry's focus has been on responsive design, the notion of building a mobile-specific site is still entirely valid. One of the huge perks to building a totally separate mobile site is that you can tailor it to the needs of mobile users. A great example of this is the Penzu site **(figure 1)**. The desktop version contains all of the elements we might expect to find on a site promoting a software service. In contrast, the mobile site is nothing more than the login screen. This laser focus on helping existing users and seemingly ignoring potential new users demonstrates the type of specialization that is possible here. Responsive design is awesome, but sometimes a separate mobile site is a preferable option. Don't get so caught up in the hype that you forget to consider traditional options, though they might not be as trendy.

There are other reasons to create a separate interface, beyond custom tailoring the content. Consider the Archikon site **(figure 2)**. The desktop version of this site is built on a very atypical structure and interface. If one were to try and run this same interface on a smartphone it would be a frustrating experience. Instead, they have a totally different interface for mobile users **(figure 3)**.

For a great demonstration of tailoring the content to the expected interface, look at the Cibgraphics site **(figure 4)** and its mobile companion **(figure 5)**. Clearly, the mobile home page contains almost none of the content the desktop version has. Instead you find the logo, one sentence to introduce the agency and a list of links to the content of the site. The desktop version is stuffed with a lot more information. Imagine how long the mobile version would be if it included everything the desktop version did. Its focus on simplicity is much appreciated and ensures users can dive in without getting overloaded.

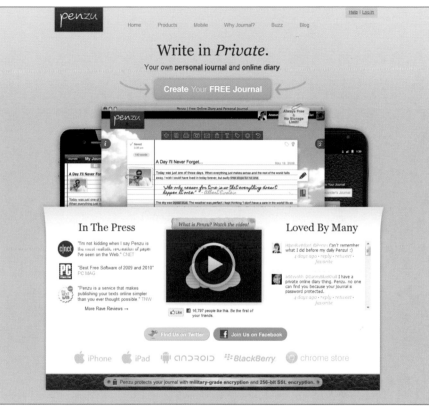

Figure 1 http://penzu.com: desktop

Figure 1 http://penzu.com: mobile

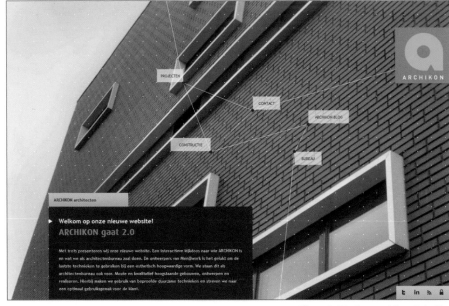

Figure 3 http://www.archikon.nl: jquery mobile

Figure 2 http://www.archikon.nl: desktop

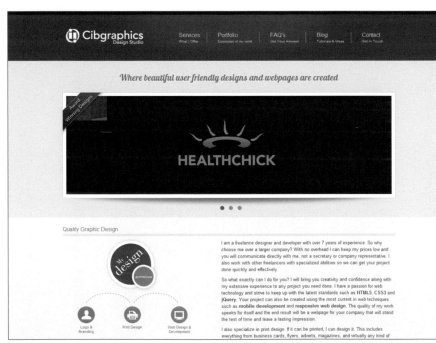

Figure 4 http://www.cibgraphics.com: desktop

Figure 5 http://cibgraphics.com/mobile: jquery mobile

Home
back to my roots

About
get to know me

Portfolio
changing the world

Journal
my restless mind

Contact
lets work together

VERSION 7

M1k³

an independent **design studio** focusing on
ui design / mobile / development

Journal & Articles

Exciting News! CAGE has been Acquired.

Two years ago I set out to re-imagine the design collaborative space and disrupt its market. Over this time, I took risks by dedicating myself and career to making that vision happen...

CONTINUE →

On being your own Entrepreneur.

Entrepreneur, I can't think of another word that's becoming more of a buzz word. More people are calling themselves Serial Entrepreneurs today because the single word Entrepreneur is not.

CONTINUE →

Designing for the Mobile Web, with Michael Dick

It's a honor to have been invited to present at Refresh Baltimore this week, December 9th! The event was held at MICA, Maryland Institute College of Art, where I spoke on...

CONTINUE →

The theory that I'm not a Web Designer.

If you asked me if I still enjoyed design, I would tell you yes and no — quickly followed up with the idea that I consider myself an entrepreneur of my ideas. Design is only a part of the process...

CONTINUE →

Using Billings 3 to track business expenses.

I've been using Billings 3 for about three years now. Two years ago I needed a better way of tracking expenses. Billings has the support for expenses built in, but they're meant to be...

CONTINUE →

The distinction between interfaces & graphics.

A very common question I encounter with in our industry is sort of a trick question, they ask me if I do graphic design. I reply with, no. Then the next question that follows asks me who designs...

CONTINUE →

Rethinking the Purpose of a Redesign

Redesigns are inevitable, no matter how well you think your website is built today. It will grow old as business models evolve and technologies progress. The key to a successful redesign is to understand...

CONTINUE →

SXSW sketch notes by a mobile designer.

Getting together with other liked minded, talented professionals & friends is what it's all about...oh and those pesky panels you almost forget about because of the night before...

CONTINUE →

Popular Tags

	
Inspiration	17 posts
Site Launches	9 posts
Design	8 posts
PureEdit	8 posts
Personal	8 posts
Web Design	7 posts
Entertainment	6 posts
Tips & Tricks	6 posts
Educational	4 posts
iPhone	4 posts
iPhone	4 posts
Back-end	4 posts
PHP	4 posts
iPhone	4 posts
Back-end	4 posts
PHP	4 posts
iPhone	4 posts
Back-end	4 posts
PHP	4 posts
iPhone	4 posts
Back-end	4 posts
PHP	4 posts
Front-End	4 posts
Redesign	3 posts
Presentations	3 posts

View all Tags →

© Michael Dick Powered by PureEdit | Switch to Mobile | Follow me on Twitter

http://m1k3.net: desktop

M1k³

creative designer
specializing *in*
interface design
& **front-end**
development.

Portfolio About Archives

http://m1k3.net: mobile

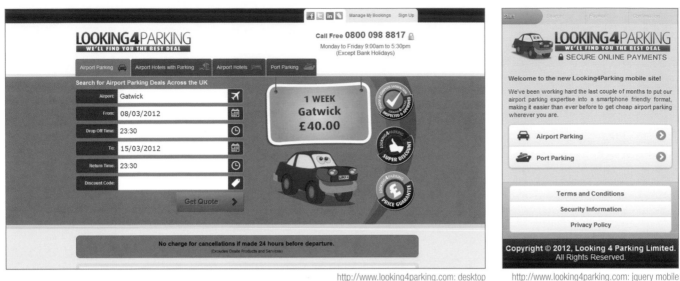

http://www.looking4parking.com: desktop

http://www.looking4parking.com: jquery mobile

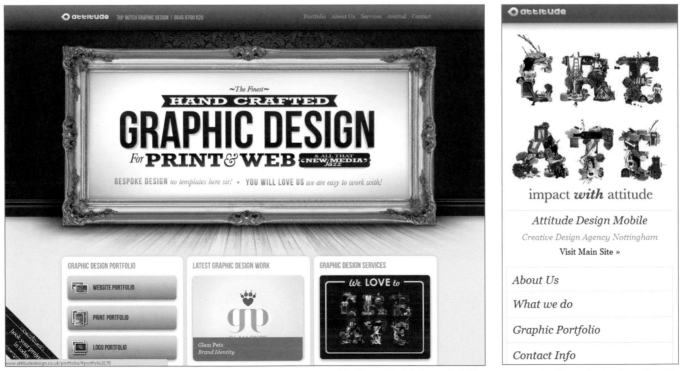

http://www.attitudedesign.co.uk: desktop

http://www.attitudedesign.mobi: mobile

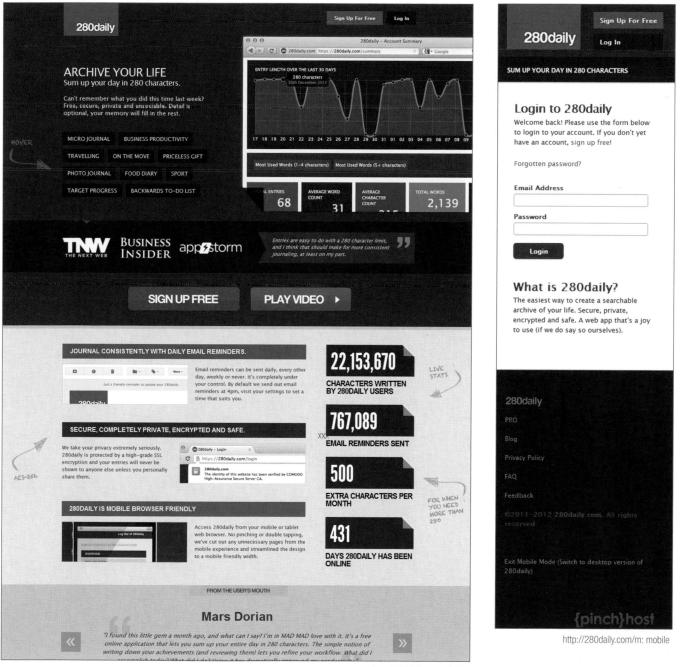

http://280daily.com: desktop

http://280daily.com/m: mobile

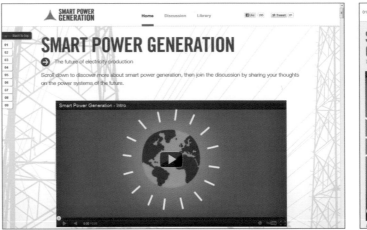

SMART POWER GENERATION

The future of electricity production

Scroll down to discover more about smart power generation, then join the discussion by sharing your thoughts on the power systems of the future.

http://www.smartpowergeneration.com: desktop

www.smartpowergeneration.com/mobile: mobile

http://smallstudio.com.au: desktop

http://smallstudio.com.au/mobile/mobile.php: mobile

http://explorestlouis.com: desktop

http://explorestlouis.com/mobile: mobile

JQUERY MOBILE

jQuery is a library of pre-built JavaScript functionality. jQuery Mobile is a similar set of tools. It is based on the core jQuery library and adds lots of functionality focused on delivering mobile optimized interfaces for tablets, smartphones and other touch-driven devices.

This tool is powerful and incredibly useful on its own. But given the context of this book (seeking to inspire you), I have opted to include this tool set as it enables some incredible functionality with very little effort. In fact, many of the technical complications of getting a mobile site up and running are removed thanks to this utility. Granted, you still have to do a lot of work to pull it together, but it gives you some robust building blocks to work with.

If you analyze the samples in this chapter, you might notice one common element—the button lists. One of the most powerful features inside jQuery Mobile is its assortment of tools for building navi-gation and transitioning between content. Given this, a common style emerges that is noticeable throughout this wide variety of samples, which range from Disney to an individual's portfolio. In my opinion, this common element is an asset as users become familiar with the feature and know what to expect.

Another thing to note about these sites is that they are mobile specific (more on this topic on page 079 in the Mobile Specific chapter). This means that they are made for the mobile web, and not intended for use on a desktop computer. In fact, many sites built using jQuery mobile automatically redirect you to a desktop optimized version when you try to load it on your computer.

Among these gorgeous samples one of my favorites is the Joy Theater site **(figure 1)**. One of the details I love is their primary navigation. Instead of using a standard button bar (as provided by jQuery Mobile), they have opted for these large circular buttons. The shape and size of these elements ensures they are easily touched, which is a plus for the usability factor. At the same time, their design is unique so that the site feels distinct, and it's not easily forgotten.

In contrast, Brett Hayes **(figure 2)** makes use of a standard button bar built with jQuery Mobile (the button bar across the top of the site). In this case it works well and the designer has used other visual elements to ensure a unique experience that is still extremely functional. It isn't always about breaking the norm or reinventing an interface; most often a perfect balance between unique design and familiar functionality leads to very effective design.

Learn more about jQuery Mobile at http://jquerymobile.com/.

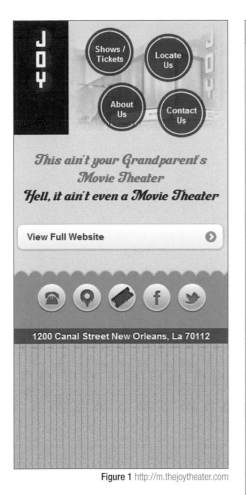

Figure 1 http://m.thejoytheater.com

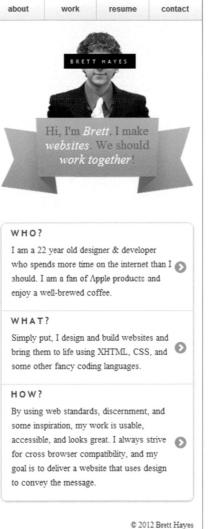

Figure 2 http://m.bretthayes.ca

http://m.disneyworld.disney.go.com

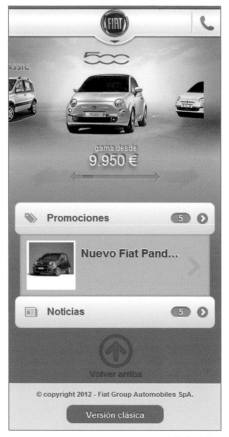

http://m.fiat.es

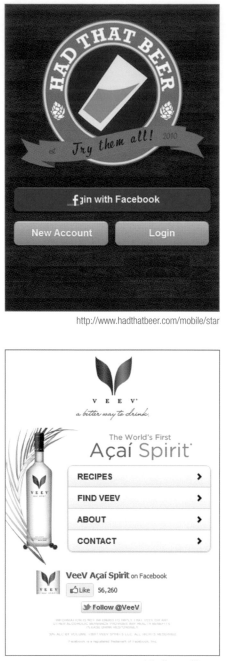

http://m.veevlife.com

http://www.hadthatbeer.com/mobile/star

http://vaio-s.de

★ TUSCAN MAREMMA ★

HOTEL RESORT
Antico Casale di Scansano

SPA & RESORT ›

ROOMS & SUITES ›

HOLIDAY APARTMENTS ›

HORSE RIDING CENTRE ›

RESTAURANT ›

WELLBEING OFFERS ›

☎ ⋯› +39 0564 507219
Call and Book

Follow and Participate in our Community

Certificate of Excellence
MAY 2011 tripadvisor™

Language 🏴󠁧󠁢󠁥󠁮󠁧󠁿 🇮🇹 Full Site

©2011 Antico Casale di Scansano
P.I. 00921450532 • Reg.Imp. 74279, 15/02/1988

designed by MuseComunicazione

Menu | Booking | Contacts | Map

http://m.anticocasalediscansano.it/en

box

Simple, secure sharing from anywhere

🔑 Log In

➲ Sign Up

☐ Box Mobile App

ⓘ About

Box for Mobile

Get 5GB FREE and browse your files on the go

Upload files from your device to Box

https://m.box.com

Home Networking cisco

Life is Good in a
Wireless Home
Find wireless solutions for gaming, streaming, working and more.

Find Solutions

Find a Router ›

Meet the E-Series Family ›

Linksys E4200 ›

Linksys E3200 ›

Linksys E2500 ›

Linksys E1500 ›

Linksys E1200 ›

Mobile View | Standard View

HOME | COMPARE | BUILD | SUPPORT

http://mhome.cisco.com

sears

Sign In | Register 🛒

🔍 Search Keyword or SKU | GO

Browse ›

Find a Store ›

$$$ LocalAd & Deals ›

➕ More ›

About | Contact | Terms | Policy | Full Site

http://m.sears.com

02 / Design Styles

One of the core goals of The Web Designer's Idea Book series is to showcase popular styles and trends. As a result I consider this section on current design styles to be core to the mission of this book. Design styles slowly morph and change with time, and though several topics presented here are perennial favorites that show up in each of the Idea Books published, I believe you will recognize clear changes in how they are used. For example, illustration and minimal styles are classic elements that have appeared in each of my previous books. And obviously these styles have histories far beyond my observation of them. So while I attempt to present as many new styles as possible, there will always be a few that show up again and again. (Perhaps someday I can assemble a secondary book that showcases all of the elements from a single style over time.)

THEMATIC DESIGN

Thematic design is certainly not a new idea, but I love the approach designers are currently taking. In years past this style was equally popular, but it seems that the current trend is to shift to a more subtle approach. Certainly this isn't universal, but if you contrast the samples here with those in *The Web Designer's Idea Book, Volume 1* (the Extreme Theme chapter) I think you will agree.

For example, let's consider the Quazar Web Design site **(figure 1)**. Here, a space theme is rather clearly and prominently used. Note however that the overall layout is familiar and comfortable. In this case,

the theme is used to style the elements that we expect to find. In stark contrast, the inTacto site **(figure 2)** also uses a space theme. However, in this case it is far more extreme. The layout is totally abnormal. In fact, the page is intended to scroll up, not down. Ironically, this extreme theme approach clearly contradicts my notion of a more minimal approach to themes. But, of course, this is the nature of things, styles are used in countless ways. The point really is to realize the range of possibilities when it comes to implementing a theme. We can paint a theme onto what's considered a "normal" layout, or we can

invent a totally thematic interface, and we can do anything in between.

In other cases, the far more minimal approach is rather clear. The Revolver site showcased here, for example, does just that **(figure 3)**. This beautiful site works a bit of theme into an otherwise minimal, superclean site. Themes can make a site more fun and often easier to design, but don't assume you have to go bonkers with them. Sites like this one demonstrate that a more subtle approach can produce gorgeous thematic designs.

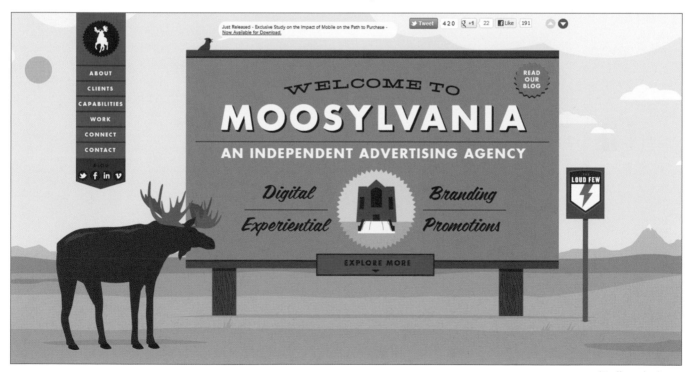

http://moosylvania.com

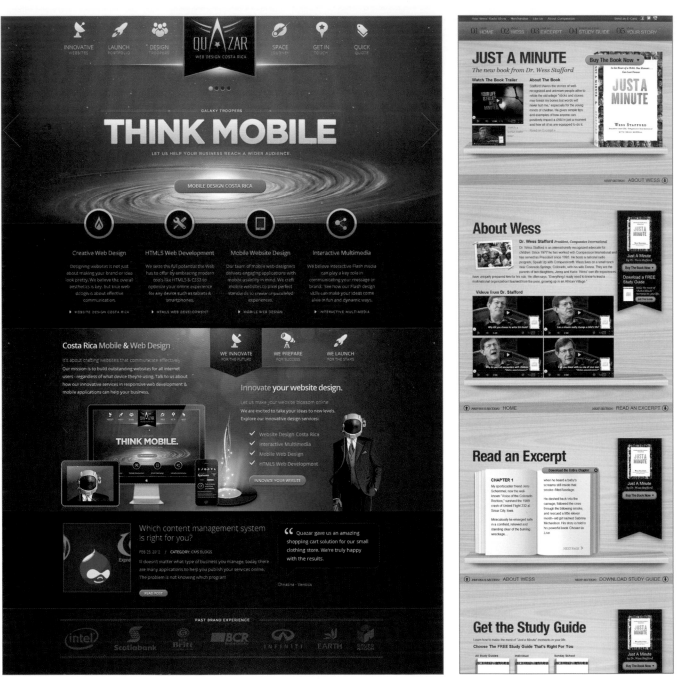

Figure 1 http://www.quazarwebdesign.com

http://www.justaminute.com

2001- LAUNCH
InTacto Digital Partner is born

Figure 2 http://www.intacto10years.com

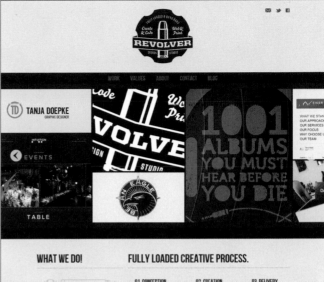

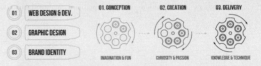

WHAT WE DO!

01 WEB DESIGN & DEV.
02 GRAPHIC DESIGN
03 BRAND IDENTITY

FULLY LOADED CREATIVE PROCESS.

01. CONCEPTION
IMAGINATION & FUN

02. CREATION
CURIOSITY & PASSION

03. DELIVERY
KNOWLEDGE & TECHNIQUE

LET'S TRY TO INTRODUCE US...

Founded in 2010, *Revolver Studio* is a Lausanne-based, young and passionate, *design and communication agency* with ten years of experience.

We achieve our best work by generating crafty and original *creative solutions* by communicating closely with our clients. Our experience allows us to create *tailor-made projects* and therefore always be up to date with the newest trends and techniques. Being *curious* and *open minded* is making us grow every day. We really appreciate being challenged, don't hesitate, contact us.

We provide imaginative solutions across *a multiple range of disciplines*, such as web design and development, graphic design, brand identity, print, logotype, stationery, editorial, copywriting and brand activation. In brief, the full package!

Finally, our enthusiasm and devotion for *graphic, web design and development* translate into a fun and creative approach that we apply to all of our projects.

We think work should be fun and creative. *That's how we rock!*

LATEST TWEET
"30 Fresh JavaScript App Resources http://t.co/6MZa6ZF8."

LET'S ROCK TOGETHER!

TRADITIONAL WAY
P: +41 (0)21 728 44 80
M: +41 (0)7 8 658 03 10
E: hello@revolverstd.com

ADDRESS
Ch. du Val d'Or 7
1009 Pully - Vaud
Switzerland

GIVE US A SHOUT
Name
Phone
E-mail
SAY HELLO!

Message

SOCIALIZE

GOOGLE MAP

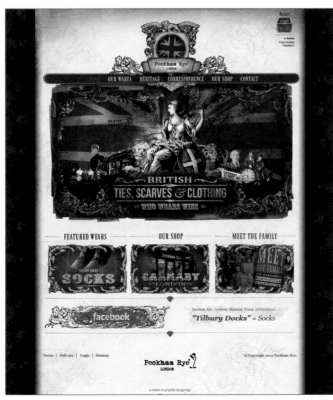

FEATURED WEARS OUR SHOP MEET THE FAMILY

Peckham Rye Cockney Rhyming Slang Definition:
"Tilbury Docks" = Socks

Terms | Delivery | Login | Sitemap © Copyright 2012 Peckham Rye.

http://www.peckhamrye.com

Figure 3 http://www.revolver-studio.com

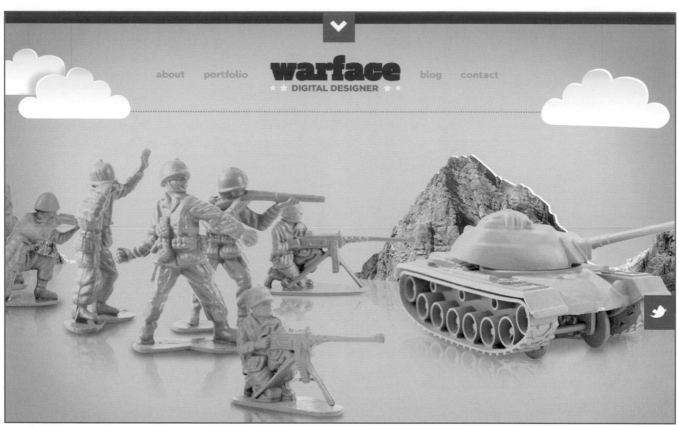

http://www.warface.co.uk

http://www.matthewdjordan.com

http://melonfree.com

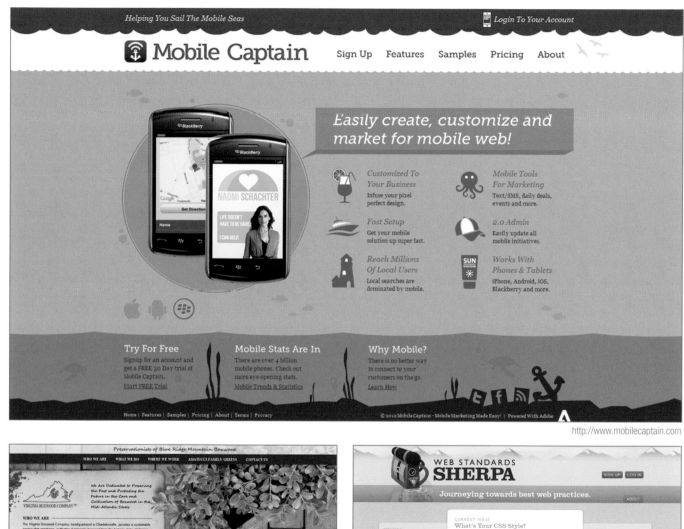

http://www.mobilecaptain.com

http://www.virginiaboxwood.com

http://webstandardssherpa.com

ART-DIRECTED BLOG

Let's begin by explaining exactly what an art-directed blog is. A blog in this style applies a unique design to each and every blog post. This means the creator not only writes a blog post, but produces a custom style for the page. Clearly this approach is far more time-consuming. Typically a blogger working with this approach will maintain a common structure or framework, as well as a common overall design style. In this way, multiple pages work together, while each stands as an independent creation. Creating a site like this is not for the faint of heart. The amount of work required is not to be underestimated. You will find, however, that, the results can be truly outstanding.

One of the most common elements when it comes to art-directed blogs is a standard page header. This is clearly visible on the Visual Idiot site **(figure 1)** as well as on the Lefft site. Through this common element, the users are given something stable to rely on. It's particularly important because each page has the potential to disorient the viewer.

The most significant downside to consider (besides the time drain) is that an overall brand style will likely be lost. You can certainly weave your own personal style into each blog, but a new visitor who lands on an individual page may become disoriented until she realizes each post is custom designed. This makes any common elements extremely important. A common overall style will be a powerful tool for unifying the varying designs.

For a good example of this, take a closer look at the Lefft site. Note that the three layouts presented here **(figure 2)** all have a common base. They are all centered around large blocks of solid colors and are largely based on typographic design. As a result, they work together extremely well, while displaying a wide range of styles.

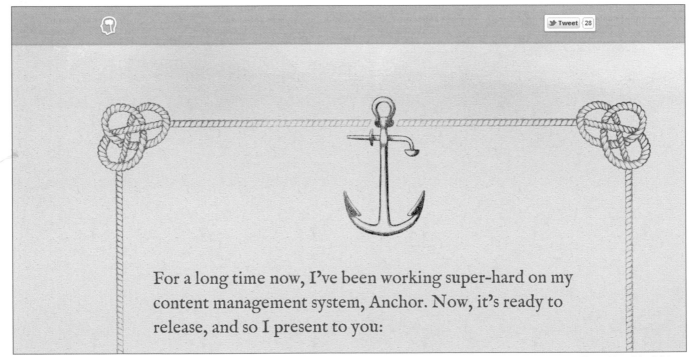

For a long time now, I've been working super-hard on my content management system, Anchor. Now, it's ready to release, and so I present to you:

Figure 1 http://visualidiot.com

Valentine's Cards (For Code Lovers)

Presenting Anchor

CSS3 For The Real World

I Forgot To Write This Article

The Greatest Browser That Ever Lived

Photoshop Simulator

Avatars: A How-Not-To Guide

Hacking Facebook

Hello, World!

FREE::STUFF SOCIAL PROJECTS

VALENTINE'S CARD IDEAS
(FOR CODE LOVERS)

It's that time of year again; the day where lovebirds spend some quality time together, where dogs eat leftover spaghetti, and where I pick up some crazy good deals on the last of the Christmas chocolate.

Unfortunately, though, that doesn't look like that's going to happen this year; you've forgotten to get a card, and the local petrol station is full of like-minded folk. What do you do?

You don't worry, that's what. Here's a selection of romantic Valentine's Day card ideas.

```
var you = {}, my = {desire: you};
// You are the object of my desire.
```

Click the image or refresh the page for another one
Got a suggestion? **Tweet me.**

Figure 1 http://visualidiot.com

AVATARS
A HOW-NOT-TO GUIDE

The humble avatar; a thumbnail that reflects you or your brand online. It's the perfect opportunity to create a lasting impression of your brand. So, why does everyone's suck?

In this article, I aim to show you how not to create the perfect avatar. Let's start with #5.

#5: Eight-bit avatars

Reminiscing back to the '80s, we have this semi-accurate pixellated representation of your face. When I say "accurate", I mean "unless your face is comprised of 90° angles, it's about as accurate as using your arm as a ruler", of course. Unfortunately, it's been used and overused (and then some), and for that reason, it earns a place in my list.

#4: Group shots

Well hi there, old school friend. Although I do vaguely remember our wacky hijinks, I'm unable to place a face to your name. Not to worry, though; you've got a profile picture. I'll identify you through that! Oh, wait. Which one are you? I don't know, because you took a group photo. Thanks(!)

(For those wondering, the person in this offending profile is on the top right)

#3: That damn Twitter egg

If you're going to join a social network, the first thing you should do is make sure you have an avatar, otherwise the first thing I do when you follow me (and a few thousand others) is block you.

Seriously, it's not hard. Just Photoshop things on your face.

#2: Filtered Beyond Oblivion

Figure 1 http://visualidiot.com

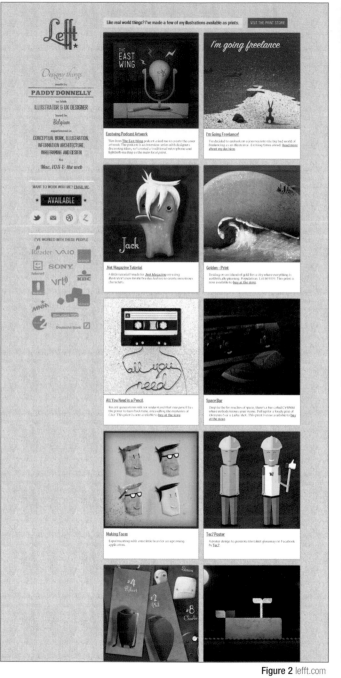

Figure 2 lefft.com

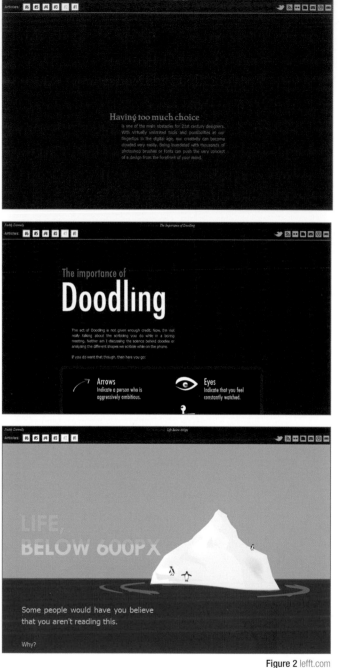

Figure 2 lefft.com

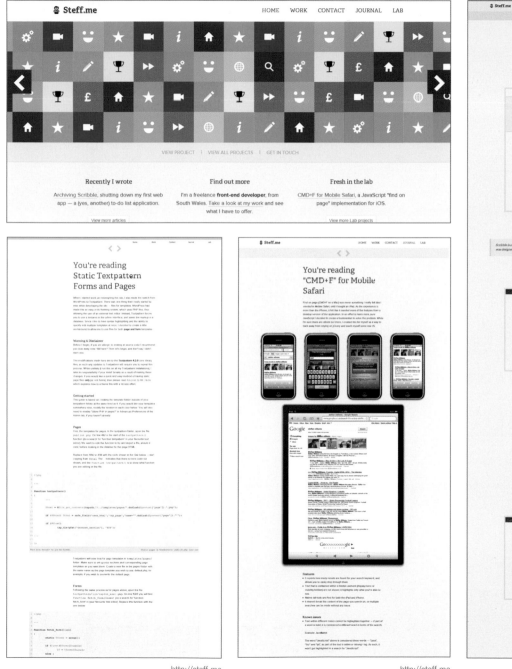

MINIMAL

As with my previous writings on the use of minimal design, the samples here by no means embrace a strict implementation of the approach. Each of the designs here could be further refined and made more minimalistic, but this is the point of showcasing *real* work here. In reality no one wants a purely minimalistic site. Instead, designers prefer the benefits the style offers when paired with their personal style to give it unique flavor. After all, a site that purely embraces the minimalist mentality would likely be extremely homogeneous and perhaps even boring.

The reality is that when we implement a style like this it isn't for the purpose of embracing the style but rather to accomplish some set of needs. In the samples here,

the minimal style allows for easy-to-use sites that communicate their purpose in an almost effortless way. The sites leverage the power of the style to accomplish the real goals and purposes of these sites. And in the end, this is the real mission of a web designer. So instead of considering how crazy I am to flag these sites as minimal, look at them and consider how the minimal style has been put to work and how you might do the same.

A perfect example of this is the Unify Interactive site **(figure 1)**. This site clearly doesn't embrace a strictly minimalist mentality. So much in this design could be cut in the name of minimalism. But then the design would be void of any personality or uniqueness. In this case, the embel-

lishments serve to dress up and give the site a unique style. At the same time, the underlying minimalist approach maintains a clean design that communicates its purpose effortlessly.

Another fine example to look at is the 51bits website **(figure 2)**. Here the minimal style is evident. The visuals showcasing the agency's work not only show off their portfolio, but give the site some unique visual elements to help the users create a visual impression of the site. Without these previews, the site would be so minimal that there would be almost nothing to file away in your brain. Instead our attention focuses on their work and it creates a lasting impression.

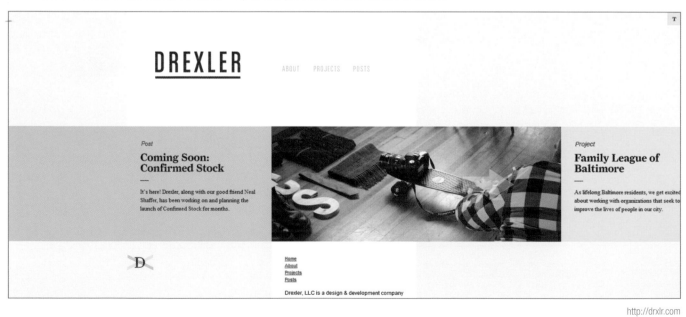

http://drxlr.com

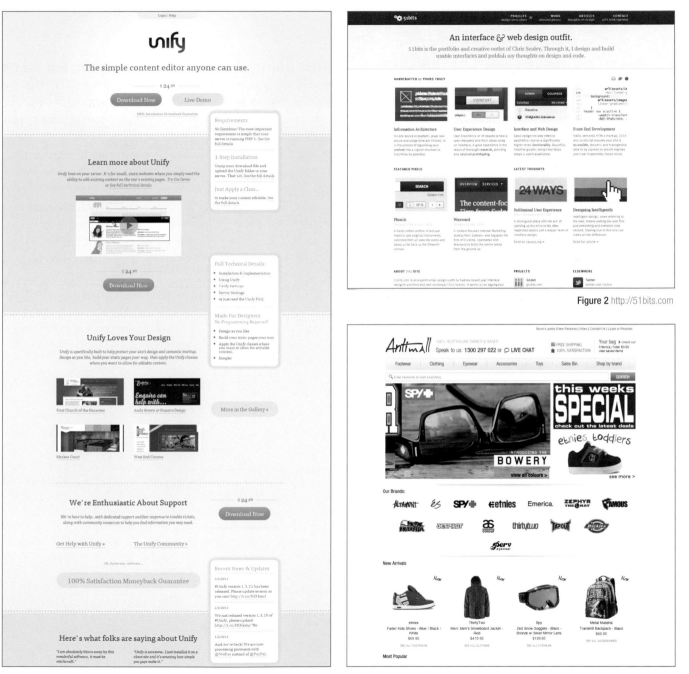

Figure 1 http://unify.unitinteractive.com

Figure 2 http://51bits.com

http://www.antimall.com.au

http://www.visualnews.com

http://www.polarfoxapp.com

http://www.thymer.com

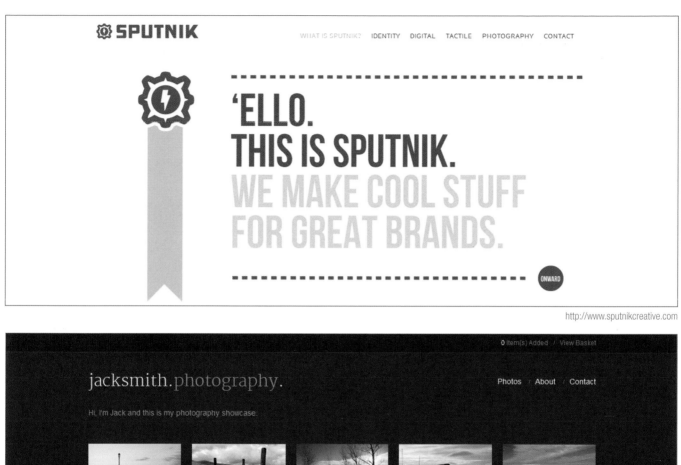

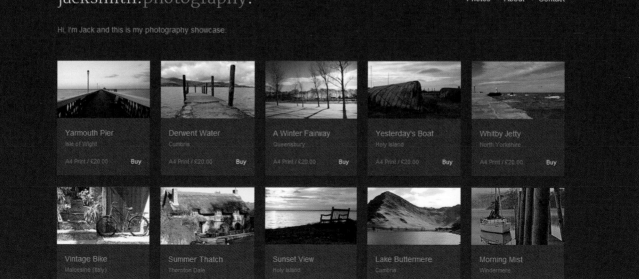

Freelance developer HTML5

Creator of website and web application.
Development for mobile.

http://freelance-html5.com

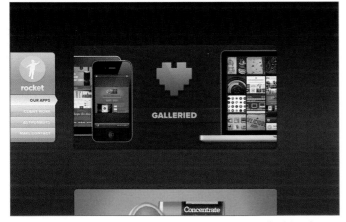

http://madebyrocket.com

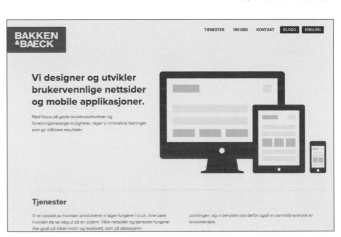

http://www.bakkenbaeck.no

MUTED WITH A RAINBOW OF COLORS

It is true, some trends are far more glamorous than others, but don't think for a second that this particular trend doesn't have some serious punch. In this section of the book, I want to showcase sites that are primarily based on a muted color palette (grays and other washed-out colors) and then peppered with a rainbow of colors. Let's review a sample that clearly illustrates this.

Consider the site SpigotDesign.com **(figure 1)**. Here the base white and gray colors are very prominent. Then a splash of color is added that doesn't rely on a single accent color: rather, a variety of colors has been used. This splash of color

further highlights the key bits of data on the page and helps drive users to the content they are likely looking for.

Another example that carries this approach to a very effective use is the Regent College website **(figure 2)**. Here the colors accent the navigation and also connect to the buckets of content as you navigate the site.

For some strange reason another trend seems to frequently show its face here—circles. In fact, I have a whole chapter in this volume on the use of the circle as a design element (see page 176). Why it is that these two go together I am not certain. I thought long and hard on the topic and

repeatedly reviewed the samples in both categories in search of some connection. Frankly, I have no idea why designers are drawn to such similar solutions. Perhaps they all derive from a similar inspiration source. Regardless, this is part of the fun of exploring trends and themes. Sometimes you stumble upon interesting patterns.

In closing, I want to highlight one key feature of the trend. Given a muted backdrop, the colored elements have the potential to stand out. For this reason, this trend is a powerful way to control the user's behavior and to encourage them to focus on the most critical conversion points of your site.

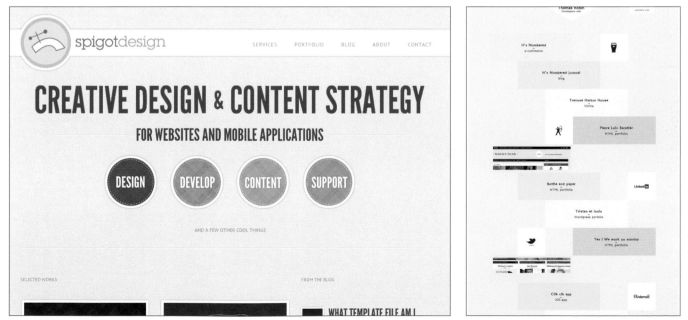

Figure 1 http://spigotdesign.com

http://www.thomasrobin.net

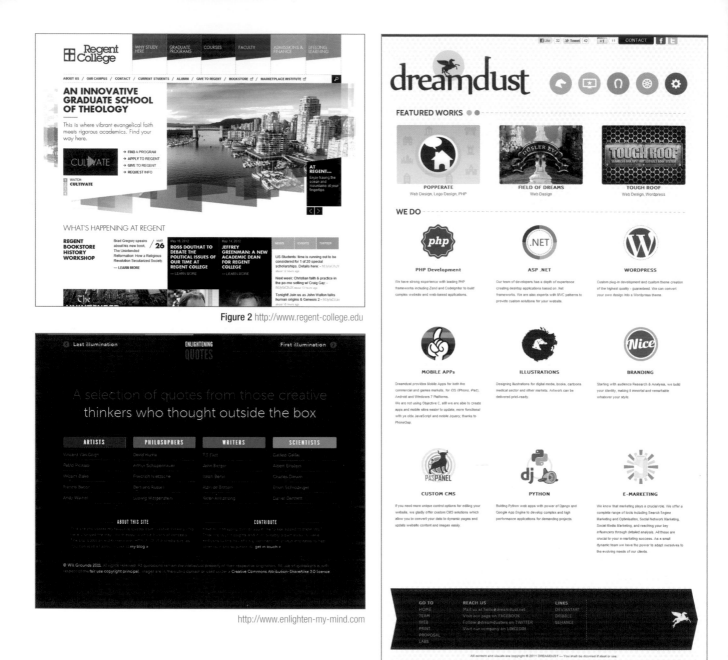

Figure 2 http://www.regent-college.edu

http://www.enlighten-my-mind.com

http://www.dreamdust.net

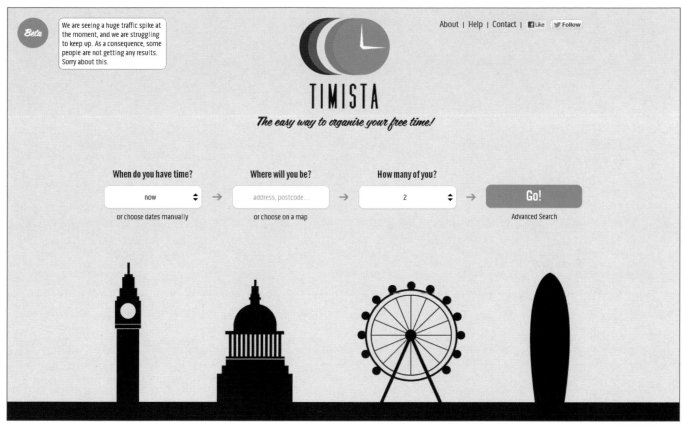

http://timista.com

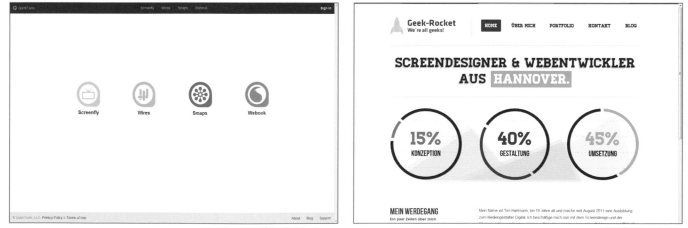

http://quirktools.com

http://geek-rocket.de

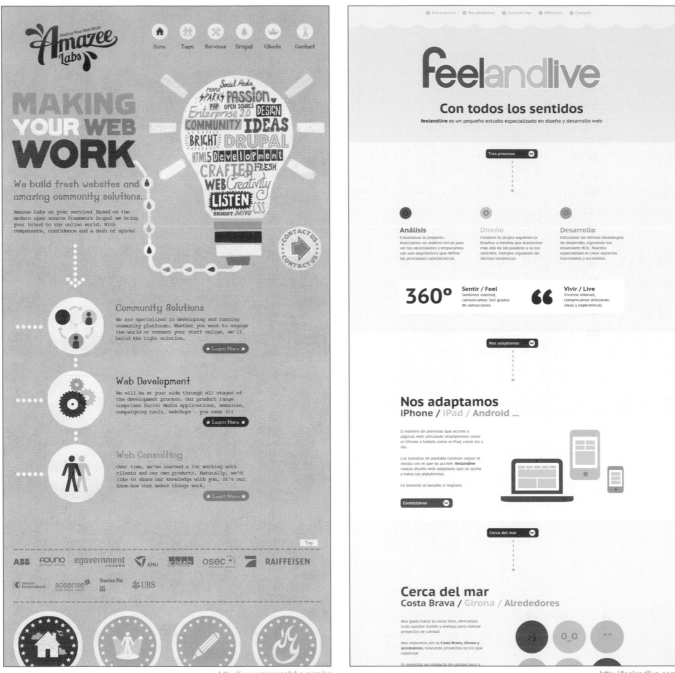

ILLUSTRATED

I have frequently stated my opinion that illustration is one of the most powerful tools in the designer's arsenal. Through illustration, an entirely unique design can be created. Many of the most memorable sites are based on unique illustrations that establish a totally distinct brand. A prime example of this is the War Child design **(figure 1)**. The designers of this site could have gone the photographic route, relying on photographs to send the message. The illustration actually creates a far more distinct image, and the site is almost impossible to forget. You might think photos of suffering children would be unforgettable, and they certainly would be, but they wouldn't be firmly connected with this site. Instead, the illustrations are unique and easily connected to this particular project. In terms of brilliant art direction, sites like these are landmarks.

One less-used approach weaves the illustrations into a site's basic structure instead of creating freestanding illustrations. For an example of this, see the Bellstrike site **(figure 2)**. Here the illustration is not a focal point as it was on the War Child site. Illustration is used to create the standard components of the site. With this perspective, almost any site might be considered illustrated, but the difference is the artistic approach which demonstrates a unique individual's touch. I bring this up because I think it's valuable to present conflicting approaches in an effort to demonstrate the wide range of possibilities.

Another fine example to study is Host-box **(figure 3)**. Here illustration comes in a rather unique form. A large number of icons are combined to create an overall image. The illustration is meaningful and renders a unique style, but it's not all-consuming. The site takes on a typical form and simply weaves illustrations into its structure. Again, the range of possibilities is huge. If you're stumped because you've been trying to implement an over-the-top illustration-based site, it may be a good idea to consider doing the opposite.

WAR child

About Us What We Do Impact Features Issues Get Involved Music & Arts **DONATE**

Teachers Jobs Contact Us FAQ

WAR DESTROYS CHILDREN'S LIVES

We're on the ground in some of the world's most dangerous countries — helping to put those lives back together

LEARN MORE ABOUT WAR CHILD

Figure 1 http://www.warchild.org.uk

http://www.egopop.net

http://www.wilsendavil.com

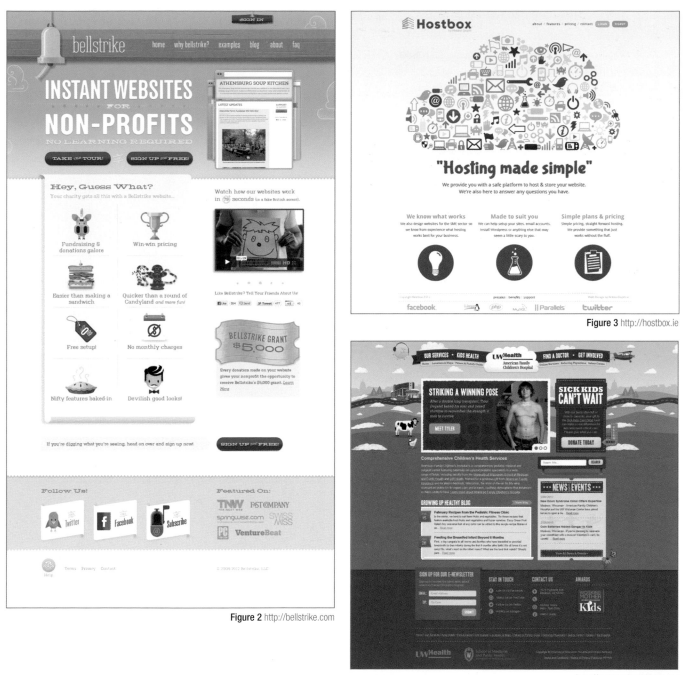

Figure 2 http://bellstrike.com

Figure 3 http://hostbox.ie

http://www.uwhealthkids.org

http://www.stopthevom.com

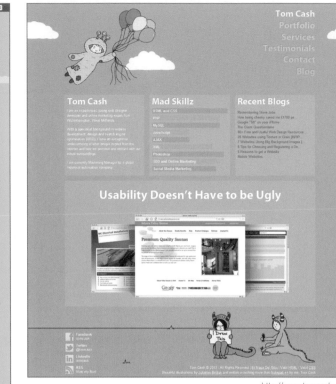

http://www.tomcash.co.uk

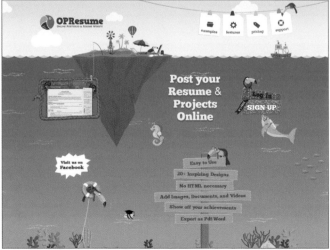

http://www.opresume.com

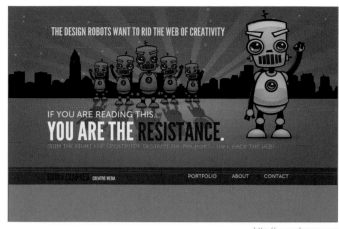

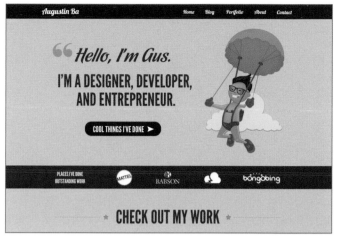

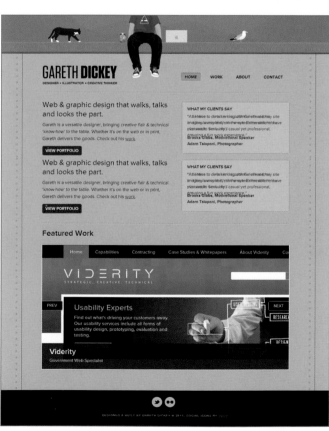

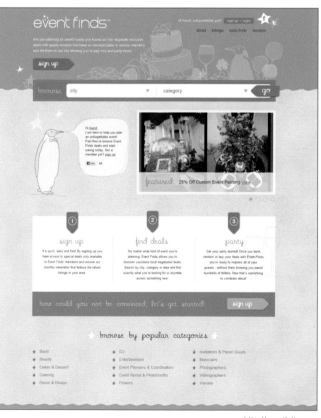

TYPE-CENTRIC DESIGNS

Given the explosion of options for online type, it should come as no surprise that many a designer has opted to create type-centric designs. Presented here is a collection of gorgeous design work that features type as the central focus. Clearly, all of these sites have some supporting elements beyond the text, but for the most part, the style of the site is predominantly contained in the type styles.

The personal site of Chris Davis **(figure 1)** is a great example of this. Though the site has some supporting design elements, the majority of the layout is fo-cused on the text. It will not come as a surprise to find that the site makes heavy use of @font-face (see page 36 for more on @font-face) to embed custom fonts into the page. After all, a site focused on its elegant type is likely to use distinct fonts as a technique for establishing a unique look and feel.

An *even* more type-centric example can be found at Viljamis.com **(figure 2)**. This design features next to nothing but text. It's amazing just how unique the design is considering it is almost entirely type based. And, of course, all of the text in the page (sans the logo) is live, editable text rendered using embedded typefaces.

One huge perk to type-centric design, especially when it is all live text (as in not rendered using images), is that it can be adapted very easily to a wide variety of layouts. Remember, responsive design (see page 071) seeks to format a page for a given device. Text-based layouts are particularly flexible and can be a great place to start when venturing into this territory.

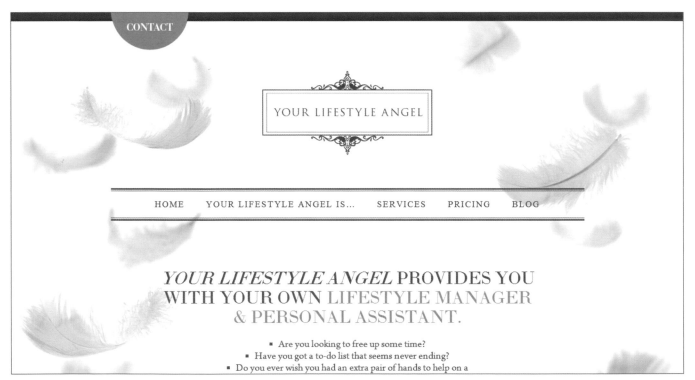

http://www.yourlifestyleangel.com

My name is Chris, I create *responsive* websites.

My name is Chris Davis, I'm a user interface designer from Shrewsbury, Shropshire, UK. I have been working as a designer for the past four years after graduating from Manchester University in 2007. I specialise in web design, front end development and brand identity. Having worked for a local design agency for the last two years I have continued my creativity by working with clients and agencies all over the world. I always strive to make pixel perfect Photoshop and illustrator designs, turning it into beautiful and responsive HTML & CSS.

Portfolio

About me

Contact

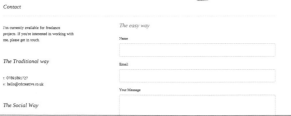

Figure 1 http://mynameischris.co.uk

RESPONSIVE DESIGN.

I BELIEVE THAT ALL CONTENT ON THE WEB SHOULD BE ACCESSIBLE TO ANYONE USING ANY KIND OF DEVICE TO ACCESS THE INTERNET. READ MORE →

WHO AM I

I'm a UI/Web Designer and Developer from Finland who works with the wonderful people at Kisko Labs. I've been designing web sites for over a decade.

View about

LATEST FROM BLOG

CSS is quite flexible language on its own, but as websites become more and more complex we sometimes need to have more control over the layout.

View blog

CONTACT ME

If you want a quick reply, send me a tweet on Twitter. If you need more than one hundred and forty characters you can always send an email.

Send email

Figure 2 http://viljamis.com

http://www.thisistwhite.com

http://www.papyrs.com

http://red-root.com/cv

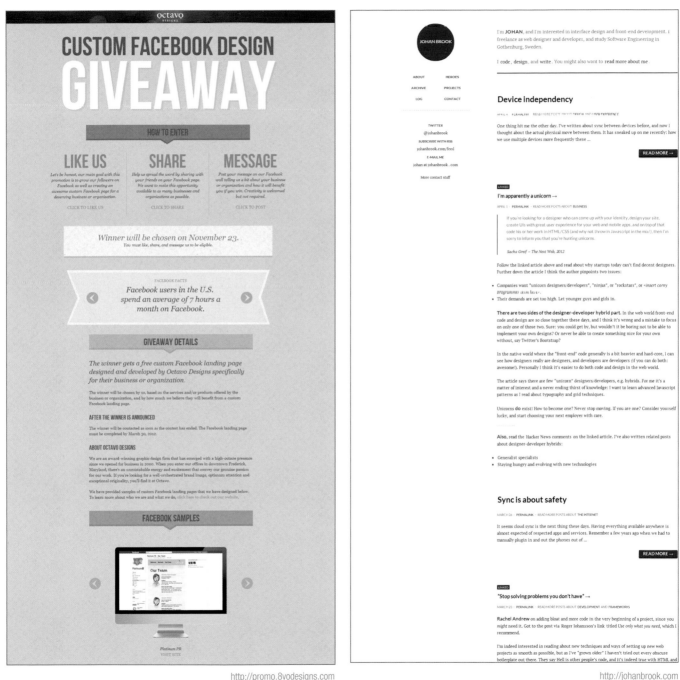

APPROACHING MOBILE

OUR GUIDE TO MOBILE MARKETING

Brought to you by:

BLUEION

http://www.blueion.com/gomobile

THE WAYWARD IRREGULAR

ESSAYS & STORYTELLING

Glutton King of the Ten Circus Buffet

April 16th, 2012

I've been having aberrant fantasies about a neon striped seafood buffet somewhere in the middle of the desert. I'm doing my best to arrange a vacation getaway to Las Vegas, the land of vice and degenerate corruption, dancing people in Asian-themed face paints and all manner of glimmer and noise. For me, the crux to any of the big Vegas resorts is the buffet, and just how vast and …

Keep Reading

The Author Narrates! Click to Listen!

Glutton King of the Ten Circus Buffet

Download: MP3 Audio

RECENTLY *on the* IRREGULAR

Clearly You Would Sleep Through a Tornado, and I Might Let it Take You
April 2, 2012

Into the Mountain Zoo for Death by a Thousand Dog Kisses
March 26, 2012

The First Sticking Point is the Word "Dinner" as a Singular Event
March 19, 2012

Vague Streams of Thought in General Regard to a Midwestern Something
March 5, 2012

Allen Masterson and the Beautiful Music He Prays You'll Never Hear
February 20, 2012

Long Drives, Failed Stratagem, and the Time I Peed All Over My Car
February 13, 2012

Want More? To the Archives!

FROM *the* TWITTERS

your host!

the book!

listen via iTunes!

Today on the Irregular: More talk of buffets, this time under powerful hallucinogens. Also: Vegas, Tylenol, and horses. waywardirregular.com »

No new Irregular tomorrow, someone has to feed marshmallows to all these turtles, might as well be me. The twisted foolery returns on 4/16. »

Today on the Irregular: Exciting adventures in carpet and seated office work. Also: Milkshakes, mold, and sweatpants. waywardirregular.com »

Today on the Irregular: I acquire a dog. Apparently you have to feed them? Also: Flapjacks, Iguanas, and feral puppies. waywardirregular.com »

Today on the Irregular: The sixteen year old version of me is disgusted. Also: Tacos, sodium, and johnny cakes. waywardirregular.com »

New Irregular design is live! Yes, I've designed it again. Yes again… DON'T YOU JUDGE ME. Sorry… I need to call my sponsor, @fiercerobot »

REVIEWS *and* SUBTLETIES *(or, occasionally)* LAVISH *and* OVERT PRAISE

http://www.waywardirregular.com

The Design Office

Place - Projects - People

A place for independent designers in downtown Providence

What's new

Headlines

1. Modern Pictograms available on Shifticons
 Download just the icons that you need
2. Heirloom Seed Kit Featured on The Dieline
3. Blog post: "Can One Size Fit All?" From John for The Noun Project

☰ Archive

On the shelves

◄ □□□ ►

Stay connected
- Twitter
- Facebook
- Mailing List
- RSS feed
- Office hours
- Visit

From twitter @MamaKimsKbbq even though it's rainy, we're still hungry downtown. 2012/05/10

What we offer The Design Office was founded in 2007 to answer the creative needs of independent designers by providing office space, shared equipment, community and resources. In addition to providing the essentials, we initiate and support collaborative projects and proposals. Visit, join, collaborate.

http://thedesignoffice.org

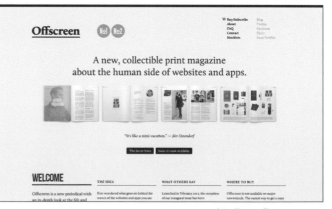

Offscreen № 1 № 2

Buy/Subscribe About FAQ Contact Stockists

Blog Twitter Facebook Flickr Heart-Set-Run

A new, collectible print magazine about the human side of websites and apps.

"It's like a mini-vacation." — Jim Ostendorf

The latest issue Issue №2 now available

WELCOME

| THE IDEA | WHAT OTHERS SAY | WHERE TO BUY |

Offscreen is a new periodical with an in-depth look at the life and …

Ever wondered what goes on behind the scenes of the websites and apps you use

Launched in February 2012, the reception of our inaugural issue has been

Offscreen is not available on major newsstands. The easiest way to get a copy

http://www.offscreenmag.com

SKETCHY

One design style that seems to return over and over again is the use of sketchy elements. Granted, it reinvents itself to fit the modern landscape. Sketchy elements are designs based largely on what appear to be hand-drawn elements. The degree of uses range from minimal to extreme, but the results are quite often fantastic.

Two key factors make this style desirable. First, sketchy elements tend to have an organic, or nontechnical, feel to them. As such, they provide a great way to express a disconnection from the digital connotations of the web. For a good example, see the portfolio site of Adrian Baxter **(figure 1)**. Though Adrian does out-standing web work, his portfolio site takes you to a very different place. The tangible, artistic beauty of the site focuses on the less technical. He sells himself as a web developer in an uncommon way.

Sketchy elements also can be extremely unique. Sometimes it seems that half the world is building sites using the same fonts, icons and stock photos. If you want to stand out from the crowd, sketchy elements can help establish a completely new style. Adrian's site is again a great example of this. Consider also the Van Nieuwe Waarde site **(figure 2)**. Here the sketchy style is used in a more subtle, less promi-nent way. But the results are very similar.

The site feels current. It fits into the style and expectations of modern work. Yet, there is something different about it. In my opinion, the number-one factor in making this gem of a site stand out is the subtle use of sketchy elements. Ironically much of it is based on a font in this style.

Another example I instantly fell in love with is the My Pizza Oven site **(figure 3)**. Here the sketchy elements dominate the page but never feel over the top or obnox-ious. Instead, they set the tone and style of the site and provide for a relaxed and comfortable atmosphere, which seem like rather significant accomplishments for such a simple technique.

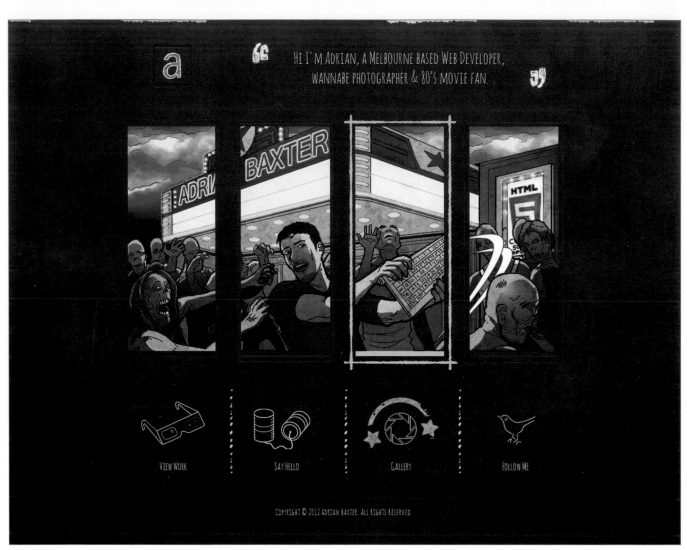

Figure 1 http://www.apbaxter.com

Figure 2 http://vannieuwewaarde.nl/voor-wie

http://www.geckoboard.com/

http://couchkumaras.com

Figure 3 http://mypizzaoven.nl

http://www.moredays.com

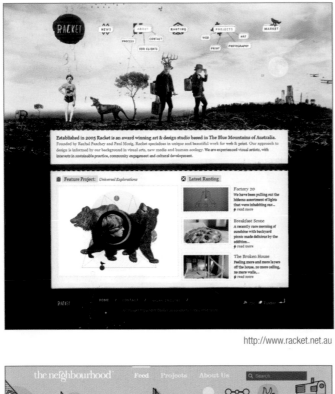

http://www.racket.net.au

http://2009.legworkstudio.com

http://www.the-neighbourhood.com

NINETEENTH CENTURY

Every now and then a common theme emerges that becomes popular for unknown reasons. Recently there have been quite a few sites popping up that incorporate text and illustration styles that resonate with nineteenth-century artwork. A clear demonstration of this is The Mischief Co.'s design **(figure 1)**. The three illustrations on the home page clearly exude a nineteenth-century style. This is, of course, supported by an overall style that merges well with this theme.

One thing you will notice is that many of the sites that use this style tend to rely on a black-and-white or a gray-scale color pallet. I imagine this is to connect with the stereotypical black-and-white letterpress work you might expect from this period. I love that this bare-bones color set allows the designer to inject an accent color that really pops. Check out The Mischief Co.'s design and then take a look at the Kilian Muster design **(figure 2)**, which demonstrates the style in a slightly less aggressive way.

While most of the sites in this style rely on illustrations, some of them focus more on the style of the type. A nice example of this can be found on mo.markheggan.co.uk. **(figure 3)**. Here the reference is far less obvious, yet the type styles connect with the featured period. I appreciate this particular sample because it proves you don't have to fall back to a plain black-and-white design in order for this approach work. The richly colored background brightens the page and gives it a pleasant punch.

Figure 1 http://themischiefco.com

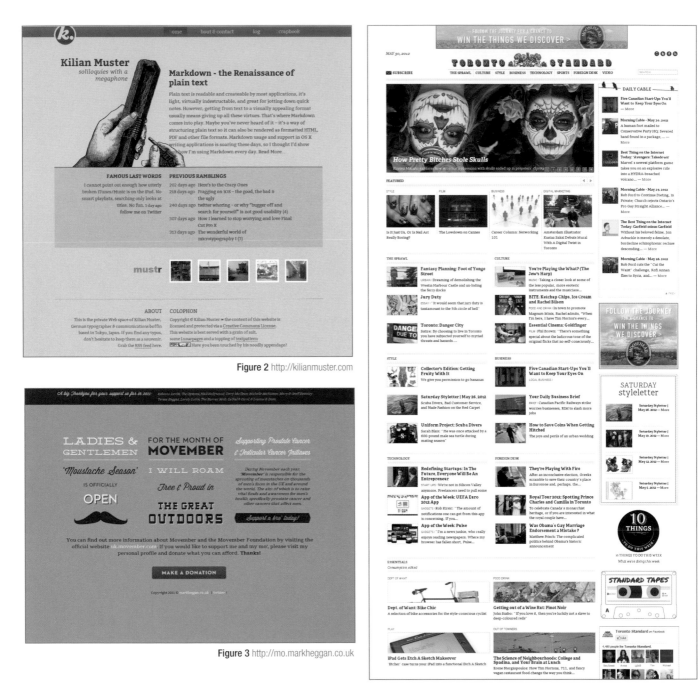

Figure 2 http://kilianmuster.com

Figure 3 http://mo.markheggan.co.uk

http://www.torontostandard.com

http://chimpchomp.us

http://nudgedesign.ca

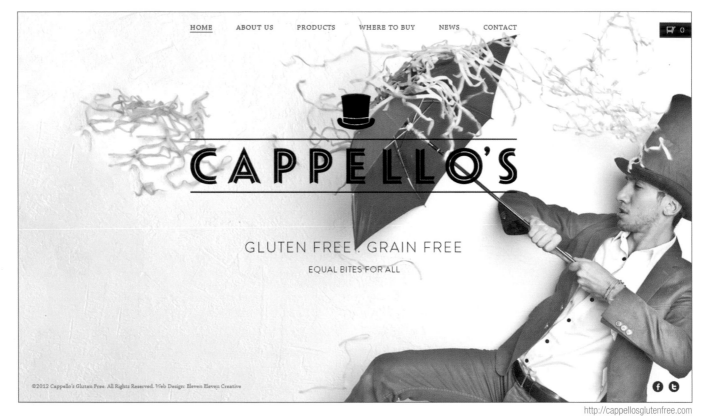

http://cappellosglutenfree.com

http://www.henry-realestate.com

http://www.lapiuma.com

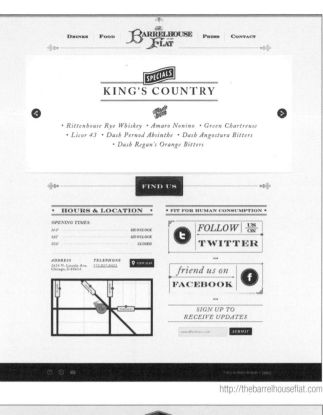

http://thebarrelhouseflat.com

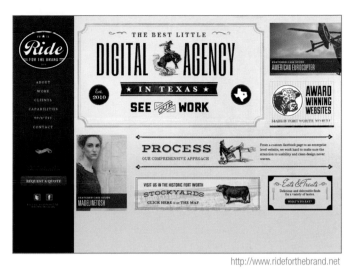

http://www.rideforthebrand.net

http://shoshorov.net

As I catalog sites for my books, one set of sites always stand out as favorites, though they defy categorization. While some of them could fit into categories, many of them are incredibly elusive. So I invented a label for them: I call them "superclean." These sites, though rich with content, are incredibly easy on the eyes, what I call "clean." These are the sites I really wish I had designed.

Thewp.co **(figure 1)** is a great place to start. The design is not quite minimal, is kind of type-centric and has some illustrations. It could fit into another category, but somehow it feels richer and yet so easy on the eyes. The primary purpose of the site is easy to grasp and the call-to-action items are easily found, yet not too in-your-face. In my humble opinion the site is perfectly balanced and absolutely delicious.

In this edition of the superclean topic, I ventured into some slightly different territory. A great demonstration of this is Jason Weavers site **(figure 2)**. This site is a clear step outside of my typical superclean collection, and yet it still fits in so nicely. I realized there was a certain overall style I tended to place in this section, and I wanted to demonstrate some diversity. As a result I think you will find this site fits the bill, yet challenges the norm in this collection.

Just to reinforce a point I have already made, I want to focus on the Commentary Box design **(figure 3)**. This superclean site is packed with content. I really wanted to point out that superclean doesn't mean the site has to be void of meat. On the contrary, Commentary Box's content-rich site maintains a style that is clearly representative of this category.

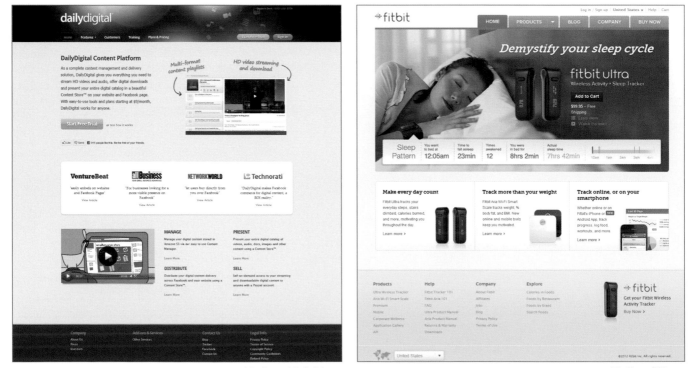

http://www.dailydigital.com

http://www.fitbit.com

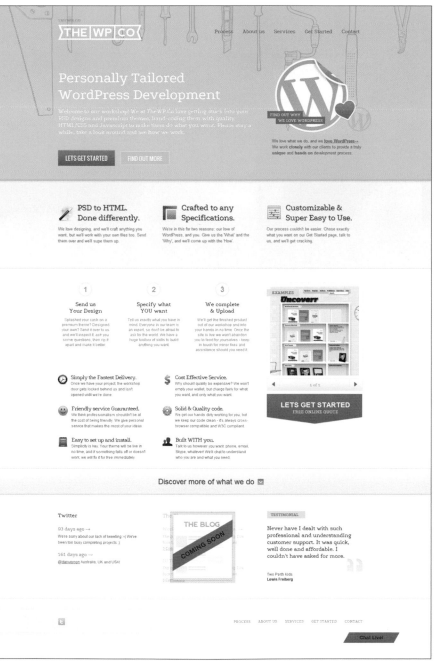

Figure 1 http://thewp.co

http://www.iavra.com

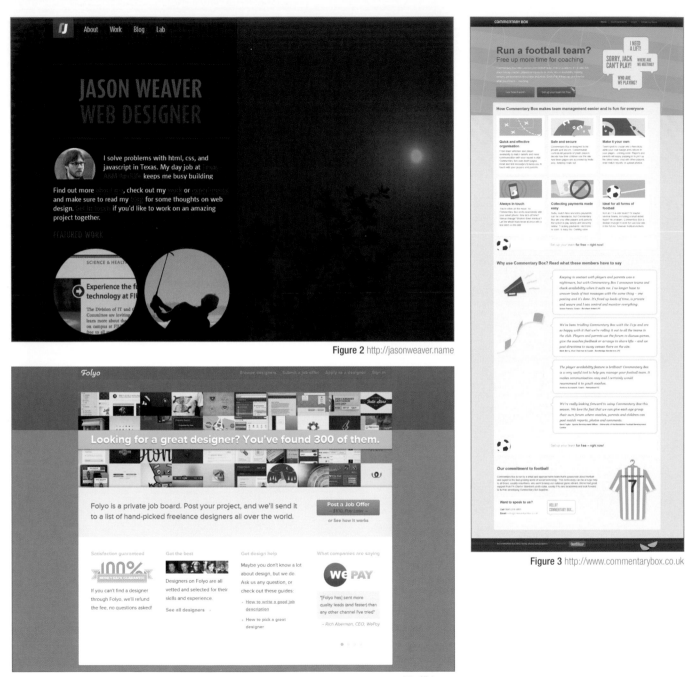

Figure 2 http://jasonweaver.name

Figure 3 http://www.commentarybox.co.uk

http://folyo.me

WEB DESIGN IS ART

2pxBorder

We craft user-centric solutions for the web. We specialize in web design and development. We work with grids, typography, colors and thousand lines of code everyday. See why people love us.

Our Websites Work on Various Devices

We use the latest web technologies and industrial standards so our websites not only look good and work well on desktop computers, but also on modern smartphones and tablet devices.

Simplicity is the Ultimate Sophistication

Some people think web design is about fancy Photoshop effects, shiny buttons and drop shadows on every element. We disagree. We believe that web design is about using the least amount of elements to achieve the ultimate sophistication - where less is more.

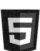

HTML5

HTML5 (HyperText Markup Language version 5) is the latest industrial standard for coding web documents. The new standards allow rich media experience and seamless support for both desktop and mobile computing devices.

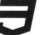

CSS3

CSS3 (Cascading Style Sheets version 3) is the state of the art language in web presentation, supporting custom fonts and complex designs. Web pages not only look good, but can also dynamically adapt to different screen sizes.

©2012 2pxBorder · Email us at heart@2pxborder.co.nz or follow us on Twitter

this is the online showcase of art director/designer Mo Kader

latest blog articles

flickr updates

twitter updates

http://2pxborder.co.nz

http://mokader.com

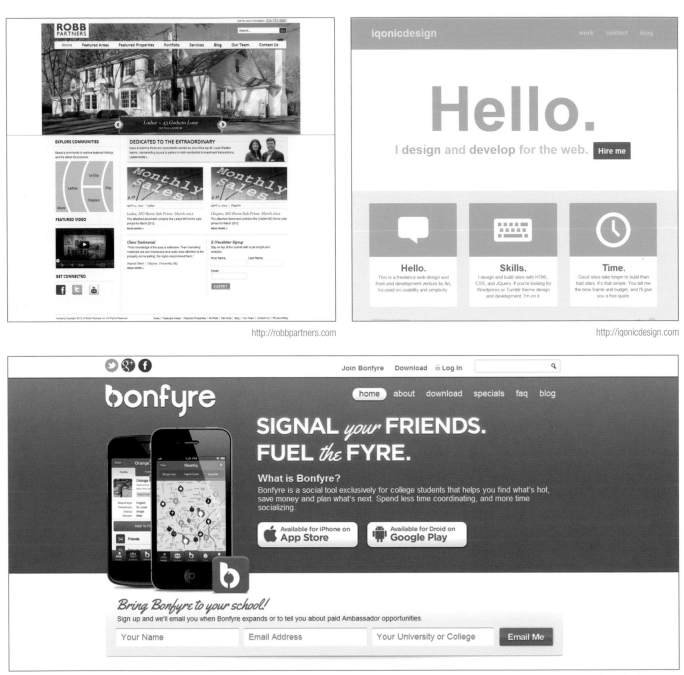

http://robbpartners.com

http://iqonicdesign.com

http://www.bonfyreapp.com

LETTERPRESS

In a way, it is rather ironic to have a design trend in the web industry based on the letterpress, and yet, the trend is running rampant. Obviously we're not cranking sites out on actual letterpresses; that would be silly. Rather this trend incorporates aspects of the letterpress look and feel. Here I want to present a collection of sites that make use of various styles (most frequently CSS3 drop shadows) to create letterpress-like effects. Most frequently this comes in the form of what appears to be inset text, through the use of a drop shadow inside the text. This extra bit gives the text the impression of being pressed into the page.

Throughout his site, Alex Buga **(figure 1)** prominently demonstrates this effect. The text and icons all have inset shadows that make them appear to be pressed into the page. This is further accented with color choices that complement the background in such a way that they look as though they were a part of it. Background and foreground elements blend together in a unified way. In this case, the letterpress effect is further accentuated by the use of cards. The white cards in the page contain text and take on a 3-D effect thanks to a drop shadow that surrounds them. The combination of techniques makes it feel even more like something printed.

As I survey the set of samples provided here I notice an interesting pattern. Many of the sites in this style have two common elements in addition to the use of inset text that play into what I consider a letterpress style or feel. First, many of them are generally based on text. You see lots of supporting textures and patterns, but most of the sites primarily use text in prominent and decorative ways. Second, many of them have a central symmetry. Certainly they are not perfect, but a preference for such an approach is evident. Again, to me this echoes a letterpress-oriented mentality. No, not all letterpress is center aligned, but something about it resonates with what you might find in a letterpress poster. If you do a quick Google image search for "letterpress poster" you will see hundreds of examples of just such an approach.

One example I want to point out is a bit of an outlier in this category. It's called Monkey Republic **(figure 2)**. In my opinion this site has a letterpress feel, but it goes about it in a totally different way. The approach used is not new—in fact, I discussed it in Volume 1; it simply emulates a real-life newspaper, and by doing so, it creates a style that also connects back to the letterpress.

Perhaps the biggest irony with this style is that in real-life letterpress work, the mission or goal is to *not* have revealing impressions. Considering that most work is printed on both sides of the page, those operating letterpresses worked really hard to avoid such impressions (which would create a total mess). On the web, however, the designer may not intend to make a letterpress reference but that is ultimately what ends up happening.

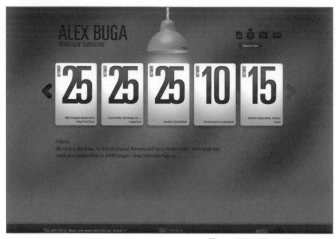

Figure 1 http://www.alexbuga.com

http://dimitropoulos.info

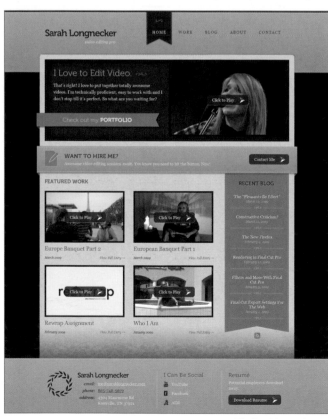

http://sarahlongnecker.com

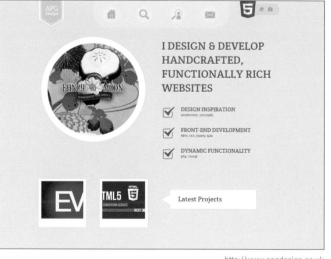

http://www.apgdesign.co.uk

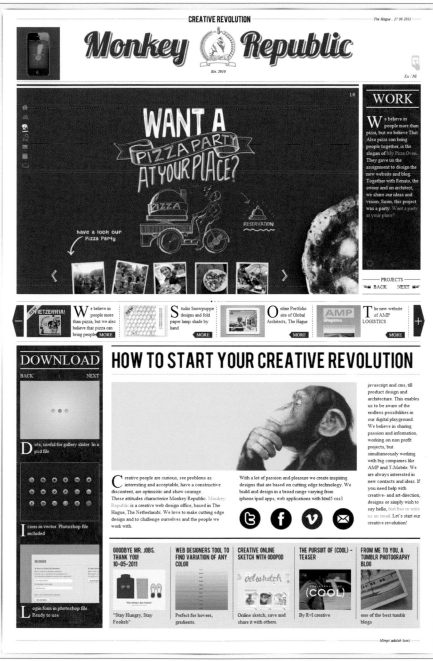

http://www.justinfinleydesign.com

Figure 2 http://ilovemonkey.nl/EN

http://www.rdcreativedesign.eu

http://67pixels.com

http://www.raymacari.com

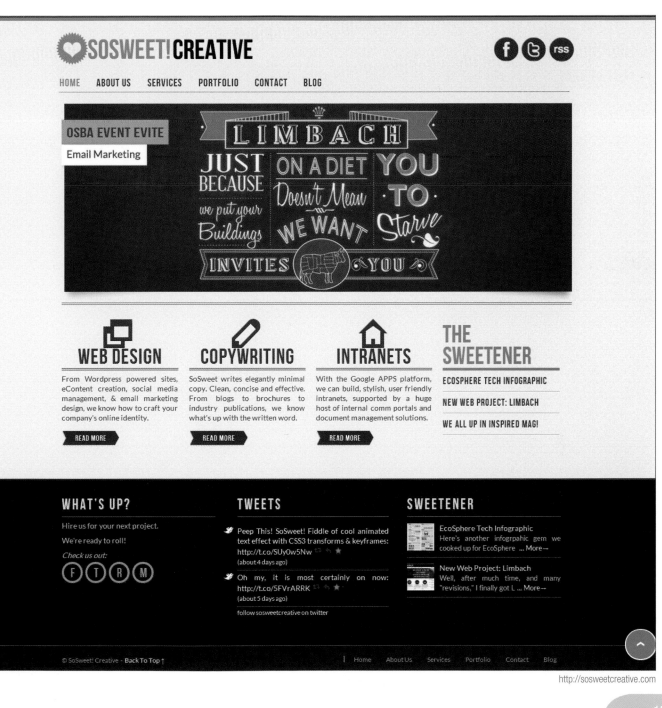

03 / Design Elements

While design styles focuses on overall styles of pages, this section on design elements focuses on individual design nuances. Some of these are trendy items that will come and go, while others are staples of design that will likely never fade from use. As you browse the collections here for fresh ideas, I encourage you to study this section and consider how these ideas can be adapted to fit your needs. Be careful, however, never to just copy elements without carefully considering how they might impact your overall product. While ribbons are an extremely popular design element, it doesn't mean you have to be yet another photocopy. Instead, consider each element, its hidden meanings and how it might connect with the design you're working on in a meaningful way.

TEXTURE

Texture is a design element that I frequently discuss, and it appears in each volume of this book series. And as I have previously mentioned, though it is an element that never goes away, the ways designers use it change over time. For this particular design element the trend seems to be toward dulling the effect to a more supportive role. This is quite different from the in-your-face textures popular in years past. In general, a shift toward more subdued effects is widespread, occurring in most styles and patterns.

A fine demonstration of this is Mark Heggan's personal site **(figure 1)**. Though textured elements appear throughout the design, texture is never the focus of the design. It helps set the tone of the site and is one of the most powerful elements in determining the overall look and feel of the site, but it does not dominate the design. You don't look at this site and say, "Wow, look at all that texture." But as you dissect the design, you'll notice the texture has been used to unify the entire layout.

In order to reinforce this perspective, compare Mark's site to the Final Elements site **(figure 2)**. Here the texture, used as a backdrop for the entire site, is extremely bold. It implies a raw, rebellious sort of style—clearly a very different purpose. Yet the result is intentional and a powerful way to help position the brand.

Last of all, I want to consider the 121cc.com site **(figure 3)** more closely. Here we see another popular approach to texture,

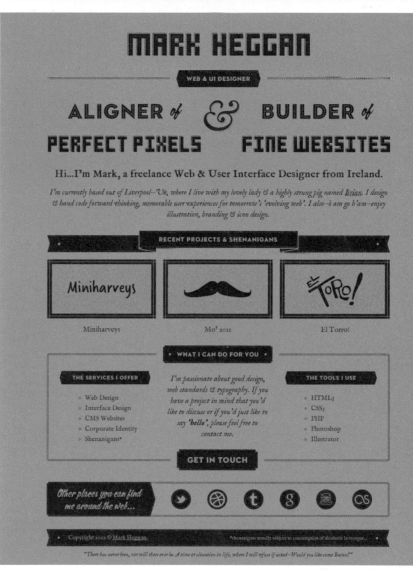

Figure 1 http://markheggan.co.uk

and that is using a large variety of them. I counted about ten distinct textures at work. That's a lot of texture! Given that none of the textures are all that bold, they serve as a common backdrop for the various elements in the page. And it works.

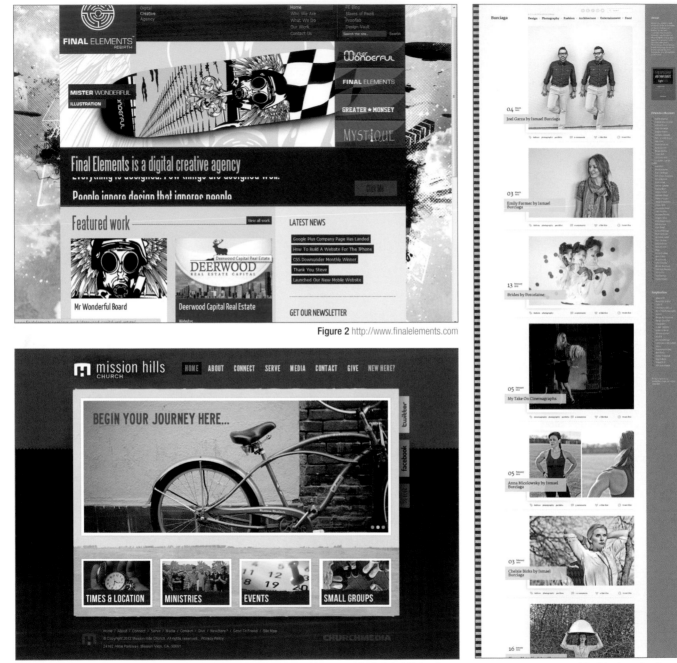

Figure 2 http://www.finalelements.com

http://missionhillschurch.com

http://blog.ismaelburciaga.com

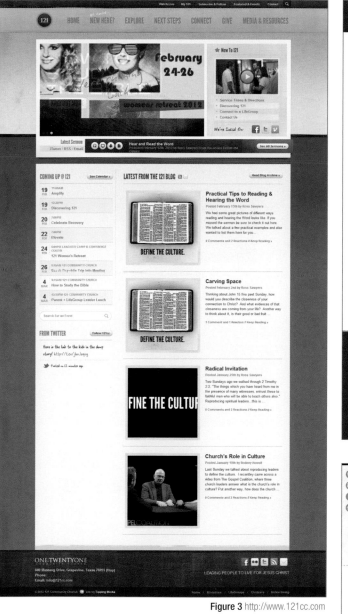

Figure 3 http://www.121cc.com

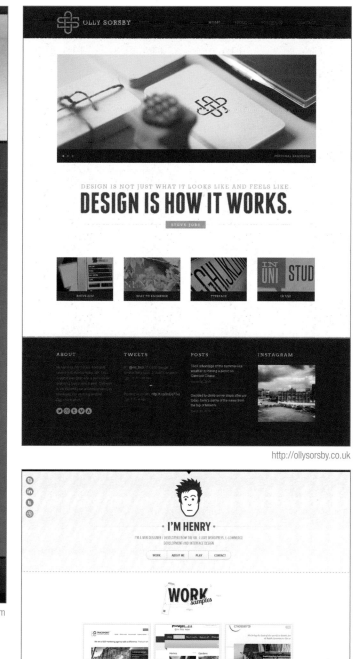

http://ollysorsby.co.uk

http://www.henry.brown.name

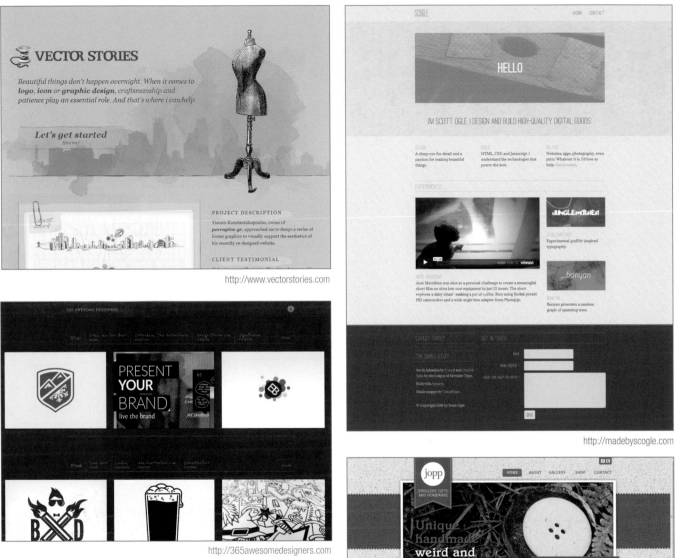

http://www.vectorstories.com

http://madebyscogle.com

http://365awesomedesigners.com

http://www.joppdesign.com

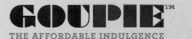
THE AFFORDABLE INDULGENCE

Home Goupie Shop Events Stockists Trade Contact

Cart: 0 items £0.00 | Checkout

A devilishly moreish **chewy chocolate** confection with a hint of **crunch**

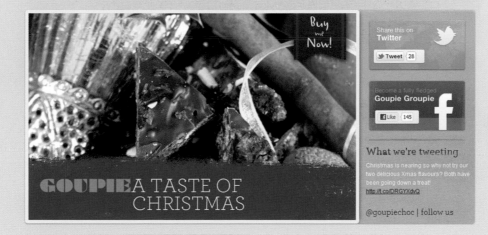

Buy me Now!

GOUPIE A TASTE OF CHRISTMAS

Share this on **Twitter**

Tweet 28

Become a fully fledged **Goupie Groupie**

Like 145

What we're tweeting

Christmas is nearing so why not try our two delicious Xmas flavours? Both have been going down a treat!
http://t.co/DRGYXdvQ

@goupiechoc | follow us

Explore Goupie

View all flavours

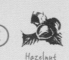 Hazelnut

 Orange

 Chilli

 Dark Lavender

White Lavender

A Bit About Us

Goupie is a devilishly moreish chewy chocolate confection, hand-produced by a small, dedicated team, led by Janet and Joe Simpson, in Goudhurst, Kent.

Using a genuine family recipe, Goupie is made fresh every week to order and then hand-cut into distinctive triangular pieces.

Goupie is made from high quality natural ingredients, topped with fine dark Belgian chocolate containing a minimum of 50% cocoa solids.

Read More

Latest News

MAR 16 Goupie is going to be at the Brighton chocolate Festival this weekend (17th & 18th March). Come and see us near the Pavilion Gardens between 10a... Read more

MAR 13 Please note that the Goupie phone number 01580 211440 is not working today Tuesday 13th March 2012. BT has been informed but "it's not our fault!" ... Read more

Where to Buy

Our Online Store

One of our Stockists

Own a shop and want to start selling Goupie? Click here to find out more

Home Goupie Shop Events Stockists Trade Contact

© Simpsons of Hawkhurst | Website by Ether Creative

As someone who obsesses over trends and patterns, I am always trying to figure out where exactly the trends and patterns originate from. Sometimes it's impossible to identify just where a trend began. That is the case with ribbons. At some point in the last year this element was leveraged in massive quantities. The samples collected here are a tiny subset of the many sites that are putting ribbons to work.

I have many theories on why ribbons are such a popular element, but all my theories come back to one point: Ribbons look nice. It may sound trite, but it's still true. All of the sites presented here get a touch of style from using ribbons. The ribbon is somewhat universal, so it is easy to understand why it is so popular. It allows designers to highlight something important in a nice supportive way. It's not inherently thematic, so it fits into nearly any layout. As a result, they are used all over.

As styles come and go, I suspect ribbons will be a passing trend. And as with all trends, it will find its suitable place in the designer's toolbox. Eventually it will feel dated and designers will only use it when it truly resonates with the topic at hand. This is the life of all trends.

In many ways, the ribbon is nothing more than the modern badge (check out badges in *The Web Designer's Idea Book, Volume 1*). See Andy Widodo's personal site as an example **(figure 1)**. Here the ribbon is brightly colored and overlaps multiple elements, thereby gaining the focus of the user. What could be more important than a call to action to hire the individual? That's the purpose of a portfolio site, so using a flashy ribbon element to highlight the conversion point makes perfect sense.

Hello, I'm Andy!

A web/user interface designer and front-end developer. I create accessible and web-standards complied websites. Always in love with well structured markup and clean code.

Bio

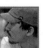

Andy Widodo
Web/UI Designer & Front-end Developer

Have more than 7 years of experience in web design and development with various clients both domestic and abroad. Always take serious attention to web standards, accessibility, usability and ease of use in every aspect of the projects output.

Also, see or download *(in .pdf)* my resume, and if you have any questions or inquiries on my

Strength

Clear and concise user interface design and front-end engineering with main focus on usability, accessibility and standards compliant output.

Advanced in (X)HTML & CSS (including the latest HTML5 & CSS3 technologies), JavaScript (with jQuery as main framework) and front-end development in general, including for handheld and mobile devices.

Other tools & familiarities: HAML, SASS, YUI Library, PHP, MySQL, Django, Ruby on Rails, Wordpress, Microformats, Git, Svn.

What People Said

"Andy is an exceptional front end developer who lives and breathes all things digital. He is easy to work with and professional throughout his approach. He possesses a wide skill set and I would not hesitate to recommend him. Looking forward to working with him again!"

- Dominic Sawyer, *Dot Tourism & Daytripfinder*

Figure 1 http://andywidodo.com

http://www.milkandgroceries.com

http://christopher-scott.com

http://subtlepatterns.com

http://www.lesleemitchell.com/blog

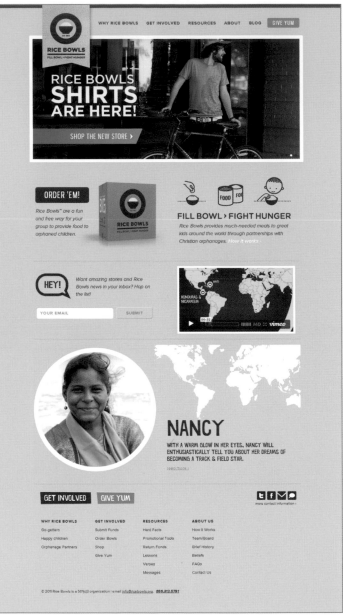

http://ricebowls.org

http://truettbrooklynburciaga.com

http://pongathon.com

http://www.eleventhedition.com

http://www.andypatrickdesign.com

http://lisher.net

http://anthmapp.com

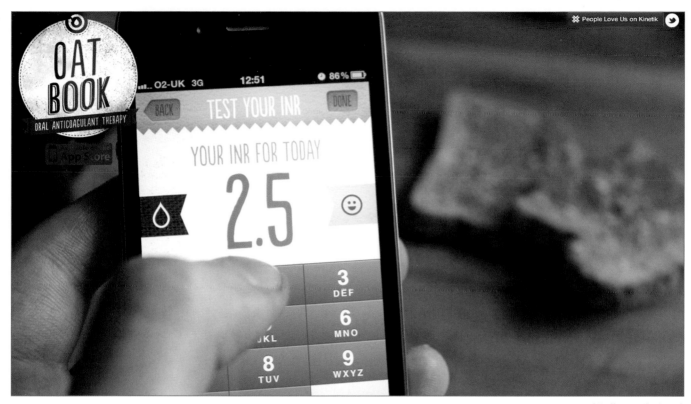

http://www.oatbook.co.uk

http://www.dannypostma.com

THREE-DIMENSIONAL

The web is an inherently flat medium, and short of some insane technology, it will remain that way for the foreseeable future. What makes this little collection of sites unique is that they all make use of visual tricks to give the illusion of depth and create a 3-D feel. None of the samples are over-the-top 3-D worlds, mind you. These are fairly typical sites that add a dimensional effect to give their pages some visual appeal.

Start by looking at the Love Leadership book site **(figure 1)**. The most noticeable element here is the large three-dimensional book. It might seem the obvious choice: to show a book in such a way. However, I think there is more to the story. Not only has the designer rendered a literal view of a book in a way that gives it volume, but he or she has also drawn the viewers' eyes to the main focus of the page. If nothing else, you see the cover of the book and that it stands out from the rest of the content. In this way, the image takes first place in the hierarchy of things viewed and effectively ingrains itself upon your memory. We find a similar effect on both the Pro Foods **(figure 2)** and the Coalma **(figure 3)** sites. In all of these cases, ensuring that the actual product garners attention is perhaps the greatest goal. The three-dimensional trick is the perfect tool to lay the focus on the featured products.

The 3-D effect is used to solve other problems as well. Consider the Beckin site **(figure 4)**. Here the photograph is part of the overall page, not just placed in the page. It is not framed in its own background and situated in a box. Instead the image is clipped out to the contents and shadows are added. It looks like a 3-D object on the page. The product is freed of drab containers. It has a much more interesting feel, and also unifies the rest of the page.

http://rtl.co.

Figure 1 http://www.loveleadershipbook.com

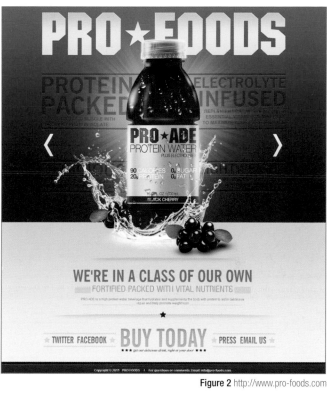

Figure 2 http://www.pro-foods.com

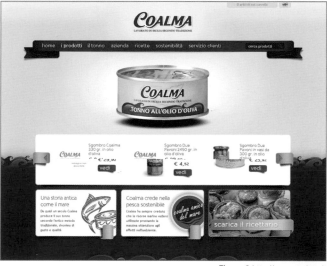

Figure 3 http://www.coalma.it

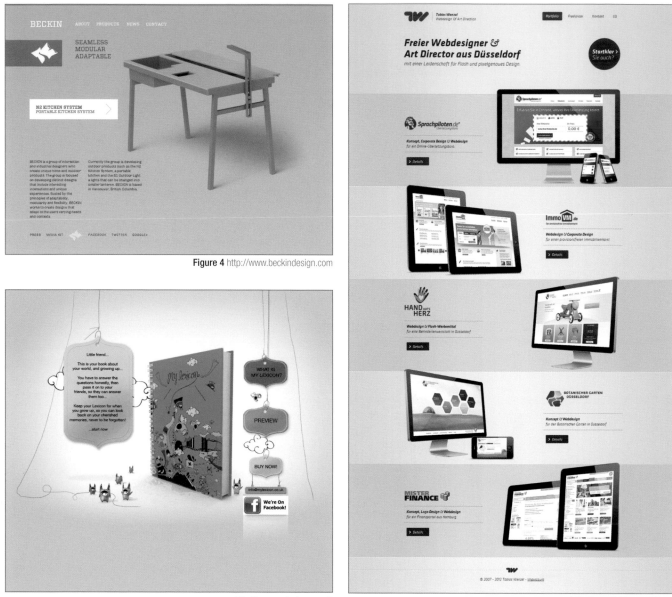

Figure 4 http://www.beckindesign.com

http://www.mylexicon.co.uk

http://www.tobiaswenzel.com

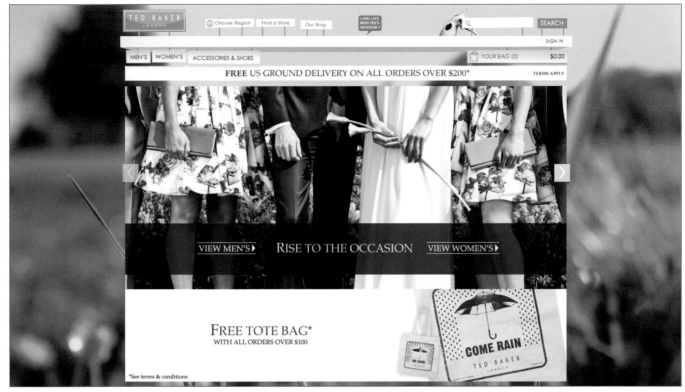

http://www.tedbaker-london.com

http://www.thefontain.com

http://atanaiplus.cz

EDGE TREATMENTS

Edge treatments are another type of design element that has become a current trend. The predominant style of choice is the zigzag edge. This is one of those things that feels sort of silly to call out, and yet it is showing up in so many places, it's hard to ignore. In fact, I could have placed one hundred sites in this chapter without too much effort. When I see a trend I report on it, so let's study this small detail and how designers are putting it to work.

As hard as I try to understand the meaning of any design element, this one seems nearly impossible. At its core this simple element is nothing more than decoration. And in this role it operates effectively. In pretty much every sample presented here, the edge treatment could be omitted and a straight line used instead. The designs wouldn't fall apart or fail. Instead the jagged edge dresses it up and gives it an extra touch of style.

The Atommica site is one of my favorites in this category **(figure 1)**. The jagged edge that runs at an angle across the page serves as a great break between the contrasting colors of the page. Yes, the design would do just fine without it, and yet it adds a gorgeous touch to the page.

As always, don't abuse the element but keep it in mind. It might give your design that extra punch it needs.

Figure 1 http://www.atommica.com

http://kennysaunders.com

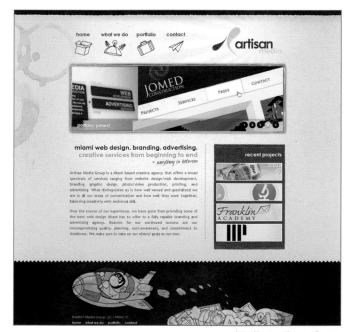

http://www.artisanmedia.com

http://www.goodiesforgifts.com

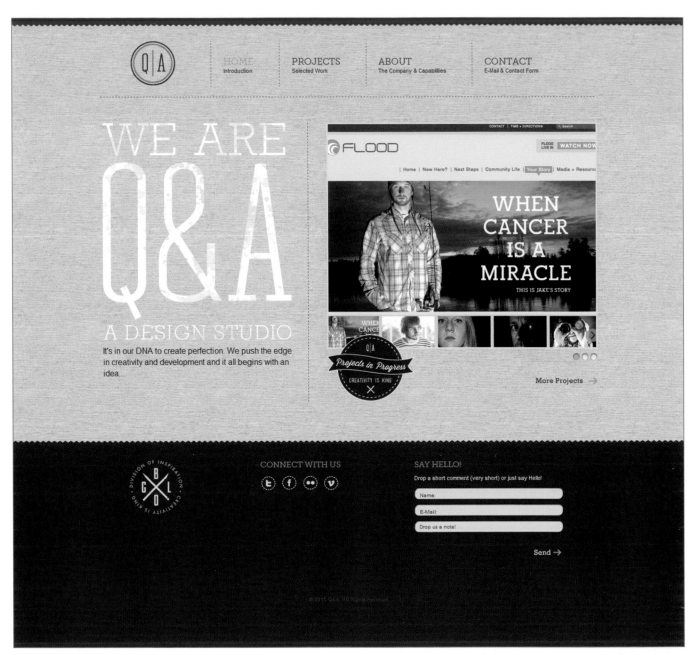

http://qnacreatives.com

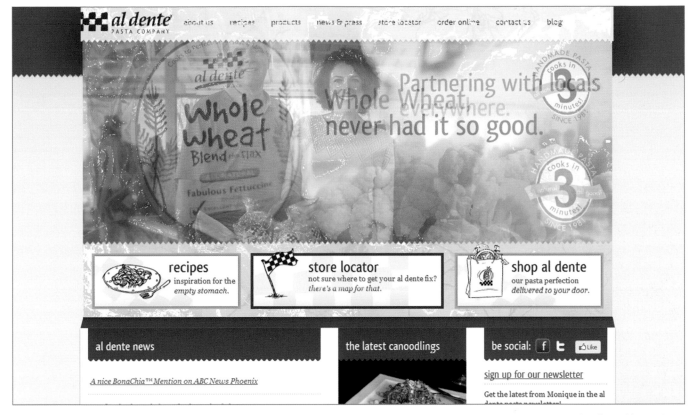

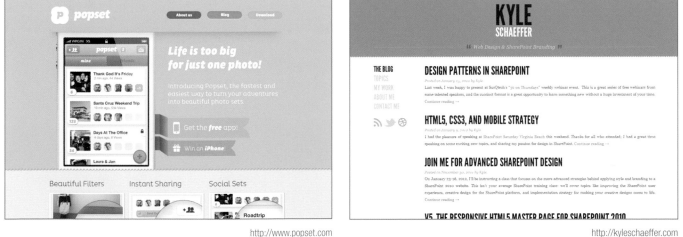

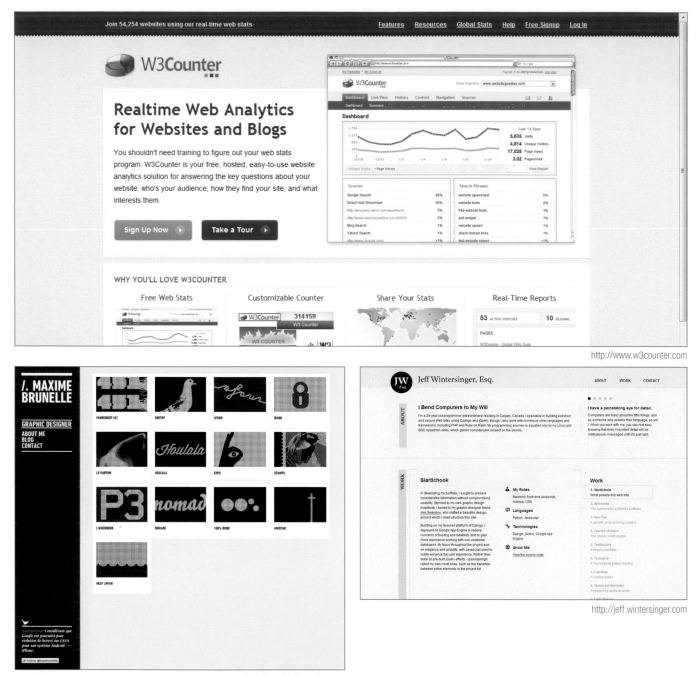

http://www.w3counter.com

http://maximebrunelle.com

http://jeff.wintersinger.com

PATTERNS

Clearly we can't claim that the use of patterns in design are anything even remotely new. Patterns have been used for thousands of years. All the same, there has been a surge in the use of patterns in web design in the last year or so. In particular there seems to be a strong interest in more subtle patterns (as epitomized in the free resource SubtlePatterns.com), but bold uses are still to be found.

It seems to me that patterns serve an important role. They can add style to a design while only adding tiny amounts of data. This means a small pattern has very little impact on the load time of a web page. Most patterns can be created by repeating a very tiny image. Patterns are also pleasant because they play a more supportive role. That is, they typically don't contain information, so they don't tend to distract.

A great example to start with is Laura Burciaga's site **(figure 1)**. Here the simple stripes and other patterns serve to stylize the page. And while they dress the page up, they don't steal the show from the featured content.

In other cases we certainly find more prominently styled patterns—such as in the Maryland Craft Beer Festival design **(figure 2)**. In this example, the bold yellow pattern offsets a content area that's based on matching colors. In this way the yellow background doesn't overtake the content. And again, the pattern doesn't compete for the primary focus of the page. In this case the pattern provides a distinct style, making it far more memorable.

http://www.eddiediazdesign.com

Figure 1 http://lauraburciaga.com

Figure 2 http://mdcraftbeerfestival.com

Search

Featured Cuckoo Clocks

Price range

£0 £7500

Search terms

Size

☐ Small
☐ Medium
☐ Large

Manufacturer

Hand carved Bird and leaves

Item no. 8010

£113.00

Traditional Hunter style

Item no. 959

£152.00

Simple line birdhouse

Item no. SL354

£286.00

http://www.justcuckoos.co.uk

Mixforms is a small multidisciplinary studio, offering a wide range of web and graphic design services — from research and strategy to GUI design and implementation, visual identity systems or printed materials.

Do you need help with your project?

LET'S GET IN TOUCH

Despre diacritice
Typography

Sibiu
Visual identity

Various GUIs
Web GUI design

Mobile browser icons
Icon design, graphic design

VIEW MORE

http://mixforms.com

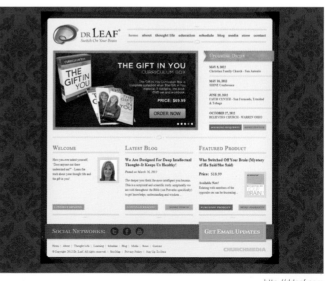

http://drleaf.com

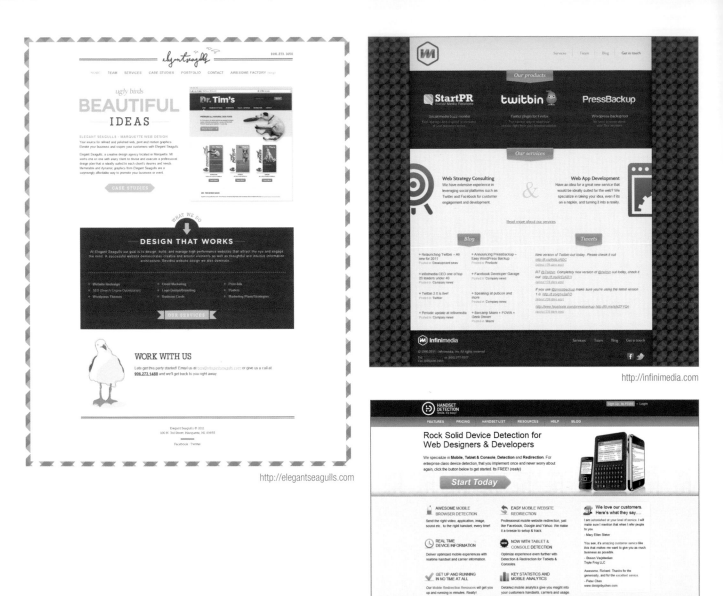

http://elegantseagulls.com

http://infinimedia.com

http://www.handsetdetection.com

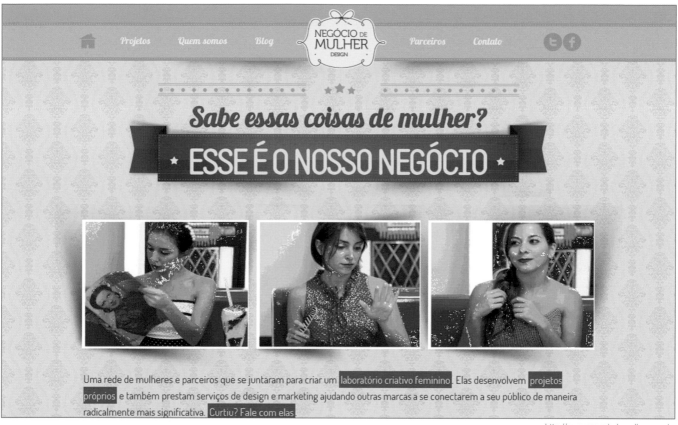

http://www.negociodemulher.com.br

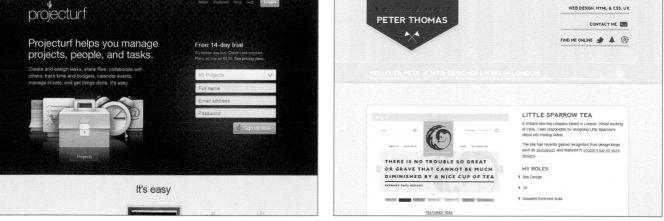

https://www.projecturf.com

http://madeforthe.net

Another trend that is extremely popular right now is the use of fabric in web design. Quite often this is a style accomplished through the use of repeating patterns, subtle textures and the illusion of stitching. Its origin is hard to discern. Certainly it is a visually appealing style, so it isn't hard to imagine why designers have latched onto it.

In my opinion one of the main draws for this style is that it disconnects the viewer from the technical underpinnings of the web. The sites based on fabric patterns tend to have an organic, tangible feel with a texture you can imagine feeling, though it clearly doesn't exist. The result is a distinct look that creates a comfortable and inviting mood. Keep this in mind as you view the samples provided here.

I love showing extreme opposites when it comes to a particular style, so with this in mind I turn your attention toward the Poco Nico site **(figure 1)** Here the use of fabric styles is all-consuming. It really becomes a theme, not just a stylistic element. The tone set here is fun and playful, and matches the product offered, which happens to be children's clothing. It's an appropriate use of the style.

In stark contrast I love the way Pagelift **(figure 2)** uses fabric. Here the implementation of the style is incredibly minimal: nothing more than a pair of buttons with stitching at the top of the page. In this case, the fabric doesn't set the tone. In reality it plays into the tone that's established by the other design elements in the page. Always consider the range of options you have when it comes to the use of any stylistic element. It can be over the top or extremely subtle and anywhere in between.

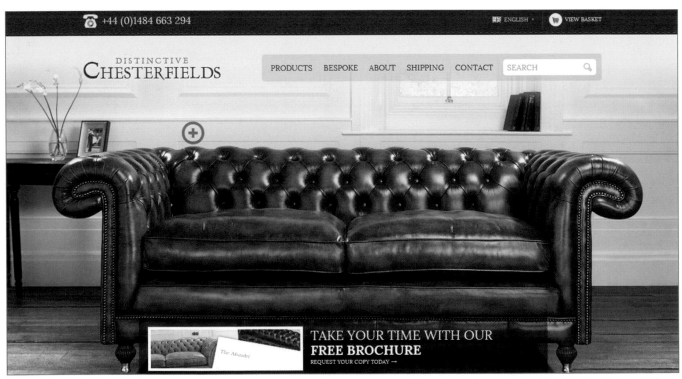

http://www.distinctivechesterfields.com

Figure 1 http://www.poconido.com

Figure 2 http://www.pagelift.com

http://www.shoepassion.de

http://ethercycle.com

http://www.drwoe.nl

http://kiskolabs.com

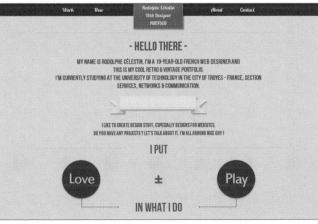

http://www.rodolphecelestin.com

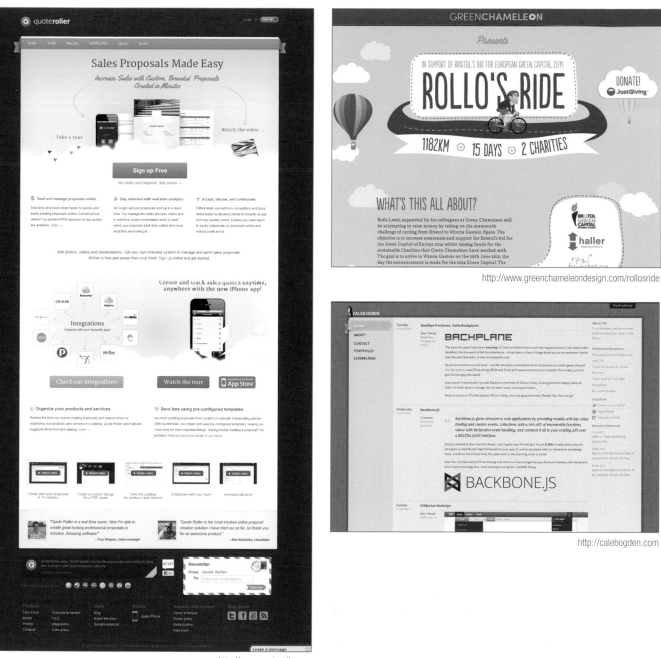

http://www.quoteroller.com

http://www.greenchameleondesign.com/rollosride

http://calebogden.com

http://www.zwartwitmedia.com

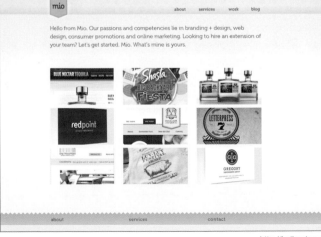

http://hellomio.com

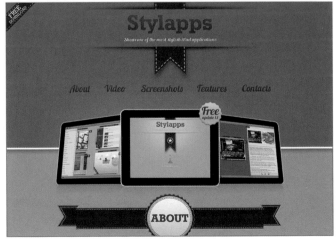

http://www.stylapps.com

Some styles speak for themselves Sometimes a trend is simply a trend. I think this is exactly such a case. I see a few brief things I want to comment on, but overall the approach is pretty clear. For many designers, the fact that so many have already used the approach will be a deterrent, while others will be inspired by an interesting design element.

In all of the samples here you will find hands holding the content containers. Most often this ends up giving the illusion that the content exists on some form of paper or board. The approach tends to add a great deal of depth to a page, most often creating three distinct layers. The foremost being the content layer, next the individual holding the content and finally the background. It is interesting how this visually pushes the content toward the viewer.

Conceptually I like the idea; it is as though the artists are literally presenting their work and clearly associating themselves with the work they do. The connection is positive and leaves a distinct impression of the individual. In other cases it seems to be less for the purpose of branding and more about adding some clever detailing.

This is the type of trend that is sometimes used flippantly. Be sure to consider the message you want to send and how this particular approach might help accomplish your goals. Maybe you want to add some fun to your design; if so this is a great way to do it.

Even better, use the samples here as inspiration. Where might you take this approach to make it your own? What twist, change or addition can you make that will make your use more unique and effective? Use the examples here as stepping stones to find your own visual solution.

http://www.petit-team.com

http://andrewshanley.co.uk

http://www.focadesign.com.br

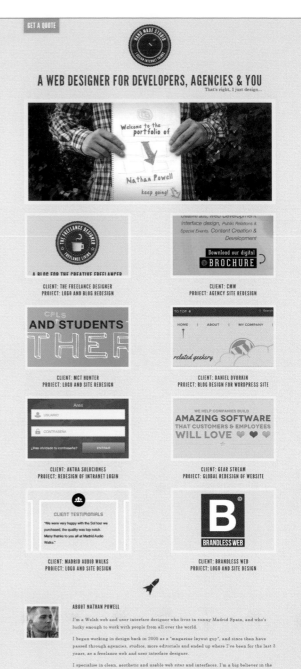

http://handmadestudio.info

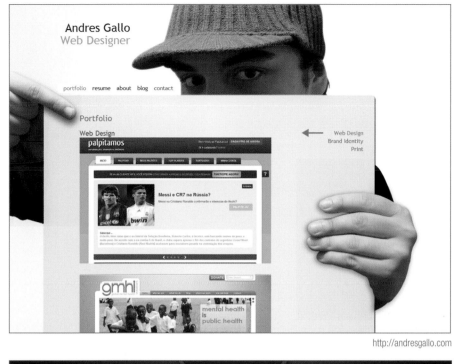

http://andresgallo.com

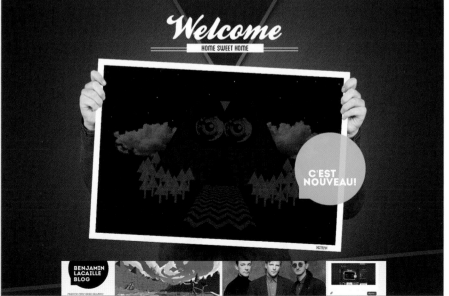

http://imp3rium.free.fr

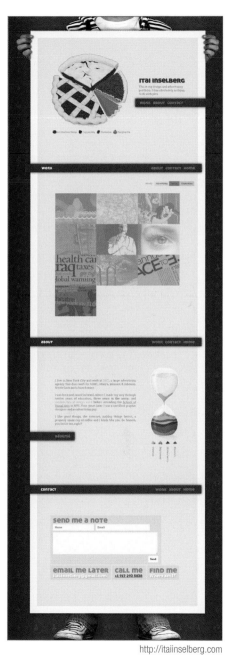

http://itaiinselberg.com

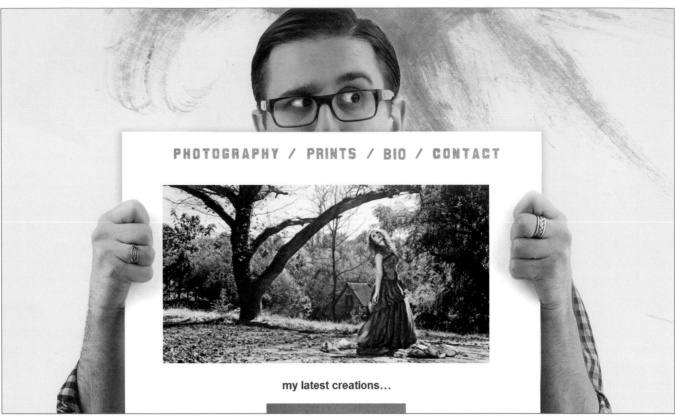

PHOTOGRAPHY / PRINTS / BIO / CONTACT

my latest creations…

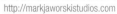

http://markjaworskistudios.com

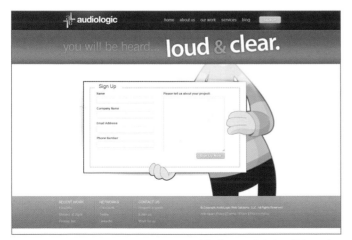

http://www.audio-logic.net/signup.php

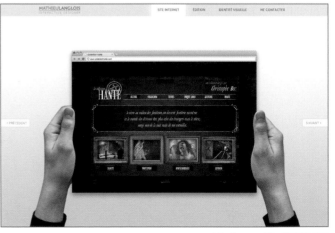

http://www.mathieulanglois.com

MIXED TYPE

Typography is one of the most critical tools in the designer's utility belt. And at times principles of typography get put to work in ways that not only create beautiful type, but also push it to the foreground as a work of art in itself. With the explosion of web-based type, as highlighted in the large section of web typography earlier on in this book (page 036), I have featured a lot of beautiful type. This small section is intended to highlight a subsection of typography that takes the type to an artistic level. Here we find prominent blocks of text used to create visual interest by combining many different typefaces into a single block. Sometimes they are the same font, but in different weights, and in others it is a mishmash of radically different fonts.

Consider first the example found on Roxanne Cook's site **(figure 1)**. Here the large text block is by far the most prominent element on the page. In fact, depending on your screen size, it might very well be the only thing you see beyond the navigation. The typography not only demonstrates Roxanne's skills, but it also contains text that explains what she does. In other words, it's not only visually interesting, it communicates something at a literal level.

A slightly different take on this style can be found on the Flint Boutique site **(figure 2)**. Here the use of mixed type plays into the crafty style of the site and the services they offer. Obviously the words communicate a message, but their visual role seems to far outweigh what they actually say. In fact, I find it kind of hard to read. With this in mind I propose that the visual purpose is the primary goal and ultimately presents the intended message: This site is about crafty, handmade stuff. The intended audience is the bride-to-be, so clearly the style and mood are not in the traditional overly formal style. They are targeting a different kind of customer in this niche, and the mixed type plays into this nicely.

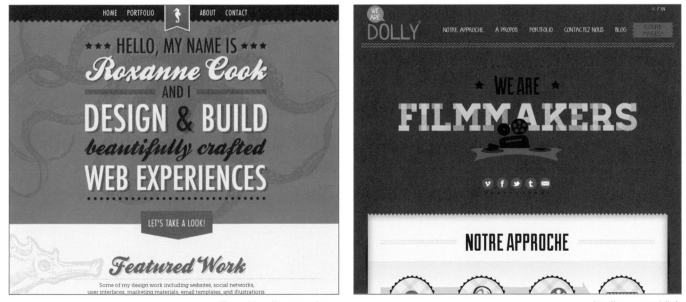

Figure 1 http://roxannecook.com

http://www.wearedolly.fr

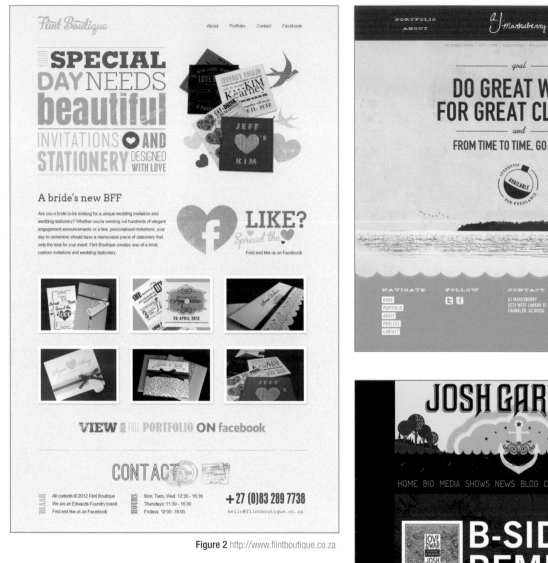

Figure 2 http://www.flintboutique.co.za

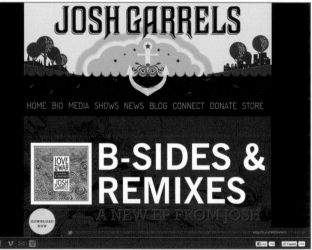

http://www.ajmarksberry.com

http://joshgarrels.com

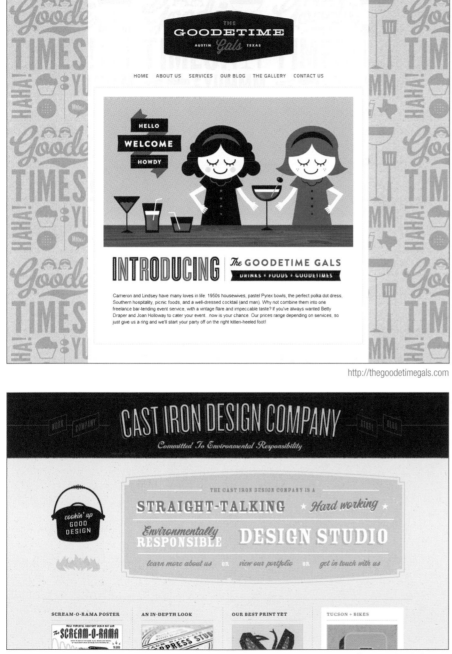

http://thegoodetimegals.com

http://www.castirondesign.com

http://www.kitchensinkstudios.com

When I started writing this category, the idea of circles as a trend seemed silly. Yet the more I looked, the more I found them. In fact, if you browse through this book, you will find many other examples that I could have included in this chapter. Initially I was limiting myself to logos that are set inside of a circle, but then I added samples that used circles in other ways as well.

Take a look at the Meltmedia **(figure 1)**, Javier Lo **(figure 2)** and Jude's Jewels **(figure 3)** sites. In all of these (and a few others from the samples) the logos either consist of or are contained inside of a circle. This all begs a single question: Why?

It isn't hard to find the circle theme far beyond a container for the logo. For example, the English Workshop **(figure 4)** or the Imagen y Codigo (in English: Image and Code) **(figure 5)** sites both make use of circles in very decorative and supportive ways that are not tied to the logo.

I don't think there is a deep underlying meaning at work here. It is simply a decorative element that works well with most any design. It happens to be a practical trend.

Part of me suspects the use of the circle is rooted in the fact that thanks to CSS3, we can now render rounded corners inside of the browser. If you set up rounded corners just right on a square element, you magically have a circle. This might not sound all that exciting, but I am fairly certain that this trick was used here and there, and the next thing you know the design world has circles on the brain.

Figure 1 http://meltmedia.com

Figure 4 http://www.englishworkshop.eu

Figure 2 http://www.javierlo.com

Figure 3 http://www.judesjewels.net

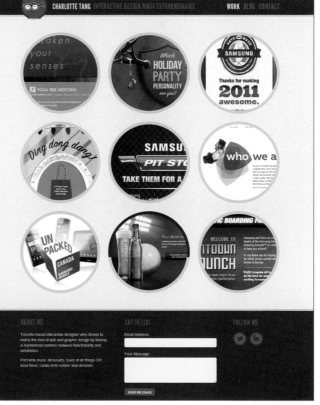

http://charlottetang.com

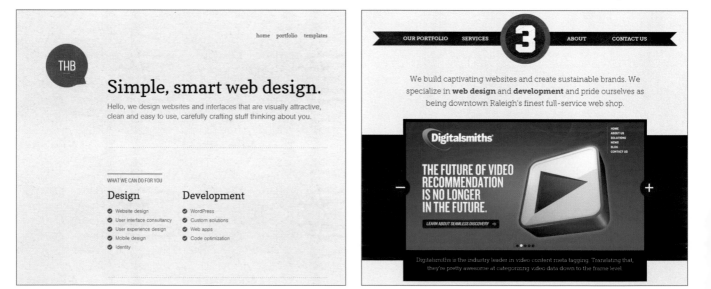

NEWS / PORTFOLIO / ABOUT *ÜBER* / PROCESS *WIE?* / WHAT ELSE? *UND SONST?*

I like design, make design & write about design. I like pens—digital and analogue ones. I like special characters and ligatures.
I <3 the internet.

Ich mag Design, mache Design, schreibe über Design. Ich mag Stifte – digitale und analoge. Ich mag besondere Buchstaben und Ligaturen. Und das Internet.

NEWS

Some of the latest things going on
Alles was gerade passiert

Railsgirls
Mon, 16 Apr 2012 16:00:00

Last week I attended Railsgirls Berlin - an event organised by some enthusiastic Fins to get more woman into tech. Being a (web)designer and co-founder of a web-agency, I am familiar with all kinds of webtech stuff, especially being surrounded by some very talented »code-artists« at

More / Mehr →

Logoworks Website
Thu, 12 Apr 2012 11:05:35

I habe gerade eine Logo-Website gelaunched: http://nadine-rossa.de/logos Warum? Über die letzten Jahre und in meiner Zeit als Freelance-Designer habe ich eine menge Logo-Jobs gemacht. Eine Menge! Nicht alle von ihnen wurden benutzt, aber da es so viele sind,

More / Mehr →

@nadrosia

nadrosia Toll! RT @kopfbunt: Daumenkino auf Facebook – Fotogalerie für den VW Amarok – futurebiz.de/artikel/daumen... facebook.com/media/set/?set...
about 1 hour ago · reply · retweet · favorite

Dmig Abstract City – mein Leben unterm Strich designmadeingermany.de/2011/36680
3 hours ago · reply · retweet · favorite

nadrosia @wiederspielwert Schöööööön! Berliner ß :-) Wo ist das her?

http://nadine-rossa.de

home portfolio templates

Simple, smart web design.

Hello, we design websites and interfaces that are visually attractive, clean and easy to use, carefully crafting stuff thinking about you.

WHAT WE CAN DO FOR YOU

Design
- Website design
- User interface consultancy
- User experience design
- Mobile design
- Identity

Development
- WordPress
- Custom solutions
- Web apps
- Code optimization

http://2011.thehappybit.com

OUR PORTFOLIO SERVICES **3** ABOUT CONTACT US

We build captivating websites and create sustainable brands. We specialize in **web design** and **development** and pride ourselves as being downtown Raleigh's finest full-service web shop.

Digitalsmiths®

HOME
ABOUT US
SOLUTIONS
NEWS
BLOG
CONTACT US

THE FUTURE OF VIDEO RECOMMENDATION IS NO LONGER IN THE FUTURE.

LEARN ABOUT SEAMLESS DISCOVERY →

Digitalsmiths is the industry leader in video content meta tagging. Translating that, they're pretty awesome at categorizing video data down to the frame level

http://www.weareo3.com

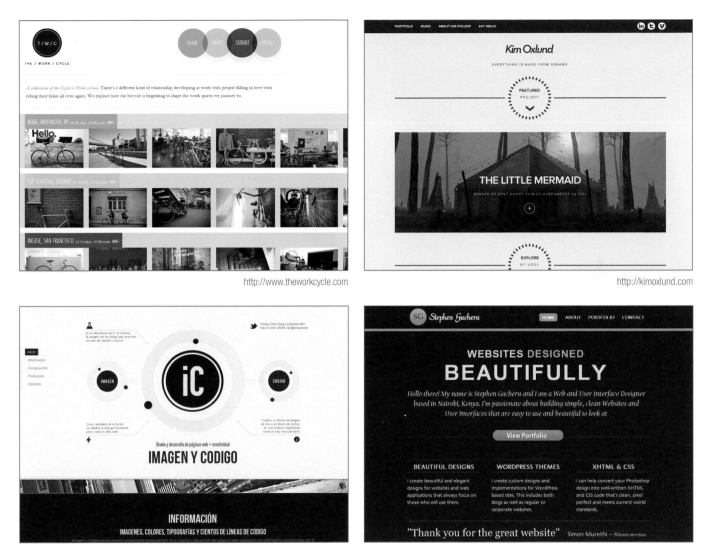

http://www.theworkcycle.com

http://kimoxlund.com

Figure 5 http://www.imagenycodigo.com.ar

http://stephengacheru.me

SKEUOMORPH

A skeuomorph is typically defined as a derivative object that has decorative design elements that come from the original. Skeuomorphs are used to reference the original and thereby create a familiar object. For example, many homes have nonfunctional shutters. In fact, I bet there are more homes with fake ones then real ones. Every house in the neighborhood I grew up in had them. The point is that they don't function, but they are familiar elements that decorate an object in a familiar way. Fake shutters aren't necessary on a house, but they sure do look nice.

Translated to the web, this definition breaks down a bit. Skeuomorphs presume that the object (in our case the web) is a derivative of some other element from which it draws inspiration. I am going to shift this to include any web interface that references real-world things with the intent of implying purpose or function. A sample will demonstrate what I mean.

The Cascade Brewery Co. website **(figure 1)** is a perfect example of a skeuomorph. Here you will find a menu system that filters the elements found below. The elements are presented as gauges and switches with a clear reference to things you might find in the brewing process and on some sort of control panel. Not only are they pretty to look at, they also communicate their function and purpose.

Another example that is packed with lots of skeuomorphs is the Fine Goods website **(figure 2)**. For example, the red and white awning is pretty and decorative, but it is also informative. It is a clear reference to the awning you find in front of a physical Fine Goods store. We also find that the product is visually placed on "shelves." Clearly we don't need shelves to hold up digital images. But the structure does highlight the product that is for sale as well as separate each item. Finally, you will notice that the link navigation on the left appear to be drawers. Again, websites don't need drawers, but it is a metaphor for containers of content. There are more skeuomorphs packed into this site, but I'll let you discover them.

script.aculo.us javascript consulting by thomas fuchs

copyright information / impressum

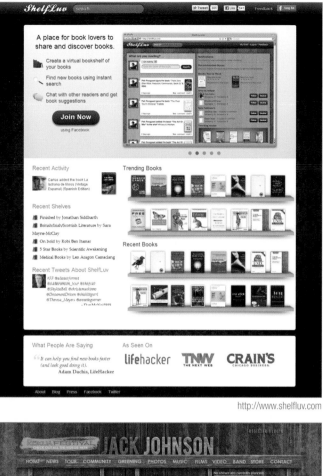

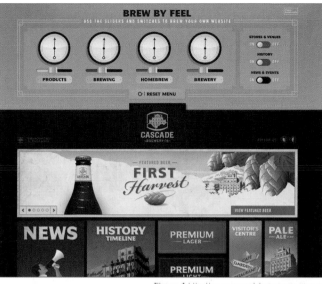

Figure 1 http://www.cascadebreweryco.com.au

Figure 2 http://www.finegoodsmarket.com

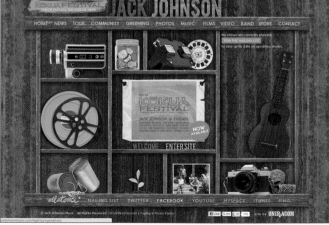

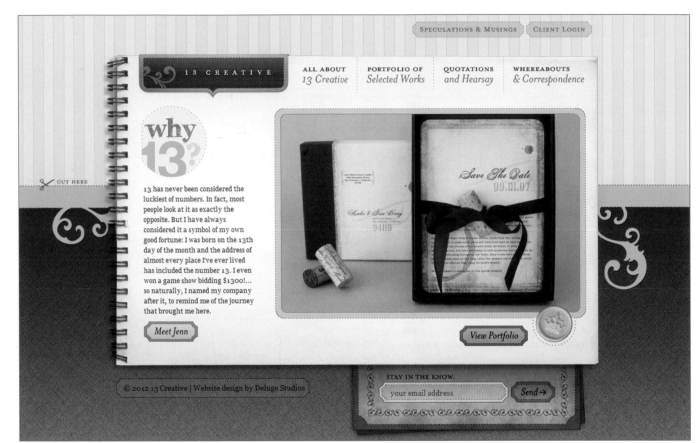

Mascots are certainly nothing new to web design. I could have easily made this chapter about ninjas, robots, aliens and a number of other frequently used character types. I settled in on monsters as an example of this particular genre. This is partly because I actually used the approach myself (see page 007 in the WordPress section for Monster Meltdown). Mascots, and in this case monsters, serve many purposes. A quick survey follows.

Perhaps the most common use of a mascot is to simply provide a personality for—or characterization of—a product. Such is the case with the Solid Giant design **(figure 1)**. Here the monster becomes a symbol for the company and a very memorable part of the design.

At other times, the monster's role is to simply lighten the mood. I think the Quodis sample is a perfect demonstration of this **(figure 2)**. Here we see a monster leaving a "web boutique." Buying a website can be an intimidating process. This simple illustration with a silly smiling monster sucks the anxiety out of the situation. Suddenly the process feels lighthearted and friendly. Seems like a pretty good sales pitch for potential clients. In this case, notice that the monster doesn't become a symbol for the site. The brand retains its identity. It uses the silly monster for just one purpose.

Figure 1 http://solidgiant.com

Perhaps one of the most iconic samples is from the Beercamp website **(figure 3)**. Here the monster is large and in charge. In fact, it dominates the home page. I wouldn't be surprised at all if the monster became a symbol for the event. It would make for cool shirts and all sorts of extensions. It's fun, memorable, quite unique, and just works really well.

As you consider using monsters or other mascots in your design, take a good look at the way others have put it to work. Not just from a visual standpoint, but from a strategic perspective as well. All design elements, big and small, can play into the overall message. Don't just use a monster because you feel like it that day. Put the tool to work for you in a meaningful way.

Figure 2 http://quodis.com

http://tutimi.com

http://www.imaginamos.com

http://www.chilid.pl

Figure 3 http://2012.beercamp.com

http://playtend.com

http://www.srburns.es

Given a problem, designers are quick to find solutions. Consider my earlier discussion of responsive design (see page 071). When faced with the question of how to fill the space available with content, one such solution is to put everything into a grid as blocks, or tiles, then simply have them flow to fill the space available. It's a simple approach that adapts to most any size screen. Naturally clever designers observed the problem and built sites around this approach. With this perspective it shouldn't be all that surprising to find this chapter in this particular volume. Though not all of the samples here adapt to the screen, and in some cases the tiling is simply decorative, it is still a valid approach that we see used on many sites.

A clear demonstration of this is Erik Marinovich's site **(figure 1)**. Since all of the elements are the exact same size, it isn't too hard to have the CSS tile them in a way that fits your screen. Load this one up in a browser—then change the size of the browser to see the results.

Another site that follows the pattern, but not with the same simplicity, is Bernd Kammerer's **(figure 2)**. Here the tiles are of varying sizes, and you have the option to filter your view based on the items you want to see. Clearly a site like this takes a bit more planning. For example, you would most likely prototype something like this first, then set up some design guidelines for the project for the designer to then work within, especially since it is based on a jQuery plug-in called "vGrid" that accomplishes much of the hard work (and provides its own set of boundaries)[6].

Another example I particularly like is the Skive Festival site **(figure 3)**. Again this site allows you to filter the content based on your area of interest. What I like about this one is how the functionality carries through to the subpages. By doing so they improve the chance that people will understand how to use the site; repletion helps them establish the use of the site. In this case, another jQuery plug-in is at work; this time, one called Isotope[7].

An interesting point to make here is how effectively these two samples make use of prebuilt plug-ins. You don't look at either of them and get the feeling that some tool was bolted into place. Instead they have a totally custom feel. This is a fantastic demonstration of how a tool can inspire and empower a design, resulting in a delicate dance between what is possible and what is needed. Consider, for example, that the Istotope plug-in used above is around 700 lines of JavaScript code. The time savings there alone is huge. Playing within the boundaries of such tools can be very profitable.

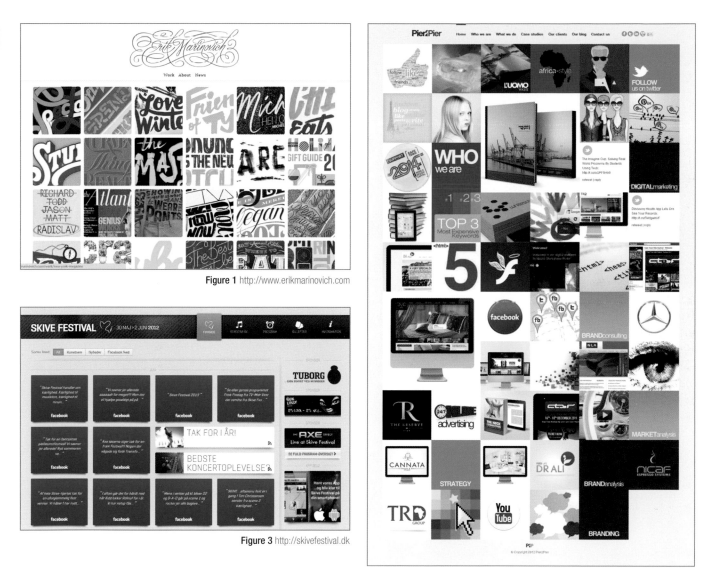

Figure 1 http://www.erikmarinovich.com

Figure 3 http://skivefestival.dk

http://www.pier2pier.co.za

Figure 2 http://berndkammerer.com

http://www.ricardocastillo.com

http://www.killingsworthstation.com

http://www.fiaschi.org

http://quelifranco.com/#home

http://www.premiere.fr/35ans

The use of wood in web design is another common design element. I covered wood previously in Volumes 1 and 2, but also on DesignMeltdown.com many years ago. With trends like this I am always torn between finding something new to cover and including patterns people frequently use. In the end, I decided to cover it because it is still such a popular style.

The use of wood in the samples included here is not hard to pick up on; most demonstrate bold usages of the element. Interestingly it is mostly a supporting element; the remainder of the structure for the site relies on other elements. It is these elements that ensure the design is modern and fits into current styles. In this way, the use of wood in design is a clear demonstration of how a single element can grow and change over time to fit in with almost any style.

A perfect example of this is the Queen City Merge site **(figure 1)**. Here the wood background sets a tone and mood for the site but does nothing in terms of structure or content. It's a purely supporting role that works well and can easily fit with any site's style. This makes it an easy-to-use option and it is no wonder designers so often turn to it.

In slight contrast to this, take a look at the Tuff Kookooshka design **(figure 2)**. Here the wood is much more dramatic, though it still fills a background role. In this case, the style of the wood much more vividly plays into the style of the product being presented. As with all design elements, the wood element offers a lot of room for variation.

For every design element there is always a way to take it over the top. Such is the case on the Enochs website **(figure 3)**. Here the use of wood has been transformed into a full on theme and finds a role as the primary containers for content. Clearly the usage fits well with the theme of the site and narrowly avoids being hideous. Sites with extreme themes commonly walk the line between terrible and awesome—and fortunately this one falls on the good side.

Figure 1 http://www.qcmerge.com

Figure 2 http://www.tuffcookie.net

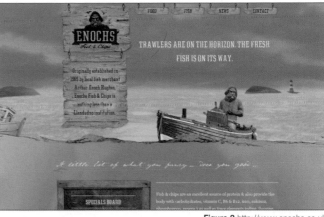

Figure 3 http://www.enochs.co.uk

http://woodtype.org

http://www.bluenectartequila.com

http://moni.whitewaterlabs.com

http://www.oatbook.co.uk

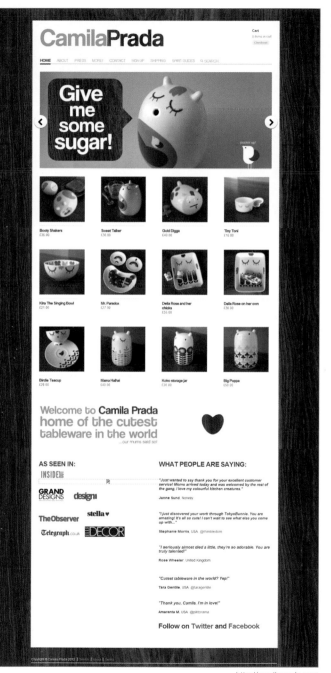

http://camilaprada.com

http://www.galandesign.com

http://www.jomedconstruction.com

http://www.taskburnapp.com

SPACE

As someone obsessed with the song "Spaceman" by The Killers (which I am using as inspiration while I write this), I am excited to present a small chapter here on space-inspired web design. Sometimes pulling a specific niche chapter like this together with sufficient samples can be difficult, but not so with this particular theme. It seems that the use of space in web design is popular right now. In fact, you will find a number of samples used elsewhere in this book that easily fit the role.

To begin, I would like to consider the design of the 40Digits web site **(figure 1)**. In this particular case the space theme gives the designer something visually interesting to work with and demonstrates to clients the quality of the design work. In many cases the design is meant to blend in and the content is meant to pop. Themes used as they are on this site create an alternate scenario where the design of the theme is a clear demonstration of the team's abilities; perfect for an agency site. Even better, a space theme oozes with connotations of forward thinking and modern practices. Why theme yourself in the past when you can be so futuristic? Check out the chapter on nineteenth-century design for the opposite perspective (page 123).

Another example that strongly relies on the connotations and associations of the space theme is the Themify site **(figure 2)**. Here the usage is extremely light—simply a stylized photograph of space that's used as a background in the header. This is certainly a much more supportive role than the 40Digits sample, but the results are very similar. The space element works to set a modern feel and places the product in a favorable light. Another extremely similar usage is the QuickSend site **(figure 3)**.

Finally I want to take a closer look at the Lander site **(figure 4)**. Here the space theme is narrowed down a bit to the idea of "landing," something that we closely connect with the moon. Thus we have a moonscape combined with some sketchy drawings of space elements to help viewers draw the connection (otherwise it might be mistaken for a desert). You have no doubt noticed that the name of the product, Lander, and the theme fit very nicely together. Cases like this are the ones that I tend to really fall in love with. Anytime a design style, theme or other element has a double meaning it works that much better. In this way, the design represents the brand in a literal way. And with samples like this, we can clearly see how perfectly matched topic and theme can be.

Figure 1 http://40digits.com

Figure 2 http://themify.me

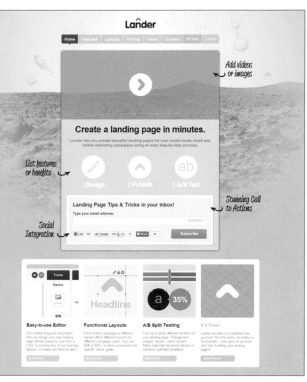

Figure 3 http://moeedm.com/quicksend

Figure 4 http://www.landerapp.com

http://www.newicemedia.com

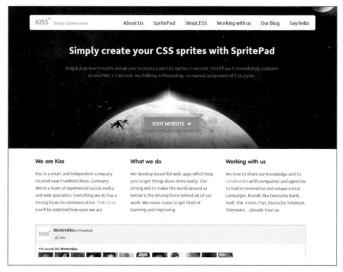

http://wearekiss.com

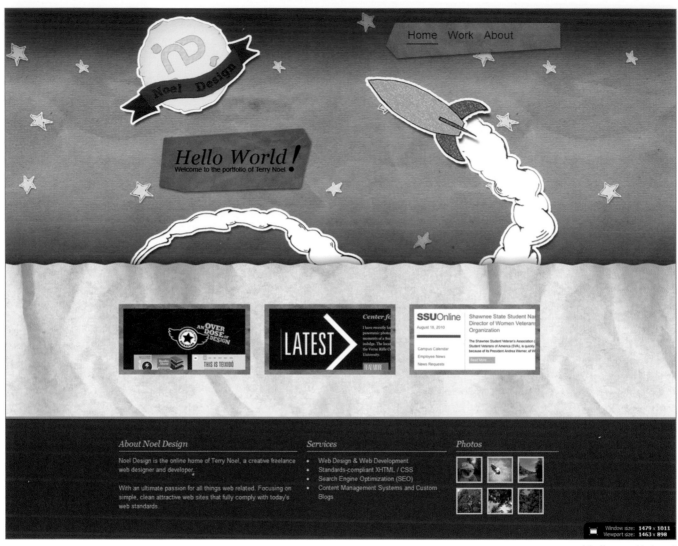

Window size: **1479** x **1011**
Viewport size: **1463** x **898**

http://www.noeldesign.net

http://www.pixelbaecker.de

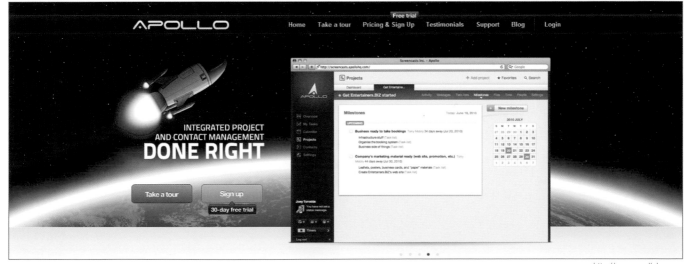

http://www.apollohq.com

04 / Site Types

In order to identify some design trends we look at specific things like the use of patterns, fabrics or ribbons—but in order to spot other trends we need to look at specific topics and a collection of sites that can give some indication of a particular style at work. In this section, we will focus on a number of specific industries or topics and any trends we can potentially find in their designs. It seems that nearly every topic or industry forms a set of common patterns that people draw on inside the space. Ironically this is even evident in the websites used by design agencies. Buying into a trend isn't inherently bad—playing into the norms people are familiar with is actually a good thing.

One of my favorite places to look for industry trends is on the agency sites. Agencies are supposed to be leaders in the online space, so they can be great places to spot innovation. One trend that seems rather clear is that agency sites have gravitated toward simpler, cleaner sites. Certainly there are still over-the-top agency sites, but for the most part there has been a huge move toward usability and extremely clear communication. Most agencies have a small set of core skills that drive most of the work they do. As such, it makes sense for an agency site to quickly communicate this niche rather than to try to convince visitors that they can do it all. The trend seems to be to focus on connecting with potential clients that closely fit the type of work the agency is interested in doing.

To illustrate this point I want to highlight a rather extreme case—Church Media **(figure 1)**. This agency focuses on building sites for churches and their associated ministries. It's a pretty clear niche. As it turns out, they produce some of the finest sites in the space and are clear trendsetters. Most of the styles found in their work show up in countless other sites that were no doubt inspired by a Church Media design. In general, you will notice that this site is extremely simple and clean. The focus is on the five-word sales pitch and a showcase of their work. In this way, they quickly filter out any visitors in search of other types of design work.

A nice contrast to Church Media is the Myjive design **(figure 2)**. Though the sites are in the same ballpark visually, both quickly establish their niche through the use of their clear content. In Myjive's case the scope is a bit wider than Church Media, but all the same a topic and area of expertise is established. They make no mention of industrial design, print design or any other medium; the focus is on digital work.

Again, the industry trend seems to be toward simplicity and clarity. This is a mentality that will do well in almost any area of online work.

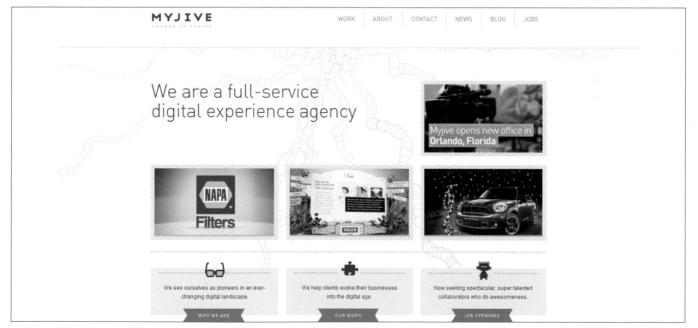

Figure 2 http://www.myjive.com

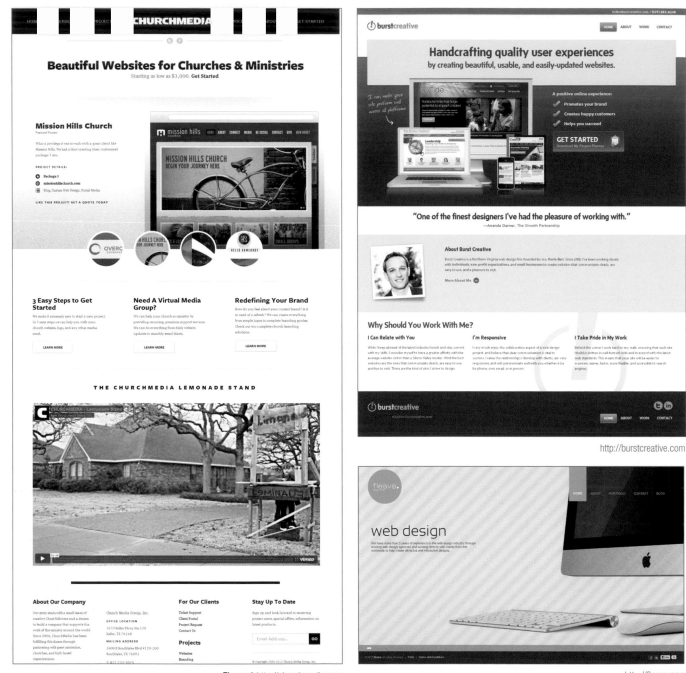

Figure 1 http://churchmedia.com

http://burstcreative.com

http://fleava.com

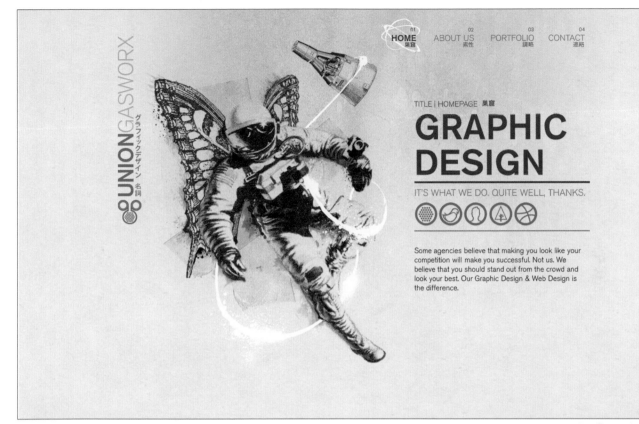

UNIONGASWORX
グラフィックデザイン 名詞

TITLE | HOMEPAGE 巣窟

GRAPHIC DESIGN

IT'S WHAT WE DO. QUITE WELL, THANKS.

Some agencies believe that making you look like your competition will make you successful. Not us. We believe that you should stand out from the crowd and look your best. Our Graphic Design & Web Design is the difference.

http://www.uniongasworx.com

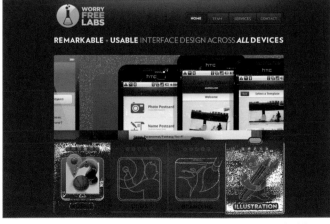

WORRY FREE LABS

HOME TEAM SERVICES CONTACT

REMARKABLE + **USABLE** INTERFACE DESIGN ACROSS **ALL DEVICES**

ILLUSTRATION

http://www.worryfreelabs.com

playground

HOME ABOUT CONTACT BLOG

Welcome to Playground, a creative agency in Toronto.
We build companies & design experiences in the digital space.

SCROLL DOWN TO TAKE A LOOK

http://playgroundinc.com

SUPEREIGHT
STUDIO

We create beautiful websites, easy to use web apps and illustration. We love to focus on user experience, web standards and the small but important details.

SOME RECENT WORK

http://www.supereightstudio.com

http://www.basili.co

http://elabs.se

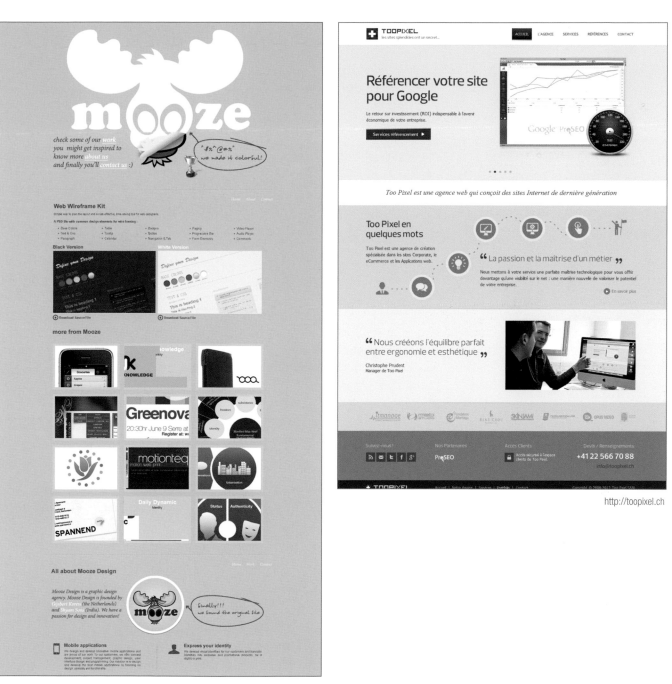

http://www.mooze design.com

http://toopixel.ch

A personal portfolio site is often cited as one of the most painful sites to build. It turns out that the lack of client restrictions drives most designers toward insanity. Without requirements, anything can be done. As a result, portfolios can be created in seemingly infinite ways. This makes it hard for someone like me to spot trends. After all, how can twelve or so samples begin to sum up the work of every creative person out there? Of course that is impossible, but I can still highlight some beautiful samples that are sure to get you thinking.

To begin, we will look at an extremely conservative sample. I recently read a description of portfolio sites that went something like "the fancier the portfolio site the crappier the work." The state-ment is fairly accurate. Fortunately for Marus Friberg **(figure 1)**, his insanely tame and minimal site contains samples of his awesome work. How is it that the better the designer, the less over-the-top their portfolio becomes? In fact, it seems that at some point there is a whole mess of incredible designers who don't bother with a portfolio anymore.

But a portfolio can present your own personal style while playing into the simplicity-based approach. Take the portfolio of Levin Mejia **(figure 2)**, for example. This is the type of site I find easy to fall in love with. I can't imagine a single tweak to the design. It's gorgeous, easy to read and paints an incredibly positive view of the individual—so much so I don't even mind that I have to dig for his name. Frankly, if I was looking to recruit someone, I would do whatever it took to find him.

Finally, we do still find some experimental work that stands as a portfolio piece all on its own, even though it does contain great design work—thereby breaking the stereotype presented above. Consider this awesome interactive creation on JayarajPR.com **(figure 3)**. In this case, the portfolio speaks volumes about the capabilities of the individual. In fact, the whole thing feels as much like an experiment as anything could. Instead of coming across as over-the-top for the sake of getting attention, it gives the impression of a really competent designer/developer who is playing around. And that is far more appealing to recruiters.

Figure 1 http://www.marcusfriberg.com

http://www.williamcsete.com

Figure 2 http://www.fourandthree.com

Figure 3 http://www.jayarajpr.com

http://www.cleansimpleclear.com

http://www.jeremymadrid.com

http://www.ggmusicandaudio.com

http://havocinspired.co.uk

E-COMMERCE

Some topics present a particularly interesting opportunity to build some inspiration, and in my opinion e-commerce is one of those. This is clearly an area strongly rooted in making money and optimizing for return on any and every design change. This is certainly the approach taken by e-commerce giants like Amazon. With this in mind, I love collecting a small set of sites that are not only gorgeous in design but also do two things: First, they break the mold and don't follow the "standard" formula. Second, they are fairly unknown when compared to Amazon and the like. Let's face it, you don't need to see Amazon for inspiration; what you need are fresh ideas. So with this type of thinking I present to you a diverse set of e-commerce sites that I hope will result in new ideas for your work.

To illustrate this, please take a look at the Krystalrae landing page **(figure 1)**. This is not the brand's main home page. There is much that I love about this page, but I want to focus on one small element. In the screenshot, you'll notice that the border of the first large image matches the actual product. It gets even better. When you hover over an item, the border changes from white to a pattern that is drawn from the individual product. Even better, the borders are animated and move as you maintain the hover state. Extra details like this provide the awesome sauce that takes a superclean and minimal design (already beautiful) and pushes it over the top. It's the kind of site that is inspiring to work on and frankly is a very different kind of e-commerce site.

Some sites have the luxury of having to showcase a single product. This creates a unique opportunity to craft a design entirely around that product and minimizes the need for supporting structure. The *A Book of Beards* site (a book by Justin James Muir) **(figure 2)** is one example.

Only having to sell viewers on one item allows the site designer to present a clear and bold picture of what this product features—beards. Personally I think this approach also could be applied when you are dealing with multiple products.

Finally, this chapter features a few samples that don't necessarily deviate from the traditional layout formula in a radical way, but they do clearly set themselves apart. Consider the Swedish Hasbeens site **(figure 3)** as an example. Here the typical layout is fairly clear, yet the overall style is anything but "normal." Instead, the thematic approach plays perfectly into the product and does much more to support it than provide a clean, unobtrusive interface to make a purchase. The process of shopping on the site becomes an experience in itself, one in which you become immersed in a style that matches their product.

Figure 1 http://shop.krystalrae.com

Figure 2 http://bookofbeards.com

Figure 3 http://www.swedishhasbeens.com

http://www.moo.com

http://www.dans-ez.com

http://store.darkcollar.com

http://www.sklz.com/shop

http://meanbeanies.com

http://www.yuppiechef.co.za

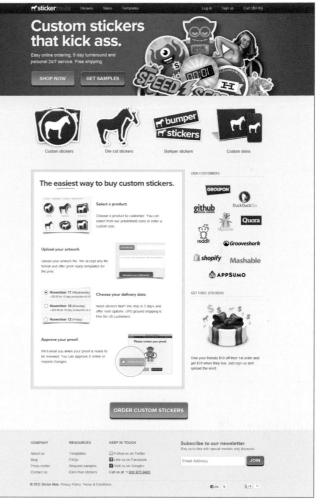

http://www.stickermule.com

Much like the previous chapter on e-commerce, the blog section represents a very familiar topic with some easy-to-identify landmarks. And as with the e-commerce chapter, the goal here is to inject some fresh ideas into the mix. As such, you won't find any big names or well-known sites here.

Some of the most interesting ideas are found in samples that are not so economically driven. Most blogs (at least the big names you might think of) are driven by revenue. They are stuffed full of ads and are there to make money. In contrast, blogs like Hidden Logic **(figure 1)** are not focused on money at all (at least not as obviously as blogs stuffed with ad blocks). This delicious site draws on some old-school inspiration, namely the Italian Renaissance. This particular style combined with some beautiful typography makes for an aesthetically pleasing site. Even better, I love the way the designer presents the list of blog posts. The result is super easy to use and enticing to dig into. I find the less-overwhelming approach pulls me in and makes me want to read more. Compare this to the more typical approach of blasting the viewer with a mountain of content. I am going to play favorites in this chapter and name this one of my best loved.

Incidentally another Tumblr-based site that is also one of my favorites is the New York Moon site **(figure 2)**. In this case, bold visuals combined with a clear typographic hierarchy make the site easy to consume. Interestingly this sample also lacks advertising, which would greatly deteriorate the quality of the design.

I particularly appreciate the site of Sacha Greif **(figure 3)**. First, I want to highlight just how easy it is to skim the content of this site. Notice in particular how the sidebar elements take second place in the visual hierarchy due to the reduced contrast of the text on the background. This allows the user to focus on the content first and the secondary elements, well, second (and only if interested). From a style (or trend) perspective, notice that the use of circles in this design is supported by the nice round typeface for the larger text and a simpler sans-serif font for the body copy. The text and imagery style go together really well. Also notice that the designer didn't go overboard making everything round. You really can overdo it and this is a fantastic example of striking a balance and not carrying a style too far.

Figure 1 http://hiddenlogic.in

http://rog.ie

Figure 2 http://editions.nymoon.com

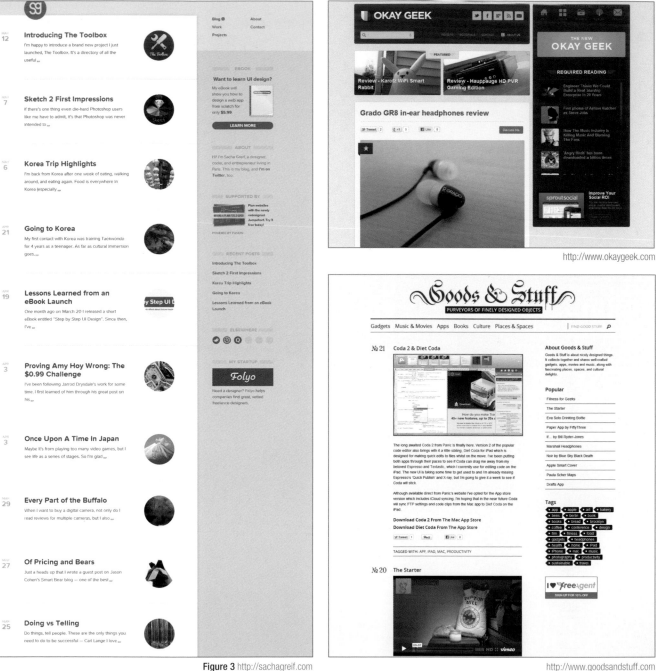

Figure 3 http://sachagreif.com

http://www.okaygeek.com

http://www.goodsandstuff.com

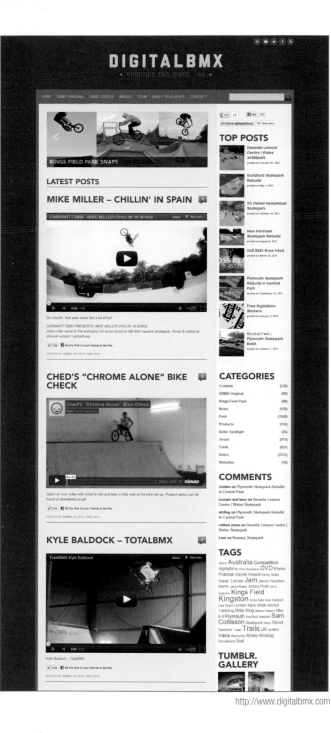

The product category is an interesting type of site. These microsites represent a specific product (not an entire brand). For example, the Nokia Swipe site **(figure 1)** isn't for the entire Nokia brand, rather it is a focused presentation of a single product. This focused approach tends to lead to a lot more inventive work. An all-inclusive brand site must accommodate for a potentially huge range of products and most often requires updating and maintenance over many years. In contrast, individual product sites seldom, if ever, change. This can lead to experimental—and often cutting edge—work.

A great place to start is the previously mentioned Nokia Swipe site. This super-clean design showcases the product in a way that complements what the product is supposed to be. The design of this phone is modern, atypical and super-smooth looking. So much so, that the images of the photo almost look three-dimensional. The point is that the site is able to reflect the style and functionality used to sell the phone.

In a radically different way, the Coast microsite **(figure 2)** seeks to set a mood, rather than reflect some intrinsic quality in the product. Here a background and overall stylistic theme sets the tone for the page and resonates with the brand in an obvious way. After all, it is a soap site, and as such it gets right to the point. Playing into the brand in an obvious way is a safe route to go.

It is amazing how exciting a product can be when it's presented in a creative way. Consider the TruMoo site, for example **(figure 3)**. It's a site that promotes milk, which doesn't leave a lot of room for blowing consumers' minds. Chances are, a customer wants to know where to find the product or wants to simply get a coupon. This simple site manages to make milk look better than I would have thought possible. And it does it without any of the most obvious visuals: cows.

http://www.libbysnectars.com

http://aisle411.com

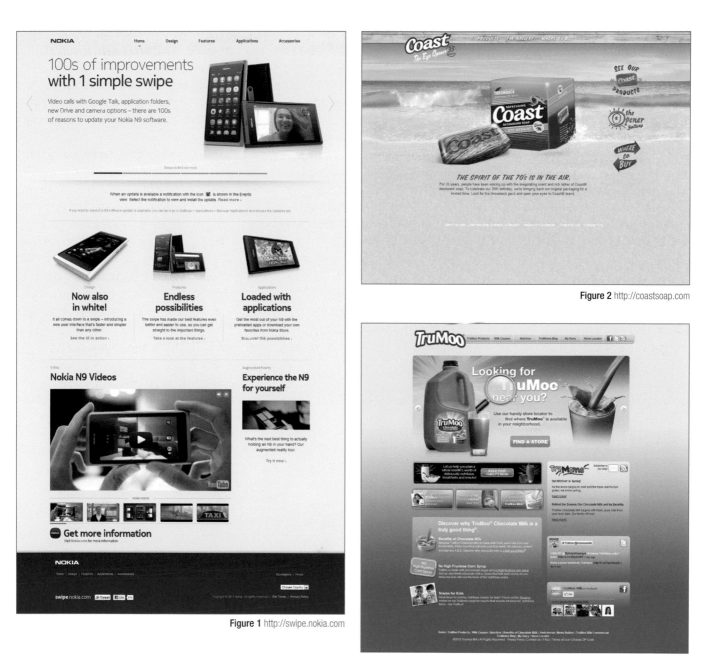

Figure 1 http://swipe.nokia.com

Figure 2 http://coastsoap.com

Figure 3 http://www.trumoo.com

http://space.angrybirds.com/launch

http://www.amperbranch.com

http://gesty.pixle.pl

http://ubooly.com

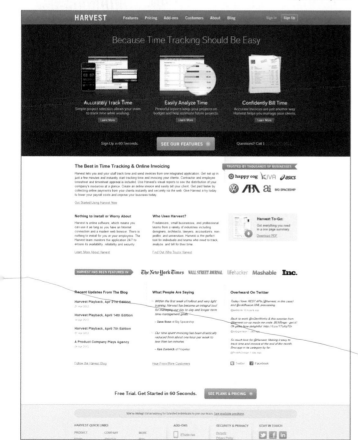

http://www.getharvest.com

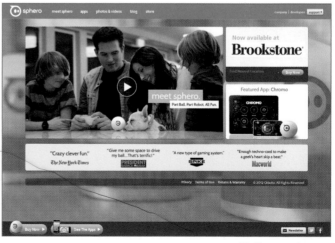

http://www.stayfocused.fi

http://www.gosphero.com

While band sites might seem like an area of interest only to those who build band sites, I think there is a lot to learn from this niche that can apply to most other sites. This is particularly true for the designer who is looking to inject some raw beauty into his work. Many designers I work with get hung up on wanting to make sure their designs reflect a personal touch. They want their sites to be works of art as much as they are functional sites. Many have forged this path, but few have come out with something worth looking at. With this perspective in mind, let's dig in and consider the band sites collected here.

The first sample I want to look at is the beautiful home page for Snow Patrol (**figure 1**). The most prominent of design elements is the band's name, the title of their latest album and the huge illustration of an eagle. These elements are directly pulled from the album art, which is hardly a surprise. What

I really appreciate is that they chose not to display the album in 3-D form. Instead they broke it up and made it fit into a website. So rather than have a large image of an album, we have a clear reinforcement of the product—but in a way that fits the medium. This is perhaps an obvious step to take, but I would argue that it is not the norm. What's more, they have merged live data, videos and more into the mix to literally bring the album to life. It isn't just a site for the band; it is a way to extend the album and interact with it.

Another example of album art driving the design of a site and making the website like a modernized version of classic album art is the Revive website (**figure 2**). Here, once again, imagery has been taken straight from the album and applied to the website. In this particular case it is easy to see how the site could change with each new album (or CD) cover. Change

some images, adjust some colors and swap out some typefaces, and the design could likely match most any album the group designs. Notice, for example, that they didn't go with some crazy thematic design and custom navigation system that somehow mirrors the theme of one of their songs. Getting over-conceptual in this way gets in the way of the purpose: to sell albums and concert tickets and to connect with fans. Thus, maintaining strong usability and an easy way to adapt to future needs while maintaining the same structure is a powerful and well-thought solution.

You will notice that all of these sites are beautiful; most include at least a touch of art via illustration or photography; and all function as easy-to-use, practical websites. They all strike a balance between ubercreative and practical.

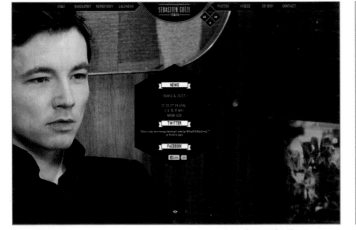

http://www.sebastiengueze.com

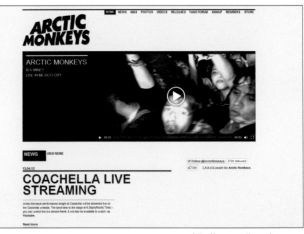

http://www.arcticmonkeys.com

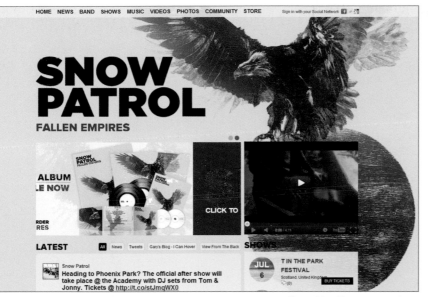

Figure 1 http://www.snowpatrol.com

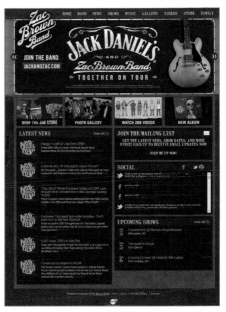

http://www.zacbrownband.com

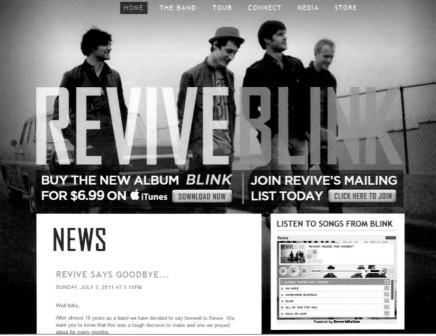

Figure 2 http://reviveband.com

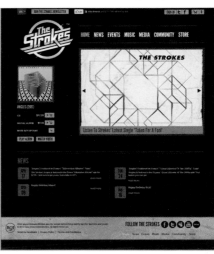

http://www.thestrokes.com

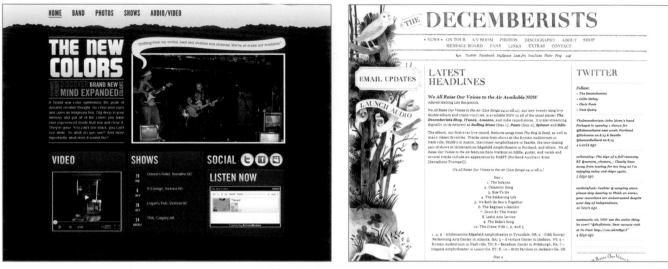

http://thenewcolors.ca

http://decemberists.com

http://www.littlekingblues.com

http://www.jamiecullum.com

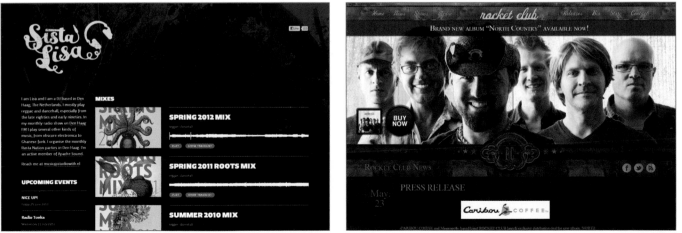

http://music.studiowith.nl

http://www.rocketclub.info

Nonprofits face many difficulties, and I imagine that setting aside the funding for a solid website is one of them. It can be hard to find impressive examples in this area. Because I filtered through a ton of them, I was able to find the gems I present to you here. Having a gorgeous site isn't critical to every nonprofit, but for some I am certain it is key to their success.

First, I want to take a closer look at Rice Bowls **(figure 1)**, a nonprofit targeted at raising money to feed orphaned children. You are most likely familiar with the TV commercials that run for organizations seeking to do the same—the ones filled with destitute little children. Perhaps this dose of reality works to raise money. But I love the rice bowls site because it doesn't focus on the downside—that kids are starving. Instead it focuses on what you can do to help. In fact, when the site finally does feature one of the troubled kids, it shows a happy one. As someone who has personally visited one of the poorest areas in Haiti (one of the poorest areas in the world), I can attest to something important here: The kids don't mope around all day. They are remarkably happy. And that makes me want to help them even more. This approach won't work for all nonprofits, but in this case putting on a happy face

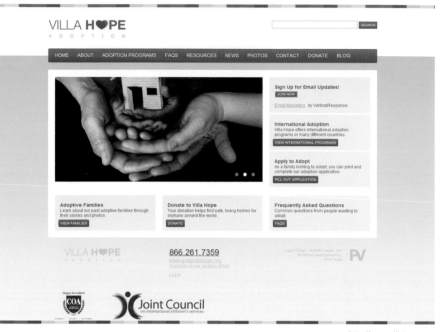

http://www.villahope.org

and making the process fun is a powerful way to get people to participate.

In stark contrast to the rice bowls site, consider the Hello Somebody organization site **(figure 2)**. Here an image of one of the people the organization seeks to help is central. The adjustments to the photo and the content of it play perfectly into the message of the site. It doesn't feel as though the site is solely pulling on your heartstrings with an emotional photo; rather the role

of the photo feels much more functional. The image reveals the purpose of the site and helps the visitor to quickly discern its purpose. Beyond this, the overall style of the site is not light and fun. Instead it feels somewhat formal and serious.

Compare the two examples. Both are serious issues, and while their tones are different, the designs of these sites match their core purposes very well.

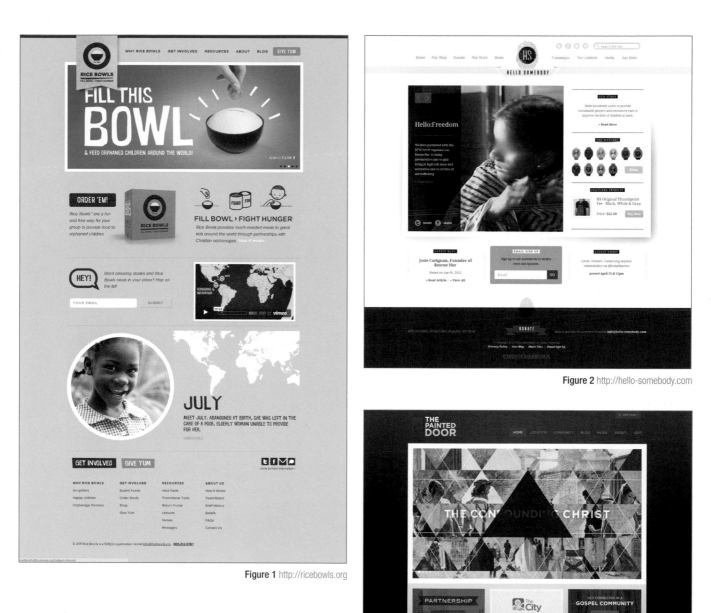

Figure 1 http://ricebowls.org

Figure 2 http://hello-somebody.com

http://thepainteddoor.org

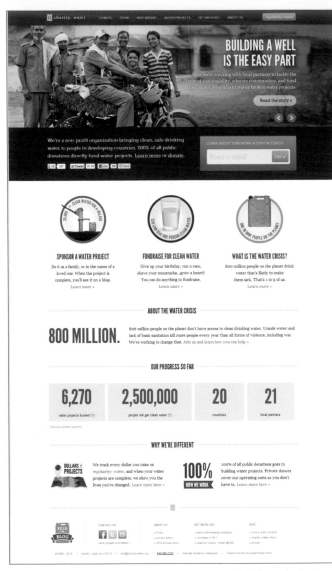

http://www.charitywater.org

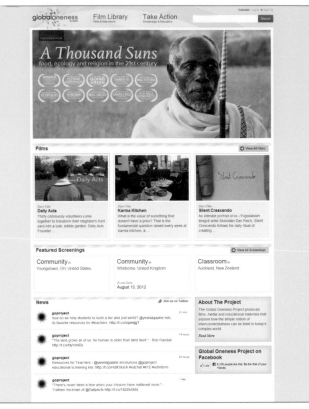

http://www.globalonenessproject.org

http://www.change.org

http://columbusfoundation.org

http://www.commendablekids.com

http://annualreport.jewishminneapolis.org

One of the most amazing things about the web community is its willingness to give things away. This section features a variety of web-based utilities that are almost exclusively free. Some also offer paid-for versions, but all allow you to use them in some form for free. Some of them are so amazingly useful you may find yourself wishing you could pay for them. While it is fun to show off cool tools, the focus of this book is inspiration, so we will look at these utilities with inspiration in mind.

I think you will find lots of fresh ideas in this section. In fact, I think this is a section that people may tend to overlook, but there is a great deal to learn from these samples. Many of these utilities rely on web interfaces that are anything but normal. In these cases, designers and developers created interesting solutions to strange needs. These aren't your everyday brochure sites after all; each has a distinct and unusual function. With this in mind, let's take a closer look at a few of them.

First I want to look at one of my favorite tools, jsFiddle **(figure 1)**. This handy tool lets you write and test code in your browser. And more important, it lets you save your work and generate a unique URL that you can share. This URL will allow anyone to view the snippet of code and play with it. If you have ever shared code, you will realize how simple this makes things and how handy it is. Technical issues aside (imagine building an app to work with HTML, CSS and JavaScript with the same tools—simply mind boggling), this site has some clear obstacles to overcome. The result is an interface that feels at home on the web though it feels nothing like a "normal" page. Your project may not warrant such a radical shift from the everyday site, but that isn't to say you can't find nuggets that apply to your work.

One of my favorite features found in these utilities sites is a singular focus. Take the CheckMyColours utility **(figure 2)** for a great example. Here the whole point is to get users to enter their URL and actually use the utility. As a result, the main form is at the top of the page and closely connected with the main brand. Even if you don't know what it does, you might give it a try. If not, you can scroll down and read more about it. This try-it-first approach is an interesting inversion of the typical "explain something and then ask the user to do something" approach. Perhaps the project you're working on could do with a radical shift in perspective.

http://www.prchecker.net

http://responsivepx.com

Figure 1 http://jsfiddle.net

Figure 2 http://www.checkmycolours.com

http://www.checkmateapp.com

http://notloremipsum.com

{🐻} bear css

Helping you build a solid stylesheet foundation based on your markup

INSTRUCTIONS

1. Upload your HTML document
2. CSS template is generated based on the HTML elements used
3. Download CSS File

UPLOAD HTML

ABOUT

Bear CSS is a handy little tool for web designers. It generates a CSS template containing all the HTML elements, classes & IDs defined in your markup.

The project was created by two MA Multidisciplinary Design students in Belfast, Northern Ireland.

Kyle Gawley
Website design & development

Jordan Henderson
Character design & branding

COLOPHON

Bear CSS was created using a combination of HTML5/CSS, jQuery and PHP, with some help from the following plugins:

- PHP Simple HTML DOM Parser
- Uploadify

All illustrations are original. Animation powered by CSS3.

Built with Coda

CONTACT

Your feedback and suggestions are most welcome, as is criticism and abuse.

feedback@bearcss.com

Contact Kyle
@kylegawley
http://kylegawley.co.uk

Contact Jordan
@skipskap
http://skipskap.com

http://bearcss.com

http://nodeca.github.com/fontomas

http://spritepad.wearekiss.com

http://minus.com

FREE PLUG-INS

As a follow-up to the utilities sites, I want to present a collection of sites for free plug-ins. These plug-ins are small bits of code that implement some functionality. What blows my mind is how much work people put into the presentation of these free resources. Much love and care has gone into the presentation and delivery of these tools; something that is reflected in the quality of the tools as well.

Why go to so much work with something you're only giving away? I think the answer is fairly simple. These tools draw lots of attention and traffic. If they are presented well, their success reflects a very positive image onto the creators. As a result, these tools are, in essence, powerful marketing tools. Want to achieve major

recognition in the industry? One way to do it is to put out an awesome resource in a beautiful package. The industry will respond, and you will most certainly build an audience.

To begin, take a look at the FitText sample **(figure 1)**. This great little jQuery plug-in capitalizes on the energy and momentum behind responsive design techniques. Not only was it among the first tools in this niche, it is clearly presented in a beautiful way. And, of course, you notice the claim to fame in the footer where they spell out who is providing you this free awesomeness.

Another great example is Font Awesome **(figure 2)**. In this case, the tool is clearly delivered and easy to download.

While the people behind it aren't quite as well-known, Font Awesome is still a powerful tool that has achieved a lot of visibility in the industry.

What I find interesting is how some of these tools sum up whole trends, in a way. For example, single page sites are rather popular. And there are some basic elements that go along with this, such as in-page scrolling. With this in mind, check out PageScroller **(figure 3)**. This slick tool makes it really easy to create in-page scrolling effects with sticky navigation (navigation that stays put even though the page scrolls). This tool makes it simple to implement this sort of functionality and plays directly into the current trends. It's a smart tool beautifully presented.

http://tableclothjs.com

http://www.turnjs.com

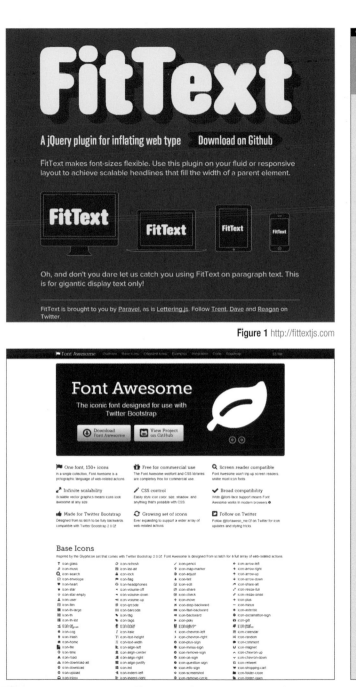

Figure 1 http://fittextjs.com

Figure 2 http://fortawesome.github.com/Font-Awesome

http://www.photoswipe.com

Figure 3 http://pagescroller.com

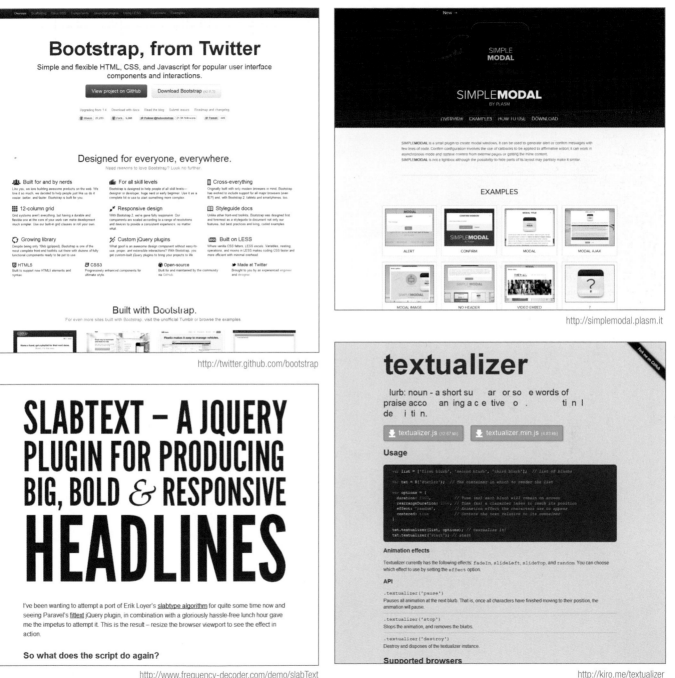

Bootstrap, from Twitter

Simple and flexible HTML, CSS, and Javascript for popular user interface components and interactions.

View project on GitHub Download Bootstrap (v2.0.3)

Upgrading from 1.4 Download with docs Read the blog Submit issues Roadmap and changelog

★ Watch 27,203 ⑂ Fork 5,388 Follow @twbootstrap 21.3K followers Tweet 14K

Designed for everyone, everywhere.

Need reasons to love Bootstrap? Look no further.

Built for and by nerds
Like you, we love building awesome products on the web. We love it so much, we decided to help people just like us do it easier, better, and faster. Bootstrap is built for you.

For all skill levels
Bootstrap is designed to help people of all skill levels—designer or developer, huge nerd or early beginner. Use it as a complete kit or use to start something more complex.

Cross-everything
Originally built with only modern browsers in mind, Bootstrap has evolved to include support for all major browsers (even IE7) and, with Bootstrap 2, tablets and smartphones, too.

12-column grid
Grid systems aren't everything, but having a durable and flexible one at the core of your work can make development much simpler. Use our built-in grid classes or roll your own.

Responsive design
With Bootstrap 2, we've gone fully responsive. Our components are scaled according to a range of resolutions and devices to provide a consistent experience, no matter what.

Styleguide docs
Bootstrap was designed first and foremost as a styleguide to document not only our features, but best practices and living, coded examples.

Growing library
Despite being only 10kb (gzipped), Bootstrap is one of the most complete front-end toolkits out there with dozens of fully functional components ready to be put to use.

Custom jQuery plugins
What good is an awesome design component without easy-to-use, proper, and extensible interactions? With Bootstrap, you get custom-built jQuery plugins to bring your projects to life.

Built on LESS
Where vanilla CSS falters, LESS excels. Variables, nesting operations, and mixins in LESS makes coding CSS faster and more efficient with minimal overhead.

HTML5
Built to support new HTML5 elements and syntax.

CSS3
Progressively enhanced components for ultimate style.

Open-source
Built for and maintained by the community via GitHub.

Made at Twitter
Brought to you by an experienced engineer and designer.

Built with Bootstrap.

For even more sites built with Bootstrap, visit the unofficial Tumblr or browse the examples.

http://twitter.github.com/bootstrap

SIMPLE**MODAL** is a small plugin to create modal windows. It can be used to generate alert or confirm messages with few lines of code. Confirm configuration involves the use of callbacks to be applied to affirmative action; it can work in asynchronous mode and retrieve contents from external pages or getting the inline content.
SIMPLE**MODAL** is not a lightbox although the possibility to hide parts of its layout may partially make it similar.

EXAMPLES

| ALERT | CONFIRM | MODAL | MODAL AJAX |
| MODAL IMAGE | NO HEADER | VIDEO EMBED | ? |

http://simplemodal.plasm.it

SLABTEXT – A JQUERY PLUGIN FOR PRODUCING BIG, BOLD & RESPONSIVE HEADLINES

I've been wanting to attempt a port of Erik Loyer's slabtype algorithm for quite some time now and seeing Paravel's fittext jQuery plugin, in combination with a gloriously hassle-free lunch hour gave me the impetus to attempt it. This is the result – resize the browser viewport to see the effect in action.

So what does the script do again?

http://www.frequency-decoder.com/demo/slabText

textualizer

lurb: noun - a short su ar or so e words of praise acco an ing a c e tive o . ti n l de i ti n.

↓ textualizer.js (12.67 kb) ↓ textualizer.min.js (4.83 kb)

Usage

```
var list = ['first blurb', 'second blurb', 'third blurb']; // list of blurbs

var txt = $('#txtlzr'); // The container in which to render the list

var options = {
    duration: 3000,         // Time (ms) each blurb will remain on screen
    rearrangeDuration: 1000, // Time (ms) a character takes to reach its position
    effect: 'random',        // Animation effect the characters use to appear
    centered: true           // Centers the text relative to its container
}

txt.textualizer(list, options); // textualize it!
txt.textualizer('start'); // start
```

Animation effects

Textualizer currently has the following effects: fadeIn, slideLeft, slideTop, and random. You can choose which effect to use by setting the effect option.

API

.textualizer('pause')
Pauses all animation at the next blurb. That is, once all characters have finished moving to their position, the animation will pause.

.textualizer('stop')
Stops the animation, and removes the blurbs.

.textualizer('destroy')
Destroy and disposes of the textualizer instance.

Supported browsers

http://kiro.me/textualizer

LEARNING SITES

What started out as a very short list of sites quickly grew into a much larger list than I expected. As someone interested in teaching outlets I was familiar with many of these sites, but I had never noticed just how many of them there were or just how gorgeous many of them are. It seems that learning online is in vogue right now. Not all of the sites here feature online learning outlets, but all of them do make use of the web to sell their services.

One detail I want to highlight is just how common a clear sales pitch is. These sales pitches are often made with language that challenges the viewer and probes her toward taking a step to use the resource.

At a minimum, the sales pitch clearly sets the stage for the purpose of the site. Here are a few:

- "Become a web developer in 8 weeks. Are you ready for the challenge?" **(figure 1)**

- "There's still time! Learn to code in 2012. 448,920 people are learning to code this year. Why not you?" **(figure 2)**

- "30 Days to Learn HTML & CSS" **(figure 3)**

- "Take and build online courses on any subject" **(figure 4)**

- "Introducing Pathwright—Everything you need to create, teach, and sell beautiful online courses." **(figure 5)**

This particular trend is one we find used on many sites well beyond the education arena. But it is interesting how often it appears in the learning arena. At the end of the day, making people guess about the purpose of your site or product is never a good thing. The sales pitches in these samples clearly articulate their purpose. As you work on your project, carefully consider whether the site's purpose and product is clear. If not, a bold sales pitch might be in order.

https://learnable.com

https://www.coursera.org

Figure 1 http://www.bloc.io

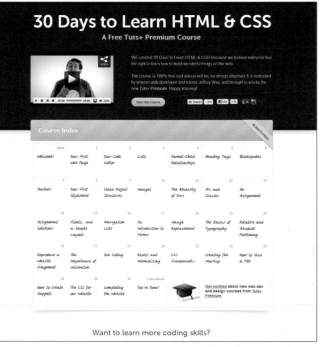

Figure 2 http://codeyear.com

Figure 3 http://learncss.tutsplus.com

Figure 4 http://www.udemy.com

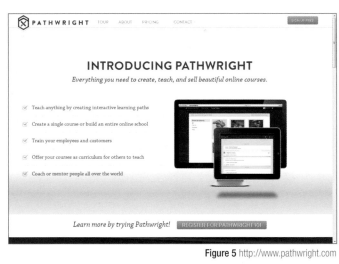

Figure 5 http://www.pathwright.com

http://hackerbuddy.com

http://www.bloomfire.com

http://teamtreehouse.com

http://www.webcoursesbangkok.com

http://railsforzombies.com

http://www.codeschool.com

Getting together is something that is particularly appealing to the web community given we don't have to meet face-to-face in order to do it. For many, it is the only opportunity to meet people, since they may live on opposite sides of the country, or even the world. Though many of the sites featured here are specific to the web community, I have diversified the collection to include several samples from outside this limited scope. Cross-pollinating ideas from various industries is perhaps one of the most effective ways to leverage inspiration. You can simply cherry-pick the best ideas from one field and apply those ideas to your field. I hope this small sampling of sites provides some big ideas.

This diverse set of samples highlights one thing very clearly for me; that the tone of an event site typically matches the purpose of the event. A vivid demonstration of this is the Ampersand event **(figure 1)**. It shouldn't come as a surprise that an event about typography features great typography on its site. The Sustainable Operations Summit event site echoes this approach **(figure 2)**. Here the illustrations and color palette represent what we might think of as sustainable. Finally, look at the Circles site **(figure 3)**. Though it doesn't thematically match the topic at hand, it is insanely gorgeous and refined, which ultimately appeals to the designer audience

http://lessmoney.lesseverything.com

it seeks. As with any product, knowing your audience is key, and these samples all play well into the areas they focus on.

Another interesting observation about event sites is that they don't seem to have a normal formula. Yes, most of them rely on similar elements like selling the speaker list or driving people to a sign-up form, but if you compare them structurally, you won't find a standard formula at work. I think event sites actually present an in-

teresting opportunity to the designer. An event site has to sell the user on why this event is worth it. After all, most conferences are not cheap to attend, and then there's airfare to consider, as well as the cost of a hotel and lost time at work. So the sales pitch has to be compelling. You will find that each of these sites has been carefully crafted to appeal to their audience in a unique way, and one of the ways they do it is to break from the traditional.

Figure 1 http://2012.ampersandconf.com

Figure 2 http://www.sustainableoperationssummit.com

http://www.wiredevent.co.uk

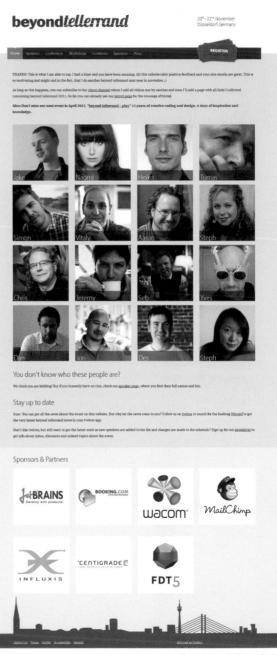

http://wmcfest.com

http://2011.beyondtellerrand.com

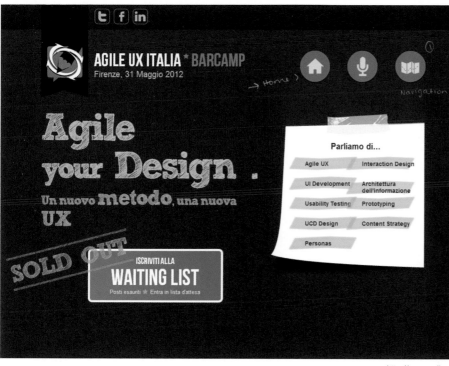

http://www.agileux.it

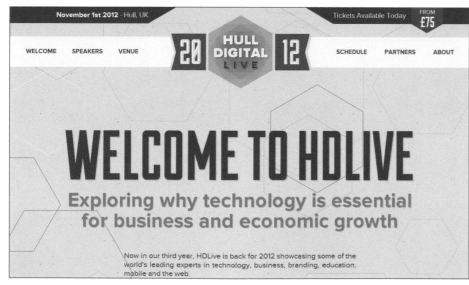

http://2012.hd-live.co.uk

http://www.leaderstheconference.com

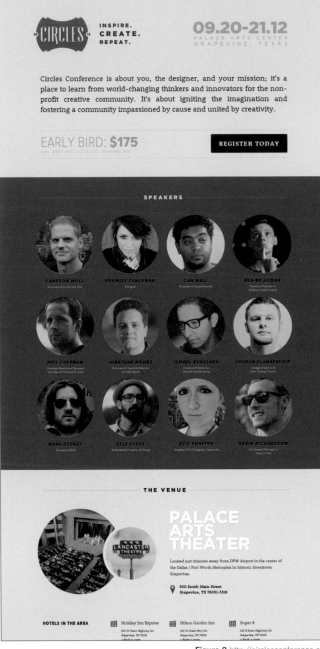

Figure 3 http://circlesconference.com

http://www.pausefest.com.au

http://convergese.com

05 / Site Structure

At first glance, a section covering various site structure patterns might seem out of place in a book all about inspiration. On the contrary: I find that designers often forget the wide range of options they have when designing sites. With this in mind, this section is largely focused on the outliers—the site structures that break the norms and forge their own path. With this kind of thinking, you are certain to discover fresh ideas to challenge your assumptions and inject a dose of inspiration into your work.

ATYPICAL LAYOUTS

One of my favorite categories is the atypical layout. Here I always collect a radically diverse set of examples: everything from sites that mash the normal elements around to those that capture the radically unusual. I love the broad range of ideas to be had, and I like to be reminded of the web's extreme possibilities.

First let's consider Ismael Burciaga's site **(figure 1)**. This site feels fairly normal, and yet it doesn't follow the standard formula. The logo and main navigation follow the rules (so to speak), but after that things take a whole new route. I really appreciate this approach, which roots the site in familiar formulas but proceeds to surprise. Sites like this are a wonderful balance between creative solutions and playing into people's expectations.

For a radical contrast, take a look at the We Heart website **(figure 2)**. Not only is the content presented in an unusual format, the main navigation and logo are found in unusual places. What's interesting is that though the site feels radically different, it is still easy to find your way around. The shifts in navigation are small enough, in contrast to the radical content styling, to keep it from being confusing.

Atypical layouts are risky business. Oftentimes the sites that push the envelope end up feeling overdone or they are painful to use. I believe the key lies in making sure there is a method to your madness. Don't create the atypical layout simply for the sake of creativity. If your approach plays into the purpose of the site, then go for it. But if you find that you're more focused on the creativity of your solution and less on solving the problems of the site, you might want to reconsider.

http://www.garyrozanc.com

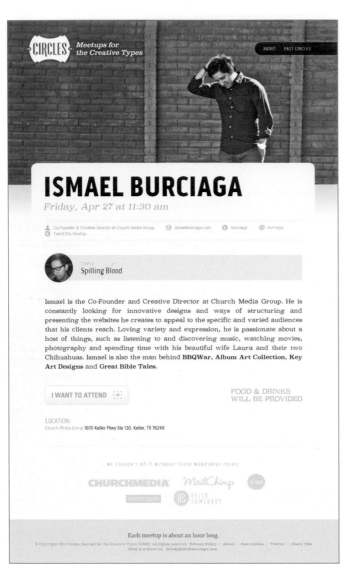

Figure 1 http://circlemeetups.com

Figure 2 http://www.weheart.co.uk

http://www.andrewrevitt.com

http://www.bichomalvado.com

http://gorohov.name

http://www.eclipse-creative.co.uk

http://36creative.com

http://lewisking.net

http://www.bunker-studios.com

http://messagela.com

ONE PAGE

The single-page approach has become insanely popular. This is a trend I really appreciate and enjoy. If you follow me on twitter or read any of my online articles, you already know it is a topic I am borderline obsessed with. With this in mind, I will do my best not to sound overly biased.

I have many reasons for my obsession. First among these is simplicity. By condensing all of the content to a single page, many sites trim extra fat that would have been necessary only to fill space. Sites like Kisielki.com **(figure 1)** demonstrate this perfectly. This site establishes the work they do, provides examples of said work and finishes off with a way to get in touch. This is about as condensed as a portfolio site can get. And I love it.

Another aspect of the single-page design that I admire is a bit harder to describe. When the end product is a single page, the flow of the page changes dramatically. In my opinion, it becomes very much like a digital version of poster design. Since all of the content is packed into a single page, the creators often have greater control over the order in which you consume the content. The same thing is certainly not true of the standard multi-page site. A good example of controlled interaction with the content is found on Soul-Reaper.com **(figure 2)**. Interact with this page and you may be shocked to find that it is built on HTML and CSS (no Flash).

One of my favorite things about one-page sites is the speed. Instead of watch-

ing a page load, picking an item and repeating forever, one-page sites can produce very fast interfaces. Cleanet.cz **(figure 3)** highlights this with fast moving in-page animations. And yes, some one-page sites end up much larger since everything is packed into a single page—note the previously mentioned Soul Reaper site that comes complete with a loader sequence to control this—but in many cases the whole site loads at once with little impact on the user's interface. As a result of this you can often browse the entire contents of the site with almost no wait time. Reducing the load time to a single block helps ensure you maintain a user's interest.

http://www.samdallyn.co.uk

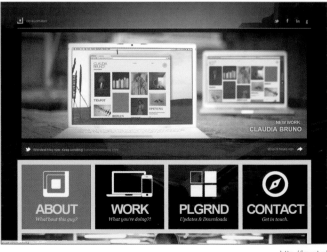

http://jpunt.nl

Figure 1 http://kisielki.com

Figure 2 http://www.soul-reaper.com

Figure 3 http://www.cleanet.cz

http://www.drewvergara.com

http://getgalleried.com

http://scentrend.com

http://danielhritzkiv.com

http://www.brianjwong.com

http://www.bloom-london.com

ONE-PAGE SALES PITCH

Given my previously confessed obsession with one-page sites, I have added this second chapter on the topic to indulge my guilty pleasure. This subset of one-page creations is focused on driving users to some conversion point. While most sites have some task they hope users complete, this set is driving toward the goal in far more focused and determined ways. The easiest way to understand this is to look at some examples, so let's dive in.

LiveSceneApp.com **(figure 1)** demonstrates the spirit of this collection perfectly. This supersimple one-page site is also superfocused. The goal here is to get people to download the app or vote for your city. Either way, the focus is on boosting app downloads. You may get the app now, or you may vote for your city and sign up to be notified when it is added to the app. Sometimes the product is so easily explained (eleven words in this case) that driving people toward the

conversion point is actually the point of the site.

Sometimes the product is a bit more complicated and requires more explanation. All the same, the goal is still highlighted and often repeated throughout the one-page design. Consider the ButtonBar site for example **(figure 2)**. Here the Buy Now buttons repeat in every section of the page. If at any point during the sales pitch the user decides to buy the product, a button is always in sight.

Figure 1 http://livesceneapp.com

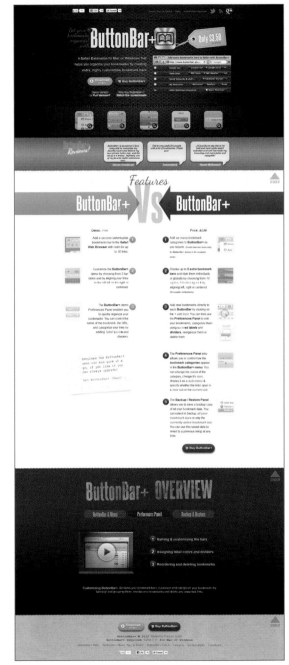

Figure 2 http://www.buttonbar-plus.com

http://www.happydangydiggy.com

http://www.peakcitypigfest.com

http://kicksend.com

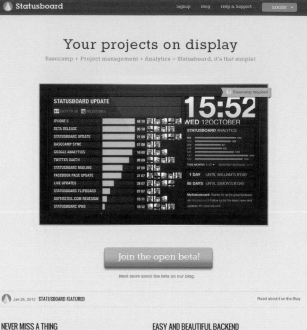

https://convertdemo.com

http://statusboard.me

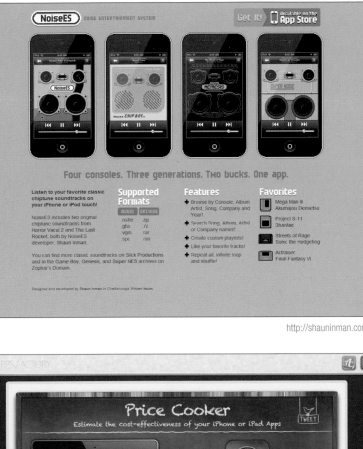

http://shauninman.com/noisees

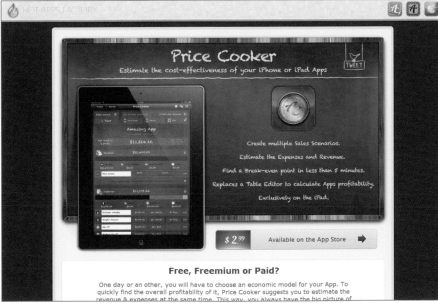

http://www.price-cooker.com

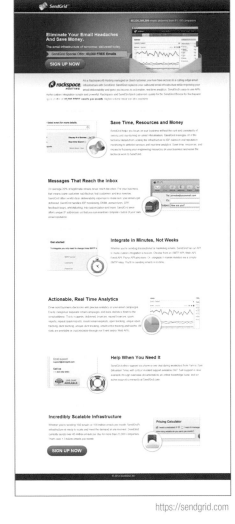

https://sendgrid.com

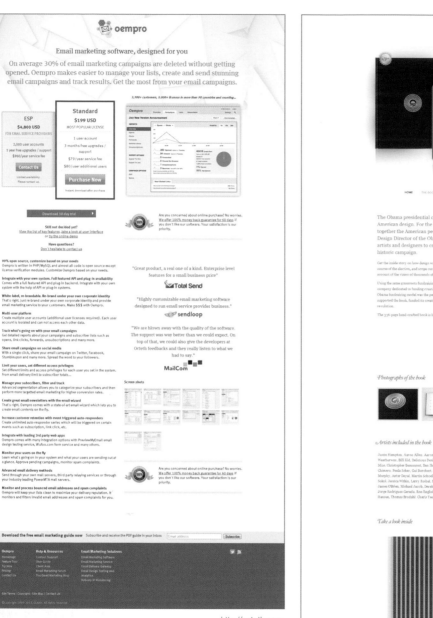

http://octeth.com

http://www.designing-obama.com

PAGE FILLERS

Every once in a while I identify a trend that doesn't have a label. This is one of those cases, and I am dubbing the collection "page fillers." Some aspects of this approach are well-known (and even labeled), but the combination of these approaches doesn't have a name—so page fillers it is.

What exactly is a page filler? Page fillers share two common properties. First, it is content that fills the page. Sometimes it is just a background that expands to fill the space and give the space the appearance of being full. Other times the content sizes and moves to fill the full space of the browser. Second, a page filler does not use scroll bars. This means the content sizes to fill the browser, while not occu-

pying more than a single screen worth of space. If it were not for this second property, these would simply be fluid layouts (a commonly accepted industry term).

The samples here tend to make use of page-filling layouts that break the rules. For example, many have the navigation anchored at the bottom of the page. The result is that these pages maximize the user's screen space while avoiding any sort of scrolling.

Many of you will recognize this formula. This is pretty much what countless Flash-based sites have done. In so many ways, this is the new approach to sites that would have previously been built on Flash. In past books, I referred to this as "pseudo Flash," but naming something

based on its resemblance to a technology it displaces seems odd. We don't call cars "pseudo horses" after all. Time marches on, and I think we need to name this approach something useful.

A clear demonstration of this approach can be found on The Remington Centre website **(figure 1)** Here the image scales to fill the space and the controls for the page move to the edges of the browser, with the main navigation fixed to the bottom of the page. Typically I would not want to highlight pages with the navigation stuck to the bottom. In most cases it creates a poor user experience, but as with all things, it can work. Fortunately for the creators of this site, the approach works well as it is implemented here.

http://www.anagnoris.us

Figure 1 http://remingtoncentre.ca

http://www.nextpagemedia.ca

http://permanentadg.com

http://designlabcph.com

Danthienne

2012 Collection

http://www.danthienne.it

NIKKEI 225

INICIO
RESTAURANTE
COCINA
GALERÍA
NOVEDADES
PRENSA
EVENTOS
CONTACTO

http://www.nikkei225.es

CONFIRMED STOCK

HOME THE EVENT ABOUT JOURNAL

http://confirmedstock.com

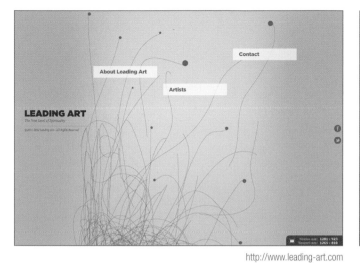

http://www.leading-art.com

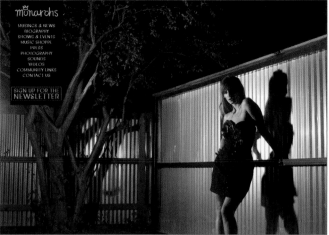

http://www.monarchsfamily.com/home

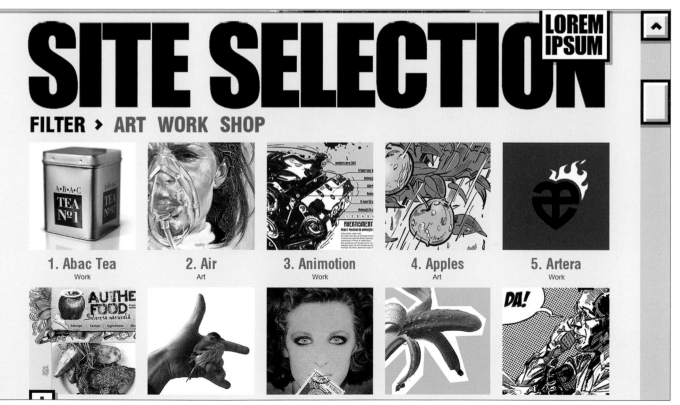

http://loremipsum.ro

267

MAP-BASED

Many sites feature location-oriented content, but few of these focus attention on the actual map in the way this small set of sites does. These sites feature location-based content—and the mapping interface—in incredibly prominent and beautiful ways. It's an unusual approach to building a site. The beauty of these sites is inspiring, but I find an even more inspiring element at work. The designers of these sites didn't just churn out a standard layout. Instead, they took a step back, considered the content and crafted an interface that revolves around the content exclusively.

In this way the maps become the primary interface on which everything else is built. By thinking like this, designers often find radical solutions that work amazingly well, all the while abandoning the norms.

Consider Mapitat and how atypical the layout is **(figure 1)**. I say it is atypical, though it feels incredibly intuitive. When looking for an apartment, location is often the most important element, second only to price. The site's interface allows you to filter options based on these primary criteria. You visually filter the locations, and the prominently placed slider allows

you to reduce the results. This approach does not follow the typical search/results/details approach to filtering data, and it probably isn't the easiest or most obvious approach. It is, however, an awesome solution to the problem at hand.

Another excellent example is Whatwasthere.com **(figure 2)**. Again, this site could simply be a listing of samples. But through the use of Google Maps and a totally custom layer of development, the end product is intuitive and fun to use. A long-running list of the same data would be far less interesting.

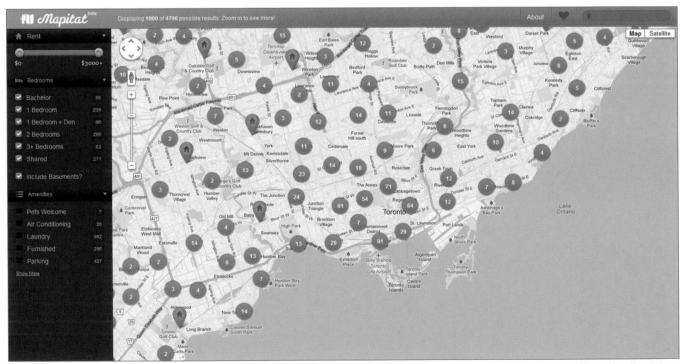

Figure 1 http://mapitat.com

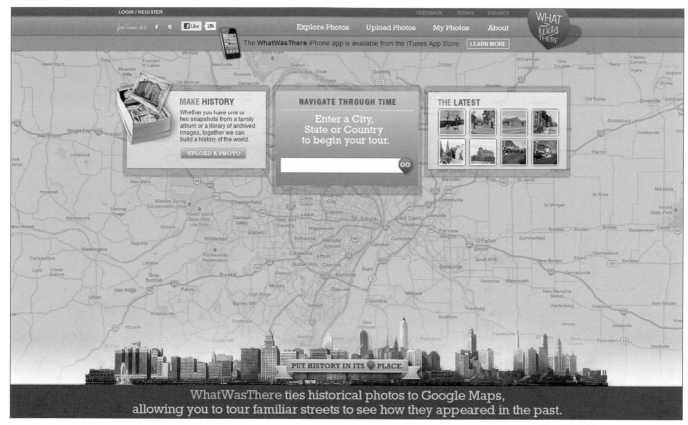

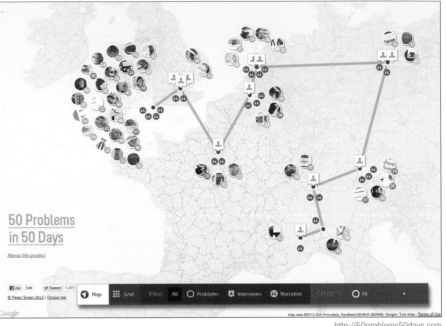

http://www.taocommunity.com/home

http://www.sepiatown.com

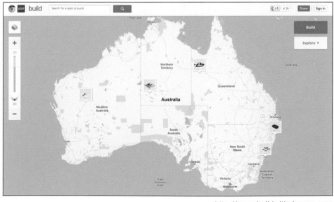

http://www.buildwithchrome.com

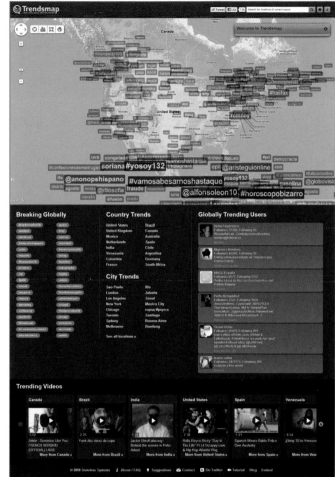

http://trendsmap.com

PINTEREST EFFECT

Before I dive into this topic I want to start with a disclaimer, so as to avoid all the objections I am likely to receive. Though the following sites clearly resemble the structure of Pinterest, some of them predate Pinterest, and many others most likely were developed without inspiration from this source at all. In fact, the structure you find on Pinterest is based on a formula that came about long before Pinterest did.

So why would I label this the "Pinterest effect," thus implying that the Pinterest design inspired and resulted in a number of followers? Well, like it or not, Pinterest is probably the biggest name attached to this particular layout method. Therefore, it gets the name. It might not be perfect, but it certainly describes the trend and most defi-nitely demonstrates how effective it can be.

Begin with a look at Brosmind.com **(figure 1)**, where we find a layout similar to Pinterest, though far from matching it. In particular you will notice that the blocks making up the page are all the exact same size. This gives the site a great deal of flexibility, makes the coding a bit easier and gives it a very consistent feel. I also appreciate that the same-size approach makes the content much easier to scan.

On the flip side, we find the website of Harry Roberts **(figure 2)**, where the blocks are not all the same size. In this case, I find that the content is harder to scan. But I also find that I much prefer this layout to one huge list stacked on top of itself. The reduced scrolling is a benefit that offsets the increased challenge of scanning the content. It also highlights the need for strong visual hierarchy in the text, so viewers can quickly find the title or label for a block of content. This is something you find at work in the Captain Daylight sample **(figure 3)**, where the title text for each block is large and easy to find, and thus much easier to scan.

Of course, a few samples here very clearly follow the Pinterest design and structure, like TheCodePlayer **(figure 4)** or Usabilla **(figure 5)**. But emulating Pinterest isn't a negative. Each of these sites has its own subtle twists and each certainly uses the approach effectively. Mimicking the patterns found on other sites can be a viable option when done responsibly.

NEWS
WORK
ABOUT
SHOP
CONTACT

Follow us!

HELLO XMAS
Brosmind Xmas Card / 2011

VIRGIN ACTIVE
Virgin Active / Publicis / 2011

OUTSIDE LANDS T-SHIRT
Outside Lands Music & Arts / 2011

MMJ POSTER
My Morning Jacket / 2011

PHISH TICKETS
Phish / 2011

SLIGHTLY STOOPID
Slightly Stoopid / 2011

A LOT CAN HAPPEN INSIDE THE
Gillette / BBDO NY / 2011

VIRGIN ACTIVE
Virgin Active / Publicis / 2011

NEW YORK POST
New York Post / Y&R NY / 2011

BROSMIND FRIENDS
Personal project / 2011

Figure 1 http://www.brosmind.com

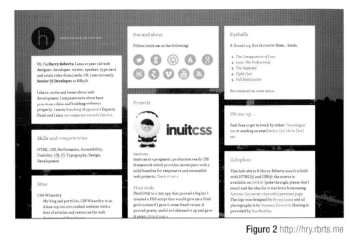

Figure 2 http://hry.rbrts.me

Figure 3 http://captaindaylight.com

Figure 4 http://thecodeplayer.com

Figure 5 http://discover.usabilla.com

http://www.brit.co

http://7pine.com

http://benjaminminnich.com

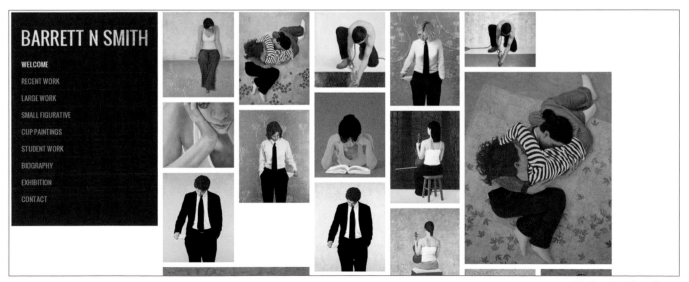

Endnotes

1. (p. 003) http://www.mikeindustries.com/blog/sifr
2. (p. 018) http://en.wikipedia.org/wiki/Open_source
3. (p. 040) https://typekit.com/fonts/adelle-web
4. (p. 040) https://typekit.com/fonts/futura-pt

5. (p. 071)To hear an outside voice on the topic, check out this post from Zeldman: http://www.zeldman.com/2011/07/06/responsive-design-i-dont-think-that-word-means-what-you-think-it-means/

6. (p. 186) http://blog.xlune.com/2009/09/vgrid/
7. (p. 186) http://isotope.metafizzy.co/

Index/permissions

278

More Great Titles from HOW Books

The Designer's Web Handbook | Patrick McNeil

Too many designers are unaware of the differences they'll face when designing for the web. Things like efficient navigation and building for easy updates or changes may be neglected in the planning process. This book will help you avoid making those costly mistakes so that your designs work the way you want them to.

Above the Fold | Brian Miller

A different kind of web design book, *Above the Fold* is not about timely design or technology trends. Instead, you'll learn about the timeless fundamentals of effective communication within the context of web design. You'll gain a deeper understanding of the web design considerations including design, typography, planning, usability and business value.

The Strategic Web Designer | Christopher Butler

In *The Strategic Web Designer,* you'll learn how to think about the web and lead web projects from the critical inception phase through the ongoing nurturing process every website needs. This indispensible guide provides a comprehensively informed point of view on the web that enables you to guide a web project intentionally, rather than reactively.

 For more news, tips and articles, follow us at **Twitter.com/HOWbrand**

 For behind-the-scenes information and special offers, become a fan at **Facebook. com/HOWmagazine**

 For visual inspiration, follow us at **Pinterest.com/HOWbrand**

Find these books and many others at MyDesignShop.com or your local bookstore.